The Quarry

THE QUARRY

Susan Howe

A NEW DIRECTIONS
PAPERBOOK ORIGINAL

"The Irish Cliffs of Moher," "To an Old Philosopher in Rome," "Vacancy in the Park," "The
Hermitage at the Center," "Certain Phenomena of Sound," "Le Monocle de Mon Oncle," "An
Old Man Asleep," "One of the Inhabitants of the West," and "The Paltry Nude Starts on a
Spring Voyage" from *The Collected Poems of Wallace Stevens* by Wallace Stevens, copyright © 1954
by Wallace Stevens and copyright renewed 1982 by Holly Stevens; "The Course of a Particu-
lar" from *Opus Posthumous: Poems, Plays, Prose* by Wallace Stevens, copyright © 1989 by Holly
Stevens. Copyright © 1957 by Elsie Stevens and Holly Stevens, copyright renewed 1985 by Holly
Stevens; Letters 449: To Harvey Breit (August 8, 1942), 641: To Thomas McGreevy (April 20,
1948), 690: To Jose Rodriguez Feo (April 22, 1949), and 842: To Barbara Church (September 29,
1952) from *The Letters of Wallace Stevens* by Holly Stevens, copyright © 1966 by Holly Stevens: all
used by permission of Alfred A. Knopf, an imprint of the Knopf Doubleday Publishing Group, a
division of Penguin Random House LLC. All rights reserved.
 The ms. fragment by Jonathan Edwards on page 47 is from the Jonathan Edwards Collection,
part of the General Collection, Beinecke Rare Book and Manuscript Library, Yale University. The
C. S. Peirce images in "Arisbe" are all from b MS Am 1632, Houghton Library, Harvard University.
We thank the Beinecke and Houghton Libraries for their generosity and assistance.
 The quotations from Robert Lax on pages 212–13 and Ian Hamilton Finlay on pages 217–18 are
from letters to the author.
 The Ad Reinhardt image on page 222 is © The Museum of Modern Art/Licensed by
SCALA/Art Resource, NY and © 2015 Estate of Ad Reinhardt/Artists Rights Society (ARS),
New York.
 Ian Hamilton Finlay's *Fisherman's Cross* on page 218 is used by courtesy of the Estate of Ian
Hamilton Finlay. The image is courtesy of the David Nolan Gallery, New York.

First published as New Directions Paperbook 1321 in 2015
Manufactured in the United States of America
New Directions Books are printed on acid-free paper

Library of Congress Cataloging-in-Publication Data
Howe, Susan, 1937–
[Essays. Selections]
The quarry / Susan Howe. — First New Directions Paperbook edition.
pages ; cm
ISBN 978-0-8112-2246-4 (alk. paper)
I. Title.
PS3558.O893A6 2015
814'.54—dc23 2015032316

10 9 8 7 6 5 4 3 2 1

New Directions Books are published for James Laughlin
by New Directions Publishing Corporation
80 Eighth Avenue, New York 10011

Contents

Vagrancy in the Park

Roaming

"March ... Someone has walked across the snow,
Someone looking for he knows not what."

"*Singeth spells.*" The poetry of Wallace Stevens makes me happy. This is the simple truth. Pleasure springs from the sense of fluid sound patterns phonetic utterance excites in us. Beauty, harmony, and order are represented by the arrangement, and repetition, of particular words on paper. No matter how many theoretical and critical interpretations there are, in the end each new clarity of discipline and delight contains inexplicable intricacies of form and measure. The last poems Wallace Stevens gathered together under a general title *The Rock* are moving, lyric meditations on the civil and particular. As if from some unfathomable source, knowledge derived from sense perception fails, and the unreality of what seems most real floods over us. As a North American poet writing in the early twenty-first century, I owe him an incalculable debt, for ways in which, through word frequencies and zero zones, his writing locates, rescues, and delivers what is various and vagrant in the near at hand. As Emily Dickinson put it: "The Zeroes—taught us—Phosphorous— / We learned to like the Fire."

—

"Nothing that is not there and the nothing that is."

Stevens wrote "The Course of a Particular" when he was seventy-three. It was published in the *Hudson Review* (Spring 1951) along with "Final Soliloquy of the Interior Paramour," but omitted by accident (according to the poet) from his 1954 *Collected Poems*. "The Snow Man," written almost exactly thirty years earlier, is eerily similar. (Both fifteen

4

line poems progress in tercets from "one," to "no one.") Perhaps, sounding its spectral refraction, he subtracted his second cold pastoral accidentally on purpose.

> Today the leaves cry, hanging on branches swept by wind,
> Yet the nothingness of winter becomes a little less.
> It is still full of icy shades and shapen snow.
>
> The leaves cry ... One holds off and merely hears the cry.
> It is a busy cry, concerning someone else.
> And though one says that one is part of everything,
>
> There is a conflict, there is a resistance involved;
> And being part is an exertion that declines:
> One feels the life of that which gives life as it is.
>
> The leaves cry. It is not a cry of divine attention,
> Nor the smoke-drift of puffed-out heroes, nor human cry.
> It is the cry of leaves that do not transcend themselves,
>
> In the absence of fantasia, without meaning more
> Than they are in the final finding of the ear, in the thing
> Itself, until, at last, the cry concerns no one at all.

Most critics read the season as autumn. For me, its lyric austerity defines late February weather in Guilford, Connecticut. Often on afternoon winter walks out on the quarry during this coldest month, there is hardly any foliage to cry in the raw air. Some brittle oak leaves still cling to their branches like tattered camouflage while tiny salt hay spindles scud across withered grass and frost-worked asphalt. Smoke-drift from indoor woodstoves is another vagrant variant. So is the coldness of green. The idea that green can be cold comes to me from Thoreau, who notes pine-green coldness in winter woods and the way light *straggles*. For Stevens, "Today the leaves cry, hanging on branches swept by wind,

/ Yet the nothingness of winter becomes a little less. / It is still full of icy shades and *shapen* snow." "Shapen" is an obsolete past participle. This wild word relic softly and serenely concerns no one. Its pastness echoes in the sound of wind soughing through pitch pines.

On my way home I see a small stream rushing along under ice. Maybe the nature of a particular can be understood only in relation to sound inside the sense it quickens. Setting sun. A mourning dove compounds invisible declensions.

"Deep dove, placate you in your hiddenness."

—

In an essay titled "The Present State of Poetry," Delmore Schwartz recalled: "In 1936 Stevens read his poems for the first time at Harvard—it was probably the first time he had ever read his poetry in public—and the occasion was at once an indescribable ordeal and a precious event: precious because he had been an undergraduate and a poet at Harvard some thirty-seven years before and had not returned since then, in his own person, although he had often gone to the Yale-Harvard games incognito. Before and after reading each poem, Stevens spoke of the nature of poetry, a subject which naturally obsessed him: the least sound counts, he said, the least sound and the least syllable. His illustration of this observation was wholly characteristic: he told of how he had wakened that week after midnight and heard the sounds made by a cat walking delicately and carefully on the crusted snow outside his house."

—

"On an old shore, the vulgar ocean rolls"

The letter *r* is frequently indicated as a characteristic mark of vulgarity. "R. is the dog's letter and hurreth in the sound" (Ben Jonson, *English Grammar*, 1640). "R. Young pious RUTH / Left all for Truth" (*New England Primer*, 1691). *R* is the eighteenth letter of the modern, and seventeenth letter of the ancient Roman alphabet. In general, the character denotes an open voiced consonant formed when the point of the tongue approaches the palate a little way behind the teeth; in many

6

languages this is accompanied by a vibration of the tongue, in which case the *r* is said to be trilled. This trill is almost or altogether absent in the *r* of modern standard English, which retains its consonantal value only when it precedes a vowel. In American English in all words spelled with *r* the sound occurs simultaneously with the vowel after it. The vowels in such cases are said to be re-colored. "Like rubies reddened by rubies reddening."

How carefully did Stevens plan the order for the poems included in *The Rock*? I often wonder if the many scattered *r* letters and sound combinations are there by chance, habit, or plot. "A repetition / In a repetitiousness of men and flies," "A new knowledge of reality," "Red-in-red repetitions never going."

—

"The river motion, the drowsy motion of the river R."

There are numerous interpretations of the last poem in his *Collected*, which he titled "Not Ideas About the Thing but the Thing Itself"; far less attention has been paid to the first:

An Old Man Asleep

The two worlds are asleep, are sleeping, now.
A dumb sense possesses them in a kind of solemnity.

The self and the earth—your thoughts, your feelings,
Your beliefs and disbeliefs, your whole peculiar plot;

The redness of your reddish chestnut trees,
The river motion, the drowsy motion of the river R.

What two worlds? When is now? Old Man River are you the reader, or are you the sleeping author your readers read inside ourselves. Your beliefs and disbeliefs, your whole peculiar plot; self and soil, a blaze of artifice reflected in earthly elements composing it. R as redness read or

any other color in the spectrum coming to us through oscillating pho-
nemes. Possibly those little mirror *r*'s on folded scraps of paper represent
time passing. The way certain autumn leaves change colors—bright but
not green, neither green nor bright—Now we see through a glass. But

Dumbfounder. Day is done. You rest it at that.

—

Practical Philosophy

Baruch Spinoza, by profession a lens-grinder, spent the last years
of his life in lodgings on the Pavilion Gracht, in the Hague, most of his
time in one room, often taking his meals there, and sometimes not leav-
ing it for several days when he was at work on a project. His first biog-
rapher listed his final possessions: "The inventory of a true philosopher.
Some small books, some engravings, a few lenses and the instruments to
polish them." His desk, containing letters and unpublished works, was
sent to his publisher in Amsterdam.

A poem is a glass, through which light is conveyed to us.

—

To Harvey Breit
August 8, 1942.

I have been away the last day or two and, while away, visited the
Dutch Church at Kingston: The Reformed Protestant Dutch Church.
This is one of the most beautiful churches that I know of.... The janitor
told me that at one time there were nine judges in the congregation
and that often the whole nine of them were there together at a service,
sitting in their separate pews. One of them was Judge Alton Parker;
another was Judge Gilbert Hasbrouck. Now Judge Hasbrouck was as
well known in Kingston as Martin Luther was in Wittenberg.

The janitor gave me a pamphlet containing an extract from the stud-
ies relating to the Reformed Church. The pamphlet consists of an article
by Judge Hasbrouck on this particular church. It starts out with this ...

"Indeed when Spinoza's great logic went searching for God it found
Him in a predicate of substance."

8

The material thing: the predicate of substance in this case was this church: the very building. Now, if a lawyer as eminent as Judge Hasbrouck went to church because it made it possible for him to touch, to see, etc., the very predicate of substance, do you think he was anything except a poet? He was only one of nine of them, so that, instead of nine judges, there were nine poets in the congregation, all of them struggling to get at the predicate of substance, although not all of them struggled to do so through Spinoza's great logic.

Another thing that this episode makes clear is that Spinoza's great logic was appreciated only the other day in Kingston; and, still more, that lawyers very often make use of their particular faculties to satisfy their particular desires.

<div style="text-align:center">Very truly yours,
Wallace Stevens.</div>

<div style="text-align:center">—</div>

"Pascal called the imagination the mistress of the world."

For Peter Brazeau's oral biography *Parts of A World: Wallace Stevens Remembered*, Richard Wilbur recalled a Cambridge gathering after Stevens's 1952 poetry reading at Harvard, when the seventy-three-year-old poet talked at length about his three years spent there as an undergraduate (1897–1900). To Wilbur's surprise, the professors Stevens remembered were the philosophers, particularly Josiah Royce and George Santayana, while he made little mention of publishing poems in the *Advocate* where he had served as an editor. At the end of the nineteenth and beginning of the twentieth centuries, the philosophical profession in the United States was dominated by an epistemological debate, of which pragmatism was an aspect, between the many forms of idealism and the even more numerous forms of realism. This debate, to which Royce, William James, and Santayana contributed so much, concerned the process of knowing and the nature of the reality known. Santayana, a charismatic young Spanish-American, born in Madrid, was at the time a popular lecturer in this, the greatest philosophy department America

has so far produced. He was also a poet, and he and Stevens exchanged work. "Cathedrals By the Sea; Reply to a Sonnet Beginning 'Cathedrals Are Not Built Along The Sea'" was written by Santayana in response to one of Stevens's early sonnets. Over twenty years later Santayana's essay "Penitent Art" appeared in the same July 1922 issue of the *Dial* along with six of Stevens's poems (later published in *Harmonium*). Thirty years later, for the Moody Lecture at Chicago on November 6, 1951, titled "A Collect of Philosophy," Stevens said of his old friend: "In the case of Santayana, who was an exquisite and memorable poet in the days in which he was, also, a young philosopher, the exquisite and memorable way in which he has always said things has given so much delight that we accept what he says as we accept our own civilization. His pages are part of the *douceur de vivre* and do not offer themselves for sensational summary." The following year in March he sent five poems ("To an Old Philosopher in Rome," "The Poem That Took the Place of a Mountain," "Vacancy in the Park," "Two Illustrations That the World Is What You Make of It," and "Prologues to What Is Possible") to the *Hudson Review* and asked they be set in this specific order. On September 29, 1952, he wrote to Barbara Church: "I grieve to hear of the death of George Santayana in Rome. Fifty years ago, I knew him well, in Cambridge, where he often asked me to come to see him. This was before he had definitely decided not to be a poet. The reason (like the law, which is only a form of the reason) is a jealous mistress."

For George Santayana, Spinoza offers an example of disillusioned philosophic liberty. He wrote of the debt we owe this philosopher for the "courage, firmness, and sincerity with which he reconciled his heart to the truth." In his later work, through intuitive, rational insight Wallace Stevens appears to have achieved, or yielded to, an understanding of our oneness with nature he names "reality," similar to Spinoza's "intellectual love of God."

—

To Jose Rodriguez Feo, April 22, 1949.

I am returning Santayana's letter. Your devotion to this superb figure delights me. How strong his handwriting is and how the whole letter convinces one that there is nothing mixes with long life like a strong mind. I love his remark: "I have always, somewhat sadly, bowed to expedience, or fate."

—

Santayana's Introduction to Spinoza's *Ethics and "De Inellectus Emendatione"* (translated by A. Boyle, first published in 1910, reissued in 1938) begins this way: "Spinoza is one of those great men whose eminence grows more obvious with the lapse of years. Like a mountain obscured at first by its foot-hills, he rises as he recedes."

—

"The Poem That Took the Place of a Mountain"

How can the chosen words "philosophy" and "poetry" ever attain true harmony? Intent on one disciplined desire you stare longingly at qualities acting and being acted on in the other ("I quiz all sounds, all thoughts, all everything / For the music and manner of the paladins / To make oblation fit. Where shall I find / Bravura adequate to this great hymn?" ("Le Monocle de Mon Oncle," 1923). Perhaps, at seventy-three, remembering the hero of his early college days, Stevens could look back and recognize that his necessary calling, its faith and risk, was to address poetically the search for truth Santayana, inspired by his master and model Spinoza, had addressed discursively. There it was.

"A place to go in his own direction."

—

Santayana is buried in the *Tomba degli Spagnoli* in Rome's Verano Cemetery. At the burial service a friend read some lines from his poem "The Poet's Testament," composed during World War I:

> I give back to the earth what the earth gave
> All to the furrow, nothing to the grave.

The candle's out, the spirit's vigil spent;
Sight may not follow where the vision went.

Laying the burden down because noiselessness is tumultuous in its oceanic sense even when the open book is turned over, face to table. Secret perceptions in readers draw near to the secret perceptions in authors. In "A Quiet Normal Life": "Here in his house and in his room / In his chair, the most tranquil thought grew peaked." The wings of an open book are the wings of desire. "Only we two may interchange / Each in the other what each has to give." Each to each over and over. "Oh you solitary singer, singing by yourself, projecting me."

—

Walt Whitman: The Primer of Words. "The Morning has its words, and Night the Evening has its words.— How much there is in the word Light! How How vast, surrounding, falling sleeping, noiseless, is the word Night!—It hugs ~~is a word that one a man~~ with ~~welcome, vast,~~ unfelt yet living arms—
 "Follow after, O my companion, my fellow, my self."

—

Here, on a clear night in February I can see so many stars. Before coming in I stop between the car and the house and fixing my gaze on one in particular I recite the same wish. "Star light, star bright, / first star I see tonight. / I wish Becky, Mark, David, Peter and I won't die until we are very old." Very old, I whisper to myself and the celestial constellations—as if I were still very young. I retain the original word order even though David died in 1992 and Peter in 2008. I never do this indoors because looking at a new moon through glass was and is terribly unlucky according to my mother's divinations so I can't take a chance of accidental sightings. If this is obsessive compulsive behavior, so what? Meaning through measure may be transmitted from one generational folklore reality through another.

—

Poetry is an incessant amorous search under the sign of love for a re-membered time at the pitch-dark fringes of evening when we gathered together to bless and believe. In "Somnambulisma" Stevens's vulgar rolling ocean follows Walt Whitman's solitary sea-bird in "Out of the Cradle Endlessly Rocking." "*Soothe! soothe! soothe! / Close on its wave soothes the wave behind, / And again another behind embracing and lapping, every one close, / But my love soothes not me, not me.*"

Sound is sight sung inwardly. I am folding tangled threads of royal purple for a robe wrapped tightly round to keep the breath of the night wind warm. The way women in Irish paintings wrap themselves in woolen blankets, or the way in *To The Lighthouse*, Virginia Woolf's Mrs. Ramsay covers the boar skull on the nursery wall with her green shawl so her children will sleep. As we grow old we return to our parents. Their absent submission to the harsh reality of Death renders the tangle luminous. A stellar pallor hangs on strips of silver bubbling before the sun. The spell is broken. There they are—embarking with other happy couples for Cythera.

Up from waves scudding over

—

Sarah Pierpont Edwards's mother Mary Hooker was a granddaughter of Thomas Hooker. In 1636 at the height of the antinomian crisis he led his congregation along Indian trails to the bend of the river where Hartford is now.

In my unspeakable fish net spectra version she's still roaming

—

Stevens wrote the magnificent ninth poem in *The Rock* series several months before Santayana's death at the Convent of the Blue Nuns of the Little Company of Mary, in September 1952, (where he was being cared for by Irish nuns) and three years before his own death at Saint Francis Hospital, Hartford (established in 1897 by the Sisters of Saint Joseph of Chambéry). Reading and re-reading this poem of parallel worlds—the city Rome, and the Rome of pastoral—composed by a

poet-philosopher in homage of a philosopher-poet, I experience the wonder and mystery of art—its mortal deception its hawk-eyed majesty.

Rome—the shattering of the hope of the ancients to build a city on a rock and defy the ages. Rome—"at once the Paradise, / The grave, the city, and the wilderness" of Shelley's *Adonais; An Elegy on the Death of John Keats, Author of Endymion, Hyperion, Etc.* "The threshold, Rome, and that more merciful Rome / Beyond, the two alike in the make of the mind." How clear and close it is. That silent chorus prescient deep inside us so we remember the night-hymn is there in that parallel perspective both shield and cry. "How easily the blown banners change to wings ..." Rome—an essence incarnate in its name. The blood of Empire. Rome during the last violent century—two World Wars followed by a Cold one. "The extreme of the known in the presence of the extreme / Of the unknown." "Your dozing in the depths of wakefulness, / In the warmth of your bed, at the edge of your chair, alive / Yet living in two worlds, impenitent / As to one, and, as to one, most penitent."

—

In the future general progress of things will Manhattan be a field of ruins like the ruins near Rome in Poussin's late landscapes? All canvases turned face inward toward the wall in a room filled with poems that take the place of mountains now turned face down in the cosmic dust of history? "Light the first light of evening." Illumination means simple understanding. "A Quiet Normal Life" begins as an order. Egotistical and lonely we gather together almost as if to ask the Lord's blessing. Electric light is artificial. The candle of the scholar reading is light from the central mind.

—

"As I went to the holy land, / That have come, that have gone."

Two old men are "dozing in the depths of wakefulness," and yet they are not human bodies, only representations inside and around the stressed and unstressed syllables of the elegy forming and framing them.

—

"Horrid figures of Medusa,
"These accents explicate / The sparkling fall of night / On Europe, to the last Alp, / And the sheeted Atlantic." Fragmentary etymological access ... arrest and flow ... what will be forever ... what was from of old ... the barbarous mother ... her daughter ... polysyllabic rest and flow ...
Distant river grass spectra

—

"There is a great river this side of Stygia." The haunted shock-effect of the last word of "The River of Rivers in Connecticut" summons mythical associations with European elegiac and pastoral traditions—the river of time that casts souls on its bank but carries away everything else without effort—this unnamed river of rivers, "far" this side of the pagan deathriver Styx, is the psalmist's river of eternal life ("*There is* a river, the streams whereof shall make glad the city of God, the holy *place* of the tabernacles of the most High."). By cutting away the letter *n* Stevens interrupts the mythic and European association with the subterranean river named for the Goddess of Death without losing its pastoral and elegiac echoes, placing it in an American tradition. "A curriculum, a vigor, a local abstraction ..." Stygia becomes a possible place name possibly in Connecticut derived from the native American designations Quonehtacut or Quinatucquet, or Quenticut meaning "long tidal river." The discontinuity between nature as original creation, and the inward perception or sensation through words clear as crystal formed in rock, up-buoys Psalm 46.4. On its banks local place names, Haddam and Farmington, gathered into steeples on their village commons, flash and flash in the sun.

—

Spinoza and us
These days I listen to the high speed Acela Express rushing through the remaining traces of woodland surrounding this four and a half acre, exurban almost suburban lot on the Northeast Corridor en route to

Boston, New York City, Philadelphia, Baltimore, and Washington. Amtrak owns the land immediately bordering the tracks. Recently there has been a lot of hammering into the rock at night for some reason connected with a five-year plan for deploying free Wi-Fi internet service on all trains including slower regional ones.

It's the new millennium. Post 9/11, spangled bleeding banners, war's carnage, the global War on Terror, Guantánamo, metadata relationships, fracking, plastic bags, nuclear power plants, climate change, global warming, black holes, possible human extinction. If we have nothing but truth to leave, how do we distinguish ideas of what we were from ideas of what we are in vibrant contemporary compost jargon trash landfill

—

"So you're home again, Redwood Roamer, and ready / To feast"

The Connecticut River enters Massachusetts from the north bisecting it. Deerfield—Deerfield River and Millers River. Tobacco belt. Tobacco and onions. Noah Webster's *American Dictionary of the English Language* was printed in 1828 in Springfield, Massachusetts.

—

"The Roamer is a voice taller than the redwoods"

At Longmeadow the river is at its widest, then it enters Connecticut. For Webster the letter *r* is numbered among the liquids and "is uttered with a guttural extrusion of the breath, and in some words, particularly at the end of or after a labial and a dental letter, with a sort of quivering motion or slight jar of the tongue." He defines a Roamer as: "A wanderer; a rover; a rambler; a vagrant."

Signal sender, faraway receiver

—

"A shutter, like the leathern eyelid of a lizard, flickered over the intensity of his gaze and obscured the letter R. In that flash of darkness he heard people saying—he was a failure—that R was beyond him. He would

never reach R. On to R, once more. R—"That's Mr. Ramsey brooding over his progress through the twenty-six letters of the English alphabet in *To the Lighthouse*, chapter six. The last line of the first poem "An Old Man Asleep" flows into the first line of the second-to-last poem "The River of Rivers in Connecticut."

—

"The Paltry Nude Starts on a Spring Voyage"

She scuds the glitters, / Noiselessly, like one more wave. / She too is discontent / And would have purple stuff upon her arms.

—

"Of Hartford in a Purple Light"

"About the beginning of June, 1636, Mr. Hooker, Mr. Stone, and about a hundred men, women, and children, took their departure from Cambridge, and travelled more than a hundred miles, through a hideous and trackless wilderness, to Hartford. They had no guide but their compass; made their way over mountains, through swamps, thickets, and rivers, which were passed only with great difficulty. They had no covering but the heavens, nor any lodgings but those which simple nature afforded. They drove with them a hundred and sixty head of cattle, and by the way subsisted on the milk of their cows. Mrs. Hooker was borne through the wilderness on a litter. The people generally carried their packs, arms, and some utensils. They were nearly a fortnight on their journey."

—

Late last night when I couldn't sleep I wondered at how the cold reversal of moonlight on snow from outside brightens the commonplace stillness of the house and how quietly night stands open to us, and sits up for us. Not fastening the door

—

In January 1538 a woman at Walsingham was carted about the market-place in deep snow and set in the stocks for saying a despoiled shrine had begun to work miracles mingled into the soul of this world a strong sun lording the sky so let us all be as we are under our own roofs

—

Fishmonger
on the beached margin after long pilgrimage, waving to the quiet moon.

2.

Ring around the Roses

"And one last look at the ducks is a look
At lucent children round her in a ring."

The second week of August 2003, on what turned out to be the day of the great northeastern blackout, Peter and I drove over to see Elizabeth Park because we wanted to see the place where Stevens had spent so much time. It was a typically hot, hazy, humid, late summer day in a northeastern American city. I like to visit parks when I'm in unfamiliar cities because experiencing them with eyes freshly open I feel (as Henry James once put it) a mystic solicitation, some welcome held out by the atmosphere, the urgent local appeal on the part of everything—immersed in time—to be reinterpreted. The parks I am familiar with, in Boston, Manhattan, New Haven, and Buffalo (all of them designed by Frederick Law Olmsted who was born in Hartford but didn't plan one here) are usually somewhat burnt out by August, but even if the roses, in this, the oldest municipal rose garden in the United States, were by now well past their glory, this was such a wet summer in Connecticut that the grass was a vivid green and still redolent with morning dew. We strolled among rose beds, rose bushes, rose ramblers, bending among them to read their names: Dainty Bess, Carefree Delight, Shreveport Grandiflora, the White Rose of York, Moonstone Hybrid Tea, Pristine Hybrid Tea, Floribunda, Hiawatha Rambler. Across the road in the annual gardens we saw high banks of white phlox, varieties of marigolds (Marigold Galore Orange, Marigold Galore Yellow, Marigold Little Hero Yellow, Marigold Bonanza) we saw impatiens, nasturtiums, forget-me-nots, ugly begonias, all sorts of lilies, some of the tiger ones a gaudy vermilion. I go on with these flower names not only because I enjoy making lists—but also to remind you, the reader, how words supersede and

displace the reality of an object sensed in space and time. According to William James: "Both the sensational and the relational parts of reality are dumb. They say absolutely nothing about themselves. We it is who have to speak for them." This is what Wallace Stevens does—he sounds the myriad ever shifting sensations—fragmentary, unpredictable, unspoken, invisible—of seemingly simple objects or events: a summer night's drive from Cornwall to Hartford, something noticed on the way to the bus, a greenhouse badly in need of paint, the way trees in November, "sway, deeply and loudly, in an effort, / So much less than feeling, so much less than speech, / Saying and saying, the way things say / On the level of that which is not yet knowledge." This interaction between reality and imagination is the benevolent, relentless vitality of nature and of poetry.

It was Thursday morning so there weren't many people around. A couple asked us to photograph them together as they posed in front of "the rustic arbor, / Under its mattresses of vines." Two elderly woman speaking in Russian paused to smell some particular blossoms and then moved on. I read the short stories on Memory Benches:

> "In memory of Louis (Gino) Menta
> Master Tailor—Good Samaritan"

> "Georgie Hernandez
> She loved us all but I was her favorite."

A young father we had seen earlier pushing his child in a stroller had paused to rest on one of the benches. A woman, seated in the perennial garden gazebo with a baby asleep in a carrier on her back, was writing something into a notebook on her lap—a poem, a list, a letter. Sitting on another in the shade of a Pyramidal European Hornbeam—the sort of tree small children love because its short trunk and overspreading branches invite climbing—the stability I felt around me, there in half-light under the Hornbeam, the richness, the calm, the time of day—its mixture of sun and shade, dwarf shrubs, climbers, rock-plants, their magical effects of green, and gold, and grey—the whole "atmosphere" recalled my first experience of Ireland in 1947. After the war we spent the summer

over there, and I used to play in Herbert Park near my grandmother's house on Wellington Place in Dublin. Hartford was Dublin. Home in the world—away in the world—landscape and language threaded.

—

Barbara Church
September 10, 1952.

"As one grows older, one's own poems begin to look like the poems of someone else. Jack Sweeney (the Boston Sweeney) sent me a post-card from County Clare the other day—the worn cliffs towering up over the Atlantic. It was like a gust of freedom, a return to the spacious solitary world in which we used to exist."

—

During the 1940s Jack ("The Boston Sweeney") sometimes drove my mother, my sister Fanny, and myself on Sunday outings to suburb areas beyond Cambridge because our father was serving in North Africa and Europe and we didn't own a car. Sometimes we picnicked beside the drowsy Concord River near the Battleground Bridge and the Old Manse. This plain clapboard parsonage built in 1770 for the patriot patriarch Reverend William Emerson (Ralph Waldo's great-great-grandfather) was subsequently occupied by a succession of Puritan clergymen, until Nathaniel and Sophia Hawthorne rented the property after their marriage in 1842. Here, in an upstairs room overlooking what is now communal ground with its apple orchards, elms, and ash trees, Emerson drafted *Nature*, and Hawthorne wrote "The Birth-mark" and "Rappaccini's Daughter," among other stories published in *Mosses of an Old Manse*. Because of the rarity of glass in eighteenth-century New England the windows were set with tiny panes. Sophia and Nathaniel left notes etched into the glass with her wedding ring diamond.

"Nath Hawthorne This is his study. / The smallest twig leans clear against the sky. / Composed by my wife and written with her diamond. / Inscribed by my husband at sunset, April 3 1843. In the Gold light."

A wedding ring is emblematically "and." The connection between two.

—

On Receiving the Gold Medal from the Poetry Society of America:

"The other day, in the middle of January, as I was taking a walk in Elizabeth Park, in Hartford, I saw at a little distance across the snow a group of automobiles that had pulled up on one side of the road. A dozen people or more got out of them. They took off their coats and threw them together in a pile on the asphalt. It was then possible to see that this was a wedding party.... The bride stood up in white satin covered with a veil. An ornament in her hair caught the sunlight and sparkled brightly in the cold wind. The bridesmaids were dressed in dark crimson with low necks. They carried armfuls of chrysanthemums. One of the men stood in the snow taking pictures of the bride, then of the bride surrounded by the bridesmaids, and so on, until nothing more was possible. Now this bride with her gauze and glitter was the genius of poetry. The only thing wrong with her was that she was out of place."

January 24, 1951.

—

"Looking Across the Fields and Watching the Birds Fly."

Concord, at the edge of things where swallows weave transparencies. As runs the glass our life doth pass. Words are widows of thought. You can't see yourself reflected because time has scratched some surface off.

The more I read you—the more I need you—the more I read you—the less I know you—

—

In *The Natural History of Selborne* (1789) the parson, naturalist, and ornithologist Gilbert White describes the way in which the female swallow, "while there is a family to be supported, spends the whole day in skimming close to the ground, and exerting the most sudden turns and quick evolutions. Avenues and long walks under hedges, and pasture-fields and mown meadows where cattle graze, are her delight." I own a second-hand copy published during wartime. I suppose the publishers

during that troubled year thought English readers needed an idea of Peace-In-Selborne-Circa-1788. He said the birds appeared around 13th April though he observed earlier stragglers. This wonderful little classic, beloved by Coleridge, Woolf, Frost, and Auden, among many others, consists of a series of Letters addressed to Thomas Pennant, a noted zoologist, and Daines Barrington, a barrister. My second-hand copy was reissued by Penguin in 1941, the same year Pearl Harbor was bombed and Wallace Stevens wrote "The Noble Rider and the Sound of Words." W. H. Auden couples White with Thoreau in "Posthumous Letter to Gilbert White": "It's rather sad we can only meet people / whose dates overlap with ours, a real shame that / you and Thoreau (we know that he read you) / never shook hands." Stevens's unnamed River of Rivers may serve as a trope for Thoreau's Concord River once called Musketaquid or Meadow.

River of peace and quietness. River of battlefield ghosts—

—

"Simplicity! simplicity! simplicity!"

"Near the end of March, 1845, I borrowed an axe and went down to the woods by Walden Pond."

—

"The Plain Sense of Things."

The great pond—before its pastoral reflection—before the waste and weltering. Frogs, and red-winged blackbirds, other precursor heralds
 chip clamor cart-path bug cricket rippleleaf

—

Letter XIII, Selborne, Sept 9, 1778.

"The language of birds is very ancient, and like other ancient modes of speech, very elliptical; little is said, but much is meant and understood."

—

The Past! The Past! The Past!

How is it possible to express a single poem's sonic force—just as it is—identical to itself—the *res*.

It must be possible possible possible!

—

April 20, 1948.
Dear Mr. McGreevy,
I took your letter home last night and read it in my room.... As a matter of fact, a man who writes poetry never really gets away from it. He may not continue to write it as poetry, but he always remains a poet in one form or another. Perhaps your book on drawings of Mr. [Jack] Yeats is your present form of being a poet.... If you don't mind, and if you don't think he would, could you take a copy of your book with you some evening when you are going to spend an hour or two with him and have him do a profile of you in the blank pages in front which both of you could then sign. This would give me something that would be precious to me.... Ireland is rather often in mind over here. Somehow the image of it is growing fresher and stronger. In any case, the picture I had of it when I was a boy is no longer the present picture. It is something much more modern and vigorous. I don't know whether you feel that change in Dublin. This has nothing to do with propaganda: it is just something that seems to take form without one's knowing why.

—

Boston with a Notebook. The Public Gardens. Ready or not! Voices of children playing near the Swan-boats have stopped. They must have been called back. It's seventy years after.

—

I don't often remember Stevens poems separately except for the early ones but they all run together the way Emerson's essays do into a long meditation moving like waves and suddenly there is one perfect portal. The quick perfection. "Night's hymn of the rock, as in a vivid sleep."

—

I have pinned a postcard reproduction of Rembrandt's small painting "The Abduction of Proserpina" on the wall of my workroom. Pluto's lion-headed chariot pulled by a furiously charging horse is dragging her to Hell while Diana and Minerva (who seem to be rising from the waves) tug at what could be her wedding dress. Its white linen or silvered silk acts as a slash of light across the center of the canvas.

—

"Snow glistens in its instant in the air." If a line is quick and strong it pierces our glassy earth. It bursts out of reflection on all sides because the heart refuses to be imprisoned; in its first and narrowest pulses it already tends outward with a vast force. Come in. Sit distantly close to me Snow Image. Let's form crosses in the air while reading and sleeping according to reciprical reflection. This broken mirror is the world, magnified. Seven years bad luck unless you quickly toss its splinters in the river. During the WWII years reciting secret languages of holy Ireland Molly and Jack clothed as fellow-performers stoop to smell the roses as balm for this cleft earth.

Wait till you see now

—

Spinoza, I skidded on ice-encrusted roads to our local post office to get your letter from Europe. You should know [thimble finger turning] I am also reading Emerson, and Hawthorne. Each author's posthumous name is a label attached to a cardboard mask for communal sharing of two realities. Ringing round, while performing somersaults in a cage of common purpose we obey the pages turning. Random connections between public parks as rustic meta-historical archetypes. Revolving beyond forgetfulness until they reach the rocks around New Quarry Road as they were thousands of years before a working quarry was wrenched from chaos and nothingness. Composed as rustic landscapes public parks are partly dreamscapes set off for communal sharing. A common curriculum waving purple floraisons of imagery.

Revelation in its first pulses is extravagant

—

"Waving Adieu, Adieu, Adieu"

The French word for "wave" is "vague." Waves are lapping against the waterline. Halyards whack at the masts. Late writing. Its relation to waving and bidding

—

The Irish Cliffs of Moher

Who is my father in this world, in this house,
At the spirit's base?

My father's father, his father's father, his—
Shadows like winds

Go back to a parent before thought, before speech,
At the head of the past.

They go to the cliffs of Moher rising out of the mist,
Above the real,

Rising out of present time and place, above
The wet, green grass.

This is not landscape, full of the somnambulations
Of poetry

And the sea. This is my father or, maybe,
It is as he was,

A likeness, one of the race of fathers: earth
And sea and air.

Go dwell upon the sea cliffs. "My father's father, his father's father, his—"(slash slash slash slash)—Oh the bias—so many prior needle eyes under the wet, green grass. Came—and were gone. Heretofore. How can echo-memory be so charged with life? It's the way of the world in the west. Pin drop. Hush—

"Ashen man on ashen cliff above the salt halloo"

Predecessor forgive our common fund credit bank corporation guilt trespass. I have risked everything to believe in an immense pattern. In "The Plain Sense of Things" "savoir" secretly goes out to meet "savior." Watch me nicking messages on hills of Myrrh, and Incense. Mark four monosyllabic cliffhangers—"self," "earth," "sea" and "air" in "Moher."

The Irish Cliffs of Moher are ragged ruin refugees. The mutinous unuttered *t* in "Moher" is raggeder than ruin.

"Ashes ashes we all fall down."

"Oh ashen admiral of the hale, hard blue ..." Whisht. Wherefore. Whistle your neathering—

Oh for that night when the absent parent will restore order by covering the child with a seamless shroud so that wrath is never the last thread in the fold. No, not at all. Plash. Requiescat. Roses, roses, the red red, roses. Fable and dream. The pilgrim sun.

"Women as half-fishes of salt shine."

2015

The Disappearance Approach

In memory of Peter H. Hare (1935–2008)

It was too quiet on the morning of January 3rd when I got up at eight after a good night's sleep. Too quiet. I showered, dressed, then came downstairs and put some water on the boil for instant oatmeal. Peter always woke up very early, he would have been at work in his study, but there was no sign of his having breakfasted. I looked out the window and saw the *New York Times* still on the driveway in its bright blue plastic wrapper. Had he gone for a walk? I checked to see if his slippers were on the floor by the window seat where he usually left them when he went out. They weren't there. Why? The water was boiling, I poured it over the cereal, stirred it, then stopped. The house was so still. I called his name. No answer. Was he sick or had he overslept? I remember thinking I shouldn't eat until I was sure he was all right. We had a running joke that at seventy anything might happen so if one of us didn't appear in the morning by nine, the other should check. I called his name again. Again, no answer. Maybe he didn't hear me because he was taking a shower. I went into his room. He was lying in bed with his eyes closed. I knew when I saw him with the CPAP mask over his mouth and nose and heard the whooshing sound of air blowing air that he wasn't asleep. No.

Starting from nothing with nothing when everything else has been said

—

"O My Very Dear Child. What shall I say? A holy and good God has covered us with a dark cloud." On April 3, 1758, Sarah Edwards wrote this in a letter to her daughter Esther Edwards Burr when she heard of Jonathan's sudden death in Princeton. For Sarah all works of God are a kind of language or voice to instruct us in things pertaining to calling and confusion. I love to read her husband's analogies, metaphors, and similes.

For Jonathan and Sarah all rivers run into the sea yet the sea is not full, so in general there is always progress as in the revolution of a wheel and each soul comes upon the call of God in his word. I read words but don't hear God in them.

—

On the morning of January 2nd, we took the train into Manhattan to be part of my son's noon wedding at City Hall. That afternoon we couldn't find seats together on the crowded peak hour Metro North from Grand Central so we sat apart. It was dark when we arrived at New Haven and crossed the track for the Shoreline connection to Guilford. When we got off I walked quickly across the parking lot to the car. He followed more slowly. I wondered why, but it was so cold I didn't bother to look back. At home we cooked up some vegetables and pasta. After dinner he said he was tired and would go straight to bed.

—

"Oh that we may kiss the rod, and lay our hands on our mouths! The Lord has done it. He has made me adore his goodness, that we had him so long. But my God lives; and he has my heart.... We are all given to God: and there I am, and love to be." I admire the way thought contradicts feeling in Sarah's furiously calm letter.

We can't be limited to just this anxious life.

—

Somewhere I read that relations between sounds and objects, feelings and thoughts, develop by association; language attaches to and envelops its referent without destroying or changing it—the way a cobweb catches a fly.

—

Now—putting bits of memory together, trying to pick out the good while doing away with the bad—I'm left with one overwhelming impression—the unpresentable violence of a negative double.

—

He was lying with his head on his arm, the way I had often seen him lie asleep. I thought of Steerforth's drowned body in *David Copperfield*, also the brutality of sending young children away to boarding school in order to forge important ties for future life. Though Steerforth is a sadistic character his perfect name forms a second skin. Something has to remain to rest a soul against stone.

—

The CPAP mask was over his face because he had sleep apnea, a disorder characterized by pauses in breathing during sleep. When the mask is plugged in and running, pressure greater than the surrounding atmosphere is enough to keep the upper airways from becoming narrowed or blocked. If he felt anything unusual, surely he would have tried to remove the cumbersome thing. It was still running in place and fogged up.

Land of darkness or darkness itself you shadow mouth.

—

A cold clear day. I'm at the computer in his study deleting spam, saving folders and e-mails for the *Transactions of the Charles S. Peirce Society: A Quarterly Journal in American Philosophy*, a magazine he co-edited for many years. I scroll to mail dated 1/2/08. There's a note from a colleague concerning the annual meeting of the eastern division of the American Philosophical Association in Baltimore they attended the week before. "We all need quiet time now after the busy fall—Shannon."

That night or was it early morning, Peter took eternal wordlessness into himself.

—

Some paperwhites he loved to plant and bring to flower are thriving in our living room. Paperwhites are in the daffodil family so have their sweet spring scent. Blooming in winter they represent happiness that costs next to nothing simply by receiving the sun's brightness, repose and harmony. On the computer screen I find a short essay he was writing on poetry and philosophy but never showed me. There's a letter to his first wife's brother, signed, "Peter and Sukey." I wish we were Hansel and Gretel with pebbles as a hedge against the day before and the day after.

Once you admit that time past is actually infinite, being a child gradually fades out.

—

Looking over autobiographical fragments he wrote during the years following his first wife's death every one of them begins with his shock at her absence. If you looked through my papers until now, you would find a former dead husband at the center. We had almost stopped needing to summon the others—not quite. Not if you rely on written traces.

Fallible and faithful—what makes loyalty so righteous in measurable space? Forever following a river to the ramparts where they form a single plume in the center we are together in our awareness of the great past founded by Daphne and David. Everything appears in a deliberately constructed manner as if the setting of our story was always architectural.

—

"At any rate." Time and again you repeated this phrase. Often you had a hard time touching down in conversation—waving your arms and going off on tangents before coming the long way round to where you started. "Bang for the buck." I was impatient with your verbal tics. "All squared away." Now I would turn to listen with elation.

—

Today I found I had forgotten to pay the land tax due the first of January so there's an added punishment fee of one hundred and twenty-six dollars. If only we could return to December so I could let you know I needed you because I know you needed to be needed

as vast a need as at this moment.

—

"You can save money—it's to save you."

The imposing front door of Peter's large house in the Central Park section of Buffalo was simple mahogany with a polished brass knocker at its center. Shortly after we met he said why don't you just leave your rented place and come live with me here. In a primogenial sense it was the first wife's territory. I didn't share her taste. Nevertheless, old family oil portraits, various objects from the China Trade, engravings of genteel nineteenth-century Episcopalian ministers, and over the dining room table a painting of "The US Squadron Commanded by Comd. S. Rodgers sailing from Port Mahon. Respectfully dedicated to M. C. Perry Esq. of the U.S.N. by his most obt. Servant S. Cabrolla, Gibralta, 10 May 1826" in its solid wood frame beckoned me into an environment where ancestors figured as tender grass springing out of the earth. There they were, saying "Susan, child of our history, come home, come on in."

—

Maybe there is some not yet understood return to people we have loved and lost. I need to imagine the possibility even if I don't believe it.

—

Now if I think about that door, I remember my mother reading Hans Andersen's "The Little Match Girl" aloud when we lived in Buffalo during the months after Pearl Harbor was bombed. The match girl is so poor she is anonymous. Huddled in the snow outside some houses on New Year's Eve she strikes one last wick to warm her fingers. Light flares, and the wall of a building is suddenly transparent as scrim. She sees a table with roast goose, pears, all sorts of food on beautiful china; the happiness and light inside surrounds her.

What treasures of knowledge we cluster around. Fear—reunited with other pre-communicable penumbral associations. God is an epigraph inscribed on memory. Blown back among ghosts—our abstract Parent restores order with covering rituals.

—

Inside the Buffalo house the room I loved most was the study upstairs. He rarely used it then except as storage space for his many books. A large dilapidated desk that his father, a modernist architect, designed and constructed during the 1930s was littered with old syllabi, letters and journals. A worn wall-to-wall carpet hushed the place and I had the same intense impression of the past pressing heavily on the present I often feel when I'm alone with books and papers. "I'll go to him—I'll find him," I thought, while rifling through old photograph albums. You could say I was intruding on another family's need to keep close once and for all—but relic rows of figures, once aware of the fact of being photographed, now enclosed in a paper world of their own, seemed to offer reluctant consent to being viewed face-to-face, in combined string voice.

—

I've been reading some of W. H. Auden's *The Sea and the Mirror*. One beautiful sentence about the way we all reach and reach but never touch.
 A skinny covering overspreads our bones and our arms are thin wings.

—

In an early morning half-waking dream you were lying on the bed beside me in a dark suit. I recently touched your black jacket, the one you loved we bought together on sale two years ago in Barney's. We were thinking about getting another this month because you had worn the original to pieces—it's in the closet now, an object for storage beside your ashes. Maybe the jacket was in my mind as distant dream knowledge of the way one figure can substitute for another with a cord attached so what is false gives life to what is fair. I thought you were really you until I woke up back in myself.

—

History intersects with unanswered questions while life possesses us, so we never realize to the full one loyal one—only an elegiac ideal. I remember needing to take off and turn off the fogged-up plastic sleep apnea mask.

Your head was heavy as marble against the liberty of life.

—

The paperwhites are blooming wonderfully. They resemble February in its thin clarity. Spare white blooms against watery green leaves and white and off-white pebbles around each ocher half-exposed bulb: the blue hyacinth I bought at Stop & Shop is also flowering. Alone with the tremendous silence of your absence, I want to fill this room between our workspaces with flowers because light flows through them—their scent is breath or spirit of life against my dread of being alone—of being cheated by people—today the electrician—next week Greco and Haynes for the well water filter.

—

Sometimes, introducing himself to people, he enjoyed adding, "Peter Hare as in Peter Rabbit."

> Esther (1695–1766)
> Elizabeth (1697–1733)
> Anne (1699–1790)
> Mary (1701–1776)
> Jonathan (1703–1758)
> Eunice (1705–1788)
> Abigail (1707–1764)
> Jerusha (1710–1729)
> Hannah (1713–1773)
> Lucy (1715–1736)
> Martha (1718–1794)

If your names are only written and no "originals" exist, do you have a real existence for us? What happens to names when time stops?

Answer: Nothing happens: There is no when.

—

Jonathan Edwards was the only son among ten unusually tall sisters their minister father jokingly referred to as his "sixty feet of daughters." Esther Stoddard Edwards, also known for her height, taught her eleven children and others in Northampton in a school that consisted of a downstairs room in their farmhouse. Later they received the same education Timothy provided to local boys in his parish in East Windsor, Connecticut. The girls were tutored along with their brother (in some cases they tutored him) in theology, philosophy, Latin, Greek, Hebrew, history, grammar and mathematics. All except Mary were sent to finishing school in Boston. All married late for that period. Mary remained single in order to care for her parents and grandparents. The Beinecke Library in New Haven owns a vast collection of Edwards family papers. It contains letters, diaries, notebooks, essays, and more than twelve hundred sermons; but apart from a journal kept by Esther Edwards Burr (Jonathan and Sarah's eldest daughter) after her marriage, and a few letters to and from the sisters, daughters, and Sarah, all that remains of this 18th-century family's impressive tradition of female learning are a bedsheet Esther Stoddard Edwards probably spun and embroidered herself, Sarah's wedding dress fragment, and several pages from Hannah Edwards Wetmore's private writings—along with posthumous excerpts collected and transcribed with commentary by her daughter Lucy Wetmore Whittlesey.

The Connecticut Historical Society in Hartford owns a fragment of Mary Edwards's crewel embroidery, and a pair of silk shoes "worked by Miss Hannah Edwards daughter of the Rev. Timothy Edwards, wife of Seth Wetmore, Esq. of Middletown."

Only tossing color coins into a well of language, while faces of magic contained in little stories outside the purview of philosophy scramble to help each other—quid pro quo.

—

The folio-size double leaves Jonathan, Sarah, and his ten tall sisters wrote on were often homemade: hand-stitched from linen rags salvaged by women from worn out clothing. Grassroots out-of-tune steps and branches, quotations of psalms, dissonant scripture clusters, are pressed between coarse cardboard covers with frayed edges. The rag paper color has grown deeper and richer in some. One in particular, with a jacket he constructed from old newspapers then tied together at the center with string, looks like a paper model for a canoe. The minister or possibly some later scholar has christened his antique paper vessel "The Doctrine of [the] Justice and Grace of God, Explained and Defended, and the Contrary Errors that Have of Late Prevailed, Confuted ..."

—

Even if ideas don't exist without the mind, there may be copies or resemblances. I never clearly understood what "academic" meant in relation to philosophy's defining essence, but Peter always used the term when speaking of the structure of his intellectual life. Perhaps he was suddenly indifferent to this self-willed world of cultural symbols, intellectual-historical records, competing research topics, future career trajectories—making a splash with books.

—

There was a curtness to the way he left. After Mark and Frances were married, our wedding party lunched together at the Odeon in Tribeca. I remember he was unusually quiet as if he had a prevision of his own unmaking and felt the cinders in our happy chatter.

—

It's snowing heavily and due to continue. Trapped in the house by weather I have been going over his photographs. None of us (apart from his colleagues at Buffalo) encouraged the hobby, certainly not this family of artists. In October he flew to Romania for an international conference on Pragmatism, society, and politics at the Constantin Brancusi University in Târgu-Jiu, where he was giving a paper. While there, every minute he could spare from meetings and panels, he photographed houses, gardens, sculptures, and churches until his Hasselblad camera was crushed when a car backed over it in a parking lot. This could have been an omen. The blood clot that later killed him probably formed in his leg during the long flights over and back. What if our interior innermost mortal happiness is all we see without ever being able to show? I wonder what to do now with these truancies from professional philosophy.

—

C.O. Milford Pa. 1904.

The way bleak north

presents itself here

as Heraclitean error

driving and driving

thought and austerity

nearer to lyricism

Often as black ice

I wrote this poem on a winter day in 1998 when my mother was still alive, and I hadn't met Peter. I had been reading Xerox copies of the last journal pages from the microform edition of the manuscripts of Charles Sanders Peirce. If you take immediate environment into account, during the winter of 1904 things were threadbare for the putative father of Pragmatism. No peace in projects—no firewood for warmth—a few

crotchety word lists used as ornaments or phantom limbs—I remember the way the lines came to me suddenly, after reading the journal, and how quiet it seemed inside the room with soft snow falling outside.

Nietzsche says that for Heraclitus all contradictions run into harmony, even if they are invisible to the human eye. Lyric is transparent—as hard to see as black or glare ice. The paved roadway underneath is our search for aesthetic truth. Poetry, false in the tricks of its music, draws harmony from necessity and random play. In this aggressive age of science, sound-colored secrets, unperceivable in themselves, can act as proof against our fear of emptiness.

Sorrows have been passed and unknown continents approached.

—

"au′top•sy, n. [Gr. αυτοψια; from αυτος, self, and όψις, sight.] Personal observation or examination; ocular view. '*Autopsy* convinceth us that it hath this use.' *Ray*."

The final seven-page Autopsy Report from the Department of Pathology arrived in the mail today.

Extracts:

CAUSE OF DEATH in caps. EMBOLIC OBSTRUCTION OF THE RIGHT VENTRICULAR OUTFLOW TRACT.

Pathologist, Demetrios Braddock, M.D.

—Report Electronically Signed Out.—

"Eyes: The body is received with the eyes previously removed."

—

Dear Dr. Braddock:

If you die in your sleep do you know you are dead? Your clinically precise word order is a failure of dream-work. It gives an effect of harmless vacancy. Why this violent tearing away?

Sincerely,

—

An old friend came for the day and brought me the exhibition catalogue for *Poussin and Nature: Arcadian Visions*. A week later I went in to see the show at the Metropolitan. After the first visit I returned for solace and pardon, several times.

The actors I encounter in Poussin's world have names ingrafted from myth and scripture. At the dawn of thought river gods are keeping watch. Venus offers herself to the gaze of shepherds. Is she sleeping or pretending? Saint Jerome is kneeling in prayer by a cross. Some people follow nature's movement others are blind to divine and supernatural light. Eurydice mortally wounded by a viper, sees her fate. No one else does. Orpheus obliviously strums his lyre for the wedding guests who have placed themselves in position for the familiar song; everything in proportion.

In 2000 the Getty Museum hung two landscape paintings by Nicolas Poussin—*Landscape with a Man Killed by a Snake*, then on loan from the National Gallery in London, and their own *Landscape with a Calm*, alone together in one small exhibition room. T. J. Clark, who was there on a Getty Fellowship, decided to describe his experience of viewing them each day at different hours. In *The Sight of Death: An Experiment in Art Writing* he describes his process as "writing pictures to death, which is what most writing on art inevitably ends up doing, to have always embedded in the *form* of the narrative the (false) suggestion that once upon a time, back there and in the present, at the end and the beginning, the picture lived everlastingly here and now. Among many other things *Landscape with a Snake* ... puts that fiction of visibility to the test." Some art historians believe Poussin conceived *Landscape with Orpheus and Eurydice* as a pendent to *Snake*.

For Jonathan Edwards, snakes represent the venomous nature of the speech of wicked men. Tongues are weapons. "They have sharpened their tongue like a serpent."

—

Blind Orion Searching for the Rising Sun.

I'm entering this open prose area in order to assuage the early loss of an early father in an earlier grandfather scion childself. Names are signs for ideas settled in the mind. Poussin and Edwards are supposed to exist until there is no such thing. No steady name.

—

In Ovid's *Metamorphoses* the fruit of the mulberry tree is forever turned black by the red blood of Pyramus. This is how Poussin introduces the narrative of love turning to misfortune into a composition he originally meant to present as merely a *Landscape with a Storm.* "All the figures one sees there are playing their roles according to the weather; some are fleeing through the dust, in the direction of the wind that is driving them along … others, on the contrary, are going against the wind, walking with difficulty, covering their eyes with their hands.… In the foreground of the painting, one sees Pyramus lying dead on the ground, and near him Thisbe, who has succumbed to grief." Clark says that in *Landscape with Pyramus and Thisbe*—everything ominous in *Snake*—size, scale of the figures in relation to the whole, use of light, intensity of dumb show, framing and shaping—runs over the edge into chaos.

By 1650 Poussin's hands were shaking so badly he was painting through the tremors; in spite of his affliction the surface of the lake at the center of *Pyramus* is smooth as glass.

This still eye reflects a neutral "you" that is me; and yet secret. Who can hold such mirroring cheap? It's a vital aspect of marriage and deep friendship.

—

Jean Redpath is singing "The Raggle Taggle Gypsies" on my iPod. Her voice brings my mother into the room with poems and ballads we read together during the Second World War when my father was away in Europe. She preferred ones, like Yeats's "The Stolen Child" or Arnold's "The Forsaken Merman," where people disappear into never-answered

questions. Listening now, it's as if a gate opens through mirror-uttering to an unknowable imagining self in heartbeat range.

When we listen to music we are also listening to pauses called "rests." "Rests" could be wishes that haven't yet betrayed themselves and can only be transferred evocatively.

I wonder at vocalism's ability to rephrase or reenact meaning and goodness even without the wished-for love. Can a trace become the thing it traces, secure as ever, real as ever—a chosen set of echo-fragments? The sound of Peter's voice communicated something apart from the words he was saying. Listening—I experienced early memories or mental images in distant counterpoint.

—

Both parents died young. He often said that after his first wife's early death in 1995 he felt sure he wouldn't live into his seventies. As if the car, with his mother, father, and Daphne inside, was waiting at the door.

—

An official in the faux-Gothic gatehouse at the Delaware Avenue entrance to Buffalo's Forest Lawn Cemetery, where urns containing "cremains" are officially approved and money for the internment changes hands, politely insisted he knew Mr. Hare had a wife, but I wasn't her.

"We're together, we're together," I told myself. All I lack is your personal name on a tilted stone.

—

GEN MSS 151, Box 24, Folder 1379. Hannah Edwards, Diary Fragment/ ca. 1739

"My Dear Children,

What shall I leave to you or what shall I say to you. Fain would I do something while I live that may contribute to your real benefit and advantage—our lives are all exceeding brittle and uncertain ..."

—

The Beinecke Rare Book and Manuscript Library, one of the largest buildings in the world devoted entirely to rare books and manuscripts, was constructed from Vermont marble and granite, bronze and glass, during the early 1960s. The Library's digital photography studio is located in a windowless room downstairs. Here objects to be copied according to the state-of-the-art North Light HID Copy Light system are prepared for reproduction. Each light is packed with 900 watts of ceramic discharge lamps and requires a typical 15-ampere, 120-volt outlet. The lamps are doubly fan-cooled, with one chamber for the hot (lamp) side and one fan for the electronic side. A diffusion screen spreads light evenly onto the copyboard while protecting the art object or manuscript from heat. This can be replaced with white Plexiglas for three-dimensional art work. Black curtains surrounding the copy table protect the photographer's vision and at the same time prevent light intensity from bleeding. One or two stuffed oblong cloth containers, known in the trade as snakes, hold the volume open. Facing pages are held down flat with transparent plastic strips.

"... & when I was out of my head, & thought myself sick & lost, or at a River Side & and among strangers that would not direct me home."

That's Hannah Edwards remembering her delirium during an illness in 1736. Under the fan-cooled copy lights, she speaks to herself of the loneliness of being Narcissus.

—

On the Shoreline Express I like to sit on the side where between Stony Creek and Guilford I can see my neighbor's house, and in winter a little further up the road catch a split-second glimpse of ours through the window as the train passes. I suppose I'm trying to capture a moment before mirror vision—because when you view objects that lie in front of your eyes as well as others in the distance behind, what you see in the mirror has already been interpreted—so far as you can tell.

More and more I have the sense of being present at a point of absence where crossing centuries may prove to be like crossing languages.

Soundwaves. It's the difference between one stillness and another stillness. Even the "invisible" scotch tape I recently used when composing "Frolic Architecture" leaves traces on paper when I run each original sheet through the Canon copier.

—

"Love in a Universe of Chance"

Yesterday afternoon while out walking on Old Quarry Road I stopped by a small pond. There at the edge of the water among the reeds was a single swan. "Stately, still, remote, assured, majestically indifferent and composed." Swans usually have mates but this one was solitary in the dying light. William Gass speaks about the impossibility of ever perfectly translating Hölderlin's image of the birds dipping their heads "ins *heilignüchterne* Wasser" because the religious undertones in the single German word carry echoes of holy water and grace and when you break the syllables apart for English meaning, what is hallowed inside perishes.

—

Outside the field of empirically possible knowledge is there a property of blueness in itself that continues to exist when everything else is sold away? I keep going back in my mind to the tiny square remnant of Sarah Pierrepont's wedding dress. This love relic has lasted over two hundred years in the form of a Prussian blue scrap. It says nothing at all to an outsider who can look at it without being seen. Could it be an illusory correlation that causes my brain to repetitively connect this single swatch with the oblong royal blue plastic throwaway sheath—protecting the early edition of the *New York Times* as it lay on our driveway on the morning of January 3rd, and again with the bright cyan book jacket on the complimentary copy of *Richard Rorty: The Making of an American Philosopher* that arrived for Peter in the mail a month later?

—

"Safe, through this wall your loving words used to pass in tiny whispers."

Pyramus picks up Thisbe's cloak and carries it to the mulberry trysting-tree. The cerulean toga streaming across the running man's body and the blue fragment of Sarah's wedding dress coexist in limit and in freedom where all things are transacted and spoken, even the fable of Orpheus being permitted to redeem his wife from hell, though losing her afterward by looking back, then through grief dwelling in deserts. I don't pretend to be saying God has promised any new grace concerning our scheme being brought to pass via parables of lost sheep. No, not the least shadow association even in the realm of wishes. Art is a mystery; artifice its form. Hannah has taken off her embroidered shoes.

She is dipping her bare feet in varieties of light.

—

I can't remember if there was snow on the ground but I do remember the cold. If winter landscape meets the being of the subject of the soul now and before, and conveys what is yours to join the finished pastoral invention of others that is rationalism's secret.

—

Returning home, after only a day or two away, I often have the sense of intruding on infinite and finite local evocations and wonder how things are, in relation to how they appear. This sixth sense of another reality even in simplest objects is what poets set out to show but cannot once and for all.

If there is an afterlife, then we still might: if not, not.

—

Midas begged Bacchus to relieve him of his dangerous talent. He has gone down to the source of the Pactolus River and kneels in profile, finally cleansed of gold. He is tired tired. In Poussin's small Ajaccio composition, yellow brushstrokes on leaves tipped by the setting sun indicate evening's reflective melancholy. There will always be people struggling for worldly power—

Do we communicate in mirror languages, through some inherent sense of form, in every respect but touch? Do we ever know each other; know who we really are? Midas, King Midas—is the secret we take away with us—touch

—

Storytellers in the expanding middle class eager for professional careers move across sites of struggle in "battleground" fields. We are our soul but we haven't yet got the dead of it. You steal on me you step in close to ease with soft promise your limit and absolute absence.

—

"Our ling'ring Parents—" At the end of Milton's poem "They looking back, all th'Eastern side beheld / Of Paradise, so late their happy seat." Now they mean to go to the end of the world—here—
 "where the body goes, ceases to be, comes to nothing—"

—

It could have been the instant of balance between silence, seeing, and saying; the moment before speech. Peirce would call this moment, secondness. Peter was returning to the common course of things—our world of signs

2010

Errand

During his ministry in Northampton, Jonathan Edwards traveled alone on horseback from parish to parish. Boston was a three-day ride east. It was easier to get to Hartford and New Haven. At Greenfield, the Mohawk Trail began its climb westward toward eastern New York (then frontier territory). As an idea occurred to him, he pinned a small piece of paper on his clothing, fixing in his mind an association between the location of the paper and the particular insight. On his return home, he unpinned each slip and wrote down its associated thought according to location. "Extricate all questions from the least confusion by words or ambiguity of words so that the Ideas shall be left naked" he once wrote. Poetry is love for the felt fact stated in sharpest, most agile and detailed lyric terms. Words give clothing to hide our nakedness. I love to imagine this gaunt and solitary traveler covered in scraps, riding through the woods and fields of Massachusetts and Connecticut.

2007

Personal Narrative

An Acount of what was lost by the souldeirs in that axshon at Dearfield:—

	£	s	d
John Allise, A coat,	1	10	00
Samuel Allise, o, gun & stript,			
Richard Biling, A coat,	3	18	
Robard Boltwhood, o, one iacket,		9	
Samuell boltwhood, a coat,	1	00	00
James bridgmon, a coat & gloves,	1	2	
Joseph Catlin, o, gun & stipt,			
Joseph church, coat & jacket,	1	10	
Samuell crofoot, pr shoose,		6	
Nathaniell dickeson, one hat & pair gloves,	2	7	
Samuel dickeson, a coat,		16	
Samuel foot, o, gun & stript,			
Samuel gilit, pr shoose,		6	
John graves, a coat, wascote & belt,	2		
David hoite, o, gun & stript,			
Thomas Hove, a coat,	1	1	
Jonathan ingrem, o, coat iacket & gun,	3		
John Mounticu, coat & neckeclothes,	1	3	
Ebenezer Seldin, coat & gloves,		16	
John smith, one coat & jacket,	1	6	0
Joseph smith, one coat & gloves,	1	8	0
Beniamin waite, o, stript,			
Daniell warner, coat & jacket,	2	3	00
Ebenezer warner, A coat,	3	9	00
Nathaniell Warner, o, A coat, iacket, gun & hat,	3	6	00
Nathaniell white, coat & hat,	1	6	0
Ebenezer wright, one pr new shooes & spurs		9	00
Sum total, [Sic]	33	5	00
More thirty four s,	1	14	
	34	19	00

The slain marked o

On May 17, 1676, the Reverend Hope Atherton and Steven Williams, along with 160 members of a local militia, marched out into nature from Hatfield, Massachusetts, on a botched expedition against neighboring Sqakeag, Nipmunk, Pocumtuck, and Mahican tribes before the land was subdued. I found their narratives in George Sheldon's *A History of Deerfield Massachusetts,* published in 1895 by the Pocumtuck Valley Memorial Association.

> Hope Atherton desires this congregation and all people tha
> ar of the Lord's dealings with him to praise and give tha
> ɔd for a series of remarkable deliverances wrought for him.
> ssages of divine providence (being considered together) m
> complete temporal salvation. I have passed through the
> the Shadow of Death, and both the *rod* and *staff* of God de
> ɛ. A particular relation of extreme sufferings that I have
> ne, & signal escapes that the Lord hath made way for, I
> enly, that glory may be given to him for his works that hav
> ɔnderful in themselves and marvelous in mine eyes; & will l
> e eyes of all whose hearts are prepared to believe what I sl

A sonic grid of homely minutiae fallen away into posterity carries trace filaments. Tumbled syllables are bolts and bullets from the blue.

I vividly remember the sense of energy and change that came over me one midwinter morning when, as the book lay open in sunshine on my work table, I discovered in Hope Atherton's wandering story the authority of a prior life for my own writing voice.

During the 1970s and early '80s I was a poet with no academic affiliation. We moved to Connecticut from Manhattan because my husband's job required that we live in the general area of New Haven. We found a house in Guilford only a five-minute walk from Long Island Sound. This particular landscape, with its granite outcroppings, abandoned quarries, marshes, salt hay meadows, and paths through woods to the center of town, put me in touch with my agrarian ancestors.

David's position provided certain benefits to his family, most importantly, access to Yale's Sterling Library. It was the first time I experienced the joy of possessing a green card that allowed me to enter the stacks of a major collection of books. In the dim light of narrowly spaced overshadowing shelves I felt the spiritual and solitary freedom of an inexorable order only chance creates. These Lethean tributaries of

lost sentiments and found philosophies had a life-giving effect on the
process of my writing.

> scow aback din
>
> flicker skaeg ne
>
> barge quagg peat
>
> ~~sieve catacomb~~
>
> stint chisel sect

In Sterling's sleeping wilderness I felt the telepathic solicitation of
innumerable phantoms. The future seemed to lie in this forest of letters,
theories, and forgotten actualities. I had a sense of the parallel between
our always fragmentary knowledge and the continual progress toward
perfect understanding that never withers away. I felt a harmony beyond
the confinement of our being merely dross or tin; something chemical
almost mystical that, thanks to architectural artifice, these grey and tan
steel shelves in their neo-Gothic tower commemorate in semi-darkness,
according to Library of Congress classification.

tub epoch too fum alter rude recess emblem sixty key

Font-voices summon a reader into visible earshot. Struggles of
conscience are taken up as if they are going to be destroyed by previous
states of fancy and imagination. Former facts swell into new convictions.
Never the warning of ends only the means. More and more I wished to
express the critical spirit in its restlessness.

severity whey crayon so distant grain scalp gnat carol

A number of shelved volumes which are tougher have so compressed
their congested neighbors that these thinner often spineless pamphlets
and serial publications have come to resemble smaller extremities of

smallest twigs along Guilford's West Wood Trails during a dry season. Often a damaged edition's semi-decay is the soil in which I thrive. Armed with call numbers, I find my way among scriptural exegeses, ethical homiletics, antiquarian researches, tropes and allegories, totemic animal parents, prophets, and poets. My retrospective excursions follow the principle that ghosts wrapped in appreciative obituaries by committee members, or dedications presented at vanished community field meetings, can be reanimated by appropriation. Always remembering while roving through centuries that, apart from call number coincidence, there is no inherent reason a particular scant relic and curiosity should be in position to be accidentally grasped by a quick-eyed reader in reference to clapping.

Hook intelligence quick dactyl

Bats glance through a wood
Bond between mad and maid

anonymous communities bond and free

Perception crumbles under character
Present past of imminent future

I believed in an American aesthetic of uncertainty that could represent beauty in syllables so scarce and rushed they would appear to expand though they lay half-smothered in local history.

During the 1980s I wanted to transplant words onto paper with soil sticking to their roots—to go to meet a narrative's fate by immediate access to its concrete totality of singular interjections, crucified spellings, abbreviations, irrational apprehensions, collective identities, palavers, kicks, cordials, comforts. I wanted jerky and tedious details to oratorically bloom and bear fruit as if they had been set at liberty or ransomed by angels.

In 1862 Thoreau begins his retrospective essay called "Walking" by declaring: "I wish to speak a word for Nature, for absolute freedom and wildness." He tells us that when he walks or rather saunters out into nature from Concord, Massachusetts, "Hope and the future ... are not in lawns and cultivated fields, not in towns and cities, but in the impervious and shaking swamps." He enters each swamp as a sacred place, a *sanctum sanctorum.*

> Muffled discord from distance
> mummy thread undertow slough

I wished to speak a word for libraries as places of freedom and wildness. Often walking alone in the stacks, surrounded by raw material paper afterlife, my spirits were shaken by the great ingathering of titles and languages. This may suggest vampirism because while I like to think I write for the dead, I also take my life as a poet from their lips, their vocalisms, their breath. So many fruits, some looked firm in spring and seemed to be promising, now amassed according to an impervious classification system. One approach to indeterminism might be to risk crossing into rigmarole as fully stated *ars poetica.* Sauntering toward the holy land of poetry I compared the trial of choosing a text to the sifting of wheat, half wild, half saved.

In Deerfield Meadows he found some horses' bones, from which h got away some small matter; found two rotted beans in yᵉ meadow where yᵉ indians had thrashed yʳ beans, & two blew birds' eggs, wᶜ was all yᵉ provision he had till he got home. He got up to Dfᵈ tow plat before dark, Saturday, but yᵉ town was burned before & no ir habitants, so he kept along. His method of travelling was to go little ways & then lye down to rest, & was wont to fall asleep, but i yᵉ nᵗ twice he mistook himself when he awoke, & went back agai till coming to some remarkable places, he was convinced of his mi take & so turned abᵗ again, & at length he took this method, to la yᵉ muzzell of his gun towards his course, but losing so much, he wa discouraged & laid himself down once & again, expecting to dye; bu after some recruit was encouraged to set forward again, but meetin wᵗʰ these difficulties he spent yᵉ whole nᵗ in getting to muddy broo (or, as some call it, bloody brook); here he buried a man's head i yᵉ path, yᵗ was drawn out of yᵉ grave by some vermin, wᵗʰ clefts c wood, &c., and upon yᵉ road to H'f'd was (like Samson after th slaughter of yᵉ Philistines) distressd for want of drink, & many time ready to faint, yet got no water till he came to Clay Gully but dive

Hope Atherton is lost in the great world of nature. No steady progress of saints into grace saying Peace Peace when there is no peace. Walking is hard labor. Match any twenty-six letters to sounds of birds and squirrels in his mouth. Whatsoever God has provided to clothe him with represents Christ in cross cultural clash conscious phonemic cacophony. Because the providence of God is a wheel within wheels, he cannot afford to dishonor any typological item with stark vernacular. Here is print border warfare *in situ*.

> rest chondriacal lunacy
>
> velc cello viable toil
>
> quench conch uncannunc
>
> drumm amonoosuck ythian

Each page is both picture and nonsense soliloquy replete with transgressive nudges. It's a vocalized wilderness format of slippage and misshapen dream projection. Lots of blank space is essential to acoustically locate each dead center phoneme and allophone tangle somewhere between low comedy and lyric sanctity.

> Prest try to set after grandmother
> revived by and laid down left ly
> little distant each other and fro
> Saw digression hobbling driftwood
> forage two rotted beans &etc.
> Redy to faint slaughter story so
> Gone and signal through deep water
> Mr. Atherton's story Hope Atherton

"P r e s t"—gives the effect of rushing forward into a syntactic chain of associative logic under pressure of arrest. Ready for action in a mind disposed to try but being upset in advance of itself by process of surrender. "In our culture Hope is a name we give women."

 Philology heaped in thin
 hearing

—only a windswept alphabet monument.

 Cries open to the words inside them
 Cries hurled through the woods

If I were to read aloud a passage from a poem of your choice, to an audience of judges in sympathy with surrounding library nature, and they were to experience its lexical inscape as an offshoot of Anglo-American modernism in typographical format, it might be possible to release our great-great-grandparents, beginning at the greatest distance from a common mouth, eternally belated, some coming home through dark ages, others nearer to early modern, multitudes of them meeting first to constitute certain main branches of etymologies, so all along there are new sources, some running directly contrary to others, and yet all meet at last, clothed in robes of glory, offering maps of languages, some with shining tones.

 from seaweed said nor repossess rest
 scape esaid

True wildness is like true gold; it will bear the trial of Dewey Decimal.

 2007

Arisbe

He loved logic
—Juliette Peirce

— sings
Fig. 11

sings
Fig 12

— sings
Fig. 13 -

It thunders
Fig 14.

It thunders
Fig. 15.

—sings
Fig. 16

sings
Fig. 17

sings
Fig 18

sings
Fig 19

kills
Fig 20

kills
Fig 21

kills
Fig 22

kills
Fig 23

kills
Fig 24

kills
Fig. 25

kills
Fig. 27

kills
Fig. 26

Kills
Fig 28

Kills
Fig 29

kills
Fig. 30

kills
Fig 32

kills
Fig 31

kills
Fig. 33

kills
Fig 34

Phenomenology of war in the *Iliad*
how men appear to each other when
gods change the appearance of things
Send him down unwilling Captain of
the Scorned he is singularly doomed
Mortality is a sign for humanity our
barbarous ancestors my passion-self
Each assertion must maintain its icon
Faith in proof drives him downward

The First Chapter of Logic.

O Creator out of blank nothing of this
Universe whose ~~a~~ immense reality, sublimity,
and beauty so little thrills me as it should,
inspire me with the earnest desire to make
this chapter useful to my brethren!

The earliest occupation of man is poetizing,
~~the inf~~ is Feeling and delighting in feeling. That
is what the infant in his cradle seems ~~to be doing~~
mainly to be about.

But feeling ~~g~~ generates ~~gives birth~~ to dreams; dreams,
desires; desires, impulses to do things. So the
main business of a normal man's ~~life~~ ~~comes~~ comes to
~~be action consists~~ in Action.

But ~~action soon makes~~ any man that
has any ~~ripening power~~ ~~potentiality of~~
~~possibility~~ ability to ripen is soon made by
~~an life of action~~ active life to realize that
his different acts must not stand each for
itself ~~unrelated~~ to the others, that mere action
is fatuous unless it accomplishes some thing

During the summer of 1997 I spent many hours in New Haven in the bowels of Sterling Library because that's where the microform room is, almost underground, next to preservation. In an adjoining, more crypt-like corridor, behind some discarded, hopelessly outdated computer terminals and microfilm viewers (nothing from the outside or inside will ever be seen on <u>them </u>again) the 38-reel *Charles S. Peirce Papers 1859–1913 (inclusive), [Micro-form] Film misc. 948* is packed inside two drawers of a slate-gray metal file cabinet. No one stays for long in this passage or chamber because it's freezing and the noise from air-conditioning generators the university recently installed in a sub-basement immediately underneath resembles roaring or loud sobbing.

>Suppose a man is locked in a
>
>room and does not want to go
>
>out his staying is voluntary
>
>is he at liberty no necessity
>
>What shall we finally say if
>
>Members of the Department of
>
>Philosophy Harvard University
>
>undertake the task of sorting
>
>his papers now in the custody
>
>of Harvard's Houghton Library

The microform room at Sterling has several new microfilm readers with Xerox copiers attached. At the left of each viewing screen there is a thin slot for a copy card. Above each slot five singular electric letters spell HELLO in red as if to confide affection

in all their minute and terrible detail these five little icons could be teeth.

A microphotograph is a type of photograph nearly as old as photography itself, in which an original document is reproduced in a size too small to be read by the naked eye so here the human mind can understand far from it. Film in the form of a strip 16 or 35 millimeters wide bearing a photographic record on a reduced scale of printed or other graphic matter for storage or transmission in a small space is enlarged to be read on a reading machine combining a light source and screen together in a compact cabinet. The original remains perfect by being perfectly what it is because you can't touch it.

Upstairs at the circulation desk, an employee has put a nondescript signal on the horizontal black strip that bisects the verso oblong surface of my white plastic YALE UNIVERSITY LIBRARIES (Lux et Veritas) copy card so the space the cut encloses now represents five dollars. As if invisibility is the only reality on the rapid highway of mechanical invention HELLO draws card number 156186 inside itself with a hiss.

It is strange how the dead appear in dreams where another space provides our living space as well. Another language another way of speaking so quietly always there in the shape of memories, thoughts, feelings, which are extra-marginal outside of primary consciousness, yet must be classed as some sort of unawakened finite infinite articulation. Documents resemble people talking in sleep. To exist is one thing, to be perceived another. I can spread historical information, words and words we can never touch hovering around subconscious life where enunciation is born, in distinction from what it enunciates when nothing rests in air when what is knowledge?

> A person throws a stone
>
> as fact through air not
>
> fact but appearance of
>
> fact floating in vacuua
>
> Blind existential being

may possibly not occur

at all we know nothing

with absolute certainty

of existent things not even

the single "word" <u>the</u>

NAME IN FULL: Charles S. Peirce (I am variously listed in print as Charles Santiago Peirce, Charles Saunders Peirce, and Charles Sanders Peirce. Under the circumstances a noncommital S. suits me best) [MS 1611]. PIERCE *v*; to run into or through as an instrument or pointed weapon does. PURSE *n*; a small bag closed with a drawstring and used to carry money. Even if he trained himself to be ambidextrous and could amaze his undergraduate classmates at Harvard by writing a question on the blackboard with one hand while simultaneously answering it with the other, Peer/se pronounced Purr/se blamed most of his problems on his own left-handedness.

1893: JOHN JAY CHAPMAN to MRS. HENRY WHITMAN: Charles Peirce wrote the definition of University in the *Century Dictionary*. He called it an institution for purposes of study. They wrote to him that their notion had been that a university was an institution for instruction. He wrote back that if they had any such notion they were grievously mistaken, that a university had not and never had had anything to do with instruction and that until we got over this idea we should not have any university in this country. He commended Johns Hopkins.

> Difficulty increases success
> in the moral world why do
> we exist at all the end of life
> all commerce with the world
> What is logic? To understand
> you must first read the book
> —Sir Proteus

64

The abrupt dismissal of Charles Sanders Peirce by the trustees of the Johns Hopkins University from his position there as part-time lecturer in logic and literature (1879–84), for reasons never fully explained, might be termed a form of banishment. In spite of clear knowledge that he was a profoundly original thinker, an effective, often charismatic teacher, in spite of the efforts of William James, who consistently recommended him for academic positions at Harvard University, the University of Chicago, and elsewhere, after 1884 Peirce was never again offered another teaching appointment. Scattered rumors and slanders (many of them continue to this day) variously represent America's great logician, the founder of pragmatism and one of the founders of mathematic, or symbolic, logic, as a decadent aesthete, a lecher, a liar, a libertine, queer, a wife beater, an alcoholic, a drug addict, a plagiarist, a wannabe robber baron; an unpractical pragmatist with suspect metaphysics.

In 1891 Peirce, the first meteorologist to use a wavelength of light as a unit of measure and the inventor of the quincuncial projection of two spheres, was forced to resign from the United States Coast and Geodetic Survey, where among other things he had been in charge of gravity and pendulum research for 20 years. According to Beverley S. Kent's *Charles S. Peirce: Logic and the Classification of the Sciences*, the U.S. Coast Survey's international reputation as America's premier scientific institution was largely indebted to his genius.

It is more than likely that Peirce lost his academic position and his government appointment primarily because the lecturer in logic from a privileged upper-class background (mother—Sarah Hunt Mills, the daughter of Senator Elijah Hunt Mills ((Daniel Webster occupied Mills's senate seat when he retired)), father—Benjamin Peirce, founder of the Harvard Observatory, one of 50 incorporators of the American Association for the Advancement of Science, an organizer of the Smithsonian Institution, distinguished professor of mathematics at Harvard, considered America's premier (((if eccentric))) 19th-century mathematician, brothers—James Mills Peirce, professor of mathematics and dean of the graduate faculty at Harvard, Herbert Henry Davis Peirce, distinguished

foreign service career) flouted conventions of genteel scholarly decorum among the American learned by openly living with a European woman of uncertain background at the same time he was married to (although separated from) his first (recent rumor says second) wife, Harriet Melusina (Zina) Fay Peirce. Zina, also from a prominent New England family, was an influential feminist political organizer in Boston and Cambridge circles. She left him for undisclosed reasons in 1878 after 14 years of marriage. If Peirce had kept this love affair quiet it might have been tolerated in the academy and the Survey, but in 1881 he began divorce proceedings against his first wife for desertion. In 1883, only two days after their divorce was finalized, he married again. In Cambridge, Boston, and Baltimore Zina's public, unorganized "desertion" was considered a breach of decorum. Unable to reinstate herself in polite circles (even as a radical feminist bluestocking) she moved to New York and Chicago, where she earned a meager living by managing boardinghouses, continued to write magazine articles, edited an edition of her sister Amy's letters, titled *Music Study in Germany*, and suffered increasingly from heart trouble and attacks of depression. Over the next 40 years she laboriously revised her now forgotten novel, *New York: A Symphonic Study*, published in 1918. I haven't been able to find a copy.

MS 1640: Juliette de Portalès from her friend and devoted servitor C. S. Peirce. [Fragment from the flyleaf of a German, French, English Dictionary, n. d.]

She might have been 17 or 19 years old. She might have been teaching him German. Elizabeth Walther (*Charles Sanders Peirce: Leben und Werk*, 1989) thinks Peirce might have met the enigmatic "Mme Pourtalai" during 1876 when he was in Berlin doing pendulum research for the Geodetic Survey. Following a trail of surnames through genealogical records in Germany, France, and Switzerland, Walther has discovered hints, rumors, embellishments, contradictions, erasures, negations, fictions. On the marriage certificate in the New York City Bureau of Records, April 26, 1883, Juliette Pourtalai's maiden name is given as Juliette Annette Froissy of Washington, D.C., daughter of August Froissy and

Rose [E]yem. The marriage to Peirce is listed as her second. She might have been the wife of a certain Pourtalai who had no first name, but there is no certificate from this former union, if there was one. Either the man was dead when she left Europe, or they were separated, or he never existed. An entry in one of Peirce's notebooks in Juliette's hand refers to "La Duchesse de Parme à Wartegg ma soeur." In another she listed places where she spent Christmas holidays in her youth. Some were spent in Nancy, apparently before her mother died. Archives in Nancy show no Froissys and no Count Pourtalai. Tracking the name Juliette Annette de Portalès, Walther was able to turn up an Anna Ada von Portalès (from a French family with a Swiss branch), the first child of Jacques Alfred von Portalès and his second wife, Sophie von Thielau, born July 28, 1857. But Anna Ada died April 17, 1889. Walther assures us it was not unusual for members of the German aristocracy to declare someone dead in order to disinherit them.

> Babel wants a scourge for its wild
>
> green grassblades not seeing me

Whatever Juliette's age or her surname the couple made sure it remained a secret. Joseph Brent (*Charles Sanders Peirce: A Life*, 1993) says that in the papers of Mary Eno Pinchot and her son, Governor Gifford Pinchot, there is correspondence and information concerning the Peirces, but even here all references to Juliette's identity have been removed. Mary Eno's daughter-in-law, Cornelia Bryce Pinchot, somewhat nastily hinted to someone that (among other possibilities) Juliette-Anna-Ada may have been one of a small group of "filles de joie" forced into exile by the French Third Republic for political reasons.

In 1936, shortly after her death, the younger Henry James (William James's son, not his brother) remembered Juliette telling Alice (William James's wife, not his sister) that after she arrived in New York in 1876 she lived at the Hotel Brevoort (the first house the James family occupied in

New York City during the 1840s, at Fifth Avenue between Eighth and Ninth Streets, had been knocked down with some others to make way for the hotel). According to Brent, the Brevoort catered to the wealthy, titled, and socially important, and Peirce was well known by the staff. According to James, Juliette shyly stayed in her room until one evening the manager told her there was to be a reception, a party or a ball, and as he knew the hosts, he arranged to have her properly introduced as a guest. Juliette told Alice that this was where and when she met her future husband. The third Henry James cautioned Henry S. Leonard, who had written to him regarding the papers being collected at Harvard, against putting any information he might have to offer concerning Juliette's origin into print: "after all, it is Peirce, not Mrs. Peirce you are writing about and so far as he is concerned her importance consists not of where she came from or what she was before he married her, but of what she did for them after they were married." Nevertheless he felt obliged to add: "Mrs. Peirce's habit of concealing all names when she alluded to or told about her past is what makes everything so blind and dubious....There is enough here to lay the foundations for a mystery story."

Joseph Brent portrays his eccentric subject as a manic-depressive, al-coholic, drug-addicted, debauched, debauching, Baudelairean dandy; difficult, but a genius. He blames the American mathematician-logician-philosopher's devotion to Juliette on the questionable influence of French *fin-de-siècle* poets and novelists. After all Peirce, a Francophile, was in Paris, where he presented a report of his discoveries on pendulum research at a meeting of the Permanent Commission of the Interna-tional Geodetic Association during the turbulent autumn of 1875.

Kenneth Laine Ketner presents his theory as to Juliette-Fabiola's gene-
alogy in *His Glassy Essence: An Autobiography of Charles Sanders Peirce*,
(1998). (Father—Adolphe Fourier de Bacourt, a distinguished French
monarchist diplomat well known in French and German circles, and
as the French ambassador to Washington during 1840–42, acquainted
with Benjamin Peirce, George Bancroft, and other cosmopolitan Ameri-
can scholars, politicians, and ambassadors ((Fabiola was illegitimate)).
Mother—famous Gypsy flamenco dancer and singer of *cante jondo*, or
"deep song," a music unique to the *Gitanos* of Andalusia). Over the cap-
tion *"Madame de Lopez / Would you care to see her photograph?"* Ketner sup-
plies the portrait of an exceedingly grim middle-aged woman dressed in
what appears to be mourning. Her left hand clutches at her skirt as if she
were on the verge of running away or had just been caught in the act. In
the act of *what*, who can say? Her right hand grips what or may not be a
deck of playing cards protruding from the end of an elaborately studded,
casket-shaped box probably intended for jewelry. When Juliette-Fabiola
met Peirce at the Brevoort House (the Charles Sanders Peirce Professor
of Philosophy at Texas Tech University and director of its Institute for
Studies in Pragmaticism says it was a Christmas costume party and that
Benjamin Peirce, who may have been acting as one of her several elite
guardians, introduced her to his son) she was a sickly 19-year-old Romany
orphan living in an apartment off Washington Square, under the care
of her duenna or governess, the Marquise de Chambrun. You will have
to read *His Glassy Essence* to learn how Ketner reaches this compelling
conclusion. It seems to be largely based on Victor Lenzen's "Babcourt
hypothesis," written for Max H. Fisch in 1973. Lenzen suggests she may
have been a Gypsy, then changes his mind. In 1966, Charles Gassman, the
Peirces' close neighbor, told Fisch that Gypsies were often in the Milford
area, and as Juliette was friendly with them, he believed she might have
been one herself. Ketner cites the pack of cards she kept encased in an
inlaid box and may have used to tell fortunes and a letter to Charles from
Wendell Phillips Garrison, the editor of the *Nation*, after having visited
the couple in 1902: "My late lamented friend Dean Sage who loved all

outdoors and was a great Booravian [George Henry Borrow, former hack writer, traveling hedge-smith, and author of *Lavrengo* and its sequel, *The Romany Rye*, among other popular accounts of the Romany world of Great Britain and Spain] went daft on the gipsies who haunted Albany for a time. As for fortune telling your wife did me up brown on your porch one day, with tales of deception & perhaps matrimony which I did not take down in shorthand. I have more respect for palmistry than for cards...."

"There was nothing that Borrow strove against with more energy than the curious impulse, which he seems to have shared with Dr. Johnson, to touch the objects along his path in order to save himself from the evil chance. Walking through Richmond Park with the present writer he would step out of his way to touch a tree." In the article he contributed to the eleventh edition of the *Encyclopaedia Britannica* Theodore Watts-Dunton cautions readers against assuming George Borrow never created a character. Even if originals in his accounts seem easily recognizable, "the man who 'touched' to avert the evil chance has so many of Borrow's own eccentricities it could be called a portrait of himself." Rumor is a story passing from one person to one person without an original authorized relation. For Peirce sentiment comes from the heart, it must also be feigned. Demosthenes with his mouthful of pebbles had to talk without choking himself or allowing the pebbles to drop from his mouth. Verbal reverberations keep us safe, that is their interest. Emerson shows in the essay he titled "The Poet" how smallest things can serve for symbols, how every relation is picture-language. "Bare lists of words are found suggestive, to an imaginative and excited mind; as it is related of Lord Chatham, that he was accustomed to read in Bailey's *Dictionary*, when he was preparing to speak in Parliament." "If my name is a terror to evil doers," Noah Webster is rumored to have said to someone, "mention it."

In poetry all things seem to touch so they are.

After their marriage the Peirces lived in Manhattan. Juliette spoke French and German fluently, taught music and French, and was an accomplished pianist. Private theatricals were popular; she became a noted amateur actress and took singing lessons. She owned some valuable jewelry and received about 18,000 francs as a pension from somewhere. One reason the couple gave for hiding her identity was that if she didn't keep it a secret the payments would stop. Gypsies had been subjected to suspicion and penalties, hounded and persecuted throughout Western Europe: if she was half Romany, there would have been good reason never to trust anyone. They both enjoyed card tricks, word games, fortune-telling, charades. He drew a cartoon of her as "the bourgeoise Athena." Together they translated and performed in *Medea*.

MS 1572: A gentleman of reputation in science and philosophy (member of the U.S. Academy of Sciences) highly successful as a teacher (especially of those who are backward) will receive into his house in new York, and instruct, without the aid of accomplished assistants, in all or many branches, three or four strictly select highly pupils young gentlemen, extending some peculiar ~~opportunities~~ advantages for cultivation.

 Drama of community never reached.

Phenomenology asks what are the elements of appearance. In my nature (cross out with) it is a sort of instinct toward (slash to) a solid (cross out visible) instinctive attraction for living facts. Microreproduction gives the trace of someone or something. Pens are noisy pencils quiet. What is the secret nature of fact? What is the fact that is present to you now? Between the law of the market and the law of exchange handwriting as noise cannot be enacted. Let y be y you cannot gasp at blue. On the one hand academic and antiquarian tendencies with lattice work in open gables on the other, Indianapolis. For most architects print modifications are silent. When I read an authorized edited Collected Work I read against original untiredness what ought to be seen, <u>generally</u>. Peirce calls secondness all naked feeling and raw life. Originality is in being such as thus this being <u>is</u>.

 At that time] at time

Four years after his dismissal from Johns Hopkins, the couple pooled some money recently inherited from somewhere, and for one thousand dollars they acquired Thomas Quick's 140-acre farm on the western bank of the Delaware River ("the wildest county of the Northern States") two and a half miles from Milford, Pike County, Pennsylvania, seven miles below Port Jervis, New York. They covered the outer walls of Quick's original farmhouse with shingles in the fashionable New England "summer cottage" style and added floors and rooms, including a library for his large book collection. Max Fisch says the Peirces probably called their property "Arisbe" after a city in Troas, the ancient colony of Miletus, the home of the early Greek philosophers, Thales, Anaximander, and Anaximenes, who first searched for the Archē, the Principle, the first of things. I think Peirce named the house for Homer's "brilliant" or "shining" Arisbe.

Arisbe mark of mortality.

> Next *Teuthras'* Son distain'd the Sands with Blood,
> *Axylus*, hospitable, rich and good:
> In fair *Arisba's* Walls (his native Place)
> He held his Seat; a Friend to Human Race.
> Fast by the Road, his ever-open Door
> To stern *Tydides* now he falls a Prey,
> No Friend to guard him in the dreadful Day!
> Breathless the good Man fell, and by his side
> His faithful Servant, old *Calesius* dy'd. [*Iliad*, vi. 15–24]

Alexander Pope was 25 when in spring 1714 economic necessity pushed him to begin the ambitious project of translating Homer into up-to-date English. As Roman Catholics he and his parents were unable to invest money easily, and their annuities from French *rentes* they depended on were in danger of default. The translation was to be published by subscription in the manner of Dryden's *Virgil*. Proposals were issued, the reaction was enthusiastic; 652 sets were reserved in advance. King George I and the Prince of Wales were among the subscribers. Only when he was

sure of making a profit did Pope begin this work that for the next five years became his obsession. The first volume, containing the first four volumes of the *Iliad of Homer,* with a Preface, Essay, and Observations, printed by W. Bowyer for Bernard Lintot between the Temple-Gates, was delivered to subscribers in 1715 and established his reputation.

JOSEPH ADDISON: Reading the *Iliad* is like traveling through a Country uninhabited, where the Fancy is entertained with a thousand Savage Prospects of vast Desarts, wide uncultivated Marshes, huge Forests, mis-shapen Rocks and Precipices. On the contrary, the *Aeneid* is like a well ordered garden—

Roman Catholics in England weren't allowed to own property, but the money Pope earned allowed him lease a country villa near London. Here "The Hermit of Twickenham," or "Twitnam" as he preferred to call it, practiced elaborate landscape gardening, constructed his fantastic grotto, and received a constant stream of brilliant visitors, including John Arbuthnot, Lady Mary Wortley Montagu, John Gray, Lord Bolingbroke, Sarah Duchess of Marlborough, Bishop Atterbury, Jonathan Swift, even Voltaire. The much celebrated house and grounds have been associated with the poet-philosopher's name ever since.

Can a name be a prediction?

In Book XII Asios leaves Arisbe and is swallowed by dark-named Destiny. In Book XXI, Lykaon, a bastard son of Priam, captured by Achilles in an earlier struggle, is sold into slavery and shipped to Lemnos fortress until Eëtion out of Imbros pays a princely ransom for the captive and sends him to Arisbe's shining walls. There he is well treated until he foolishly escapes. After many difficulties Lykaon returns to Ilion where he joins his half brother Hector's army. Not for long. Twelve days later Achilles runs across him again by accident. Time (take Zeno's flying arrow) sets out in a past we place ourselves in. If the present is connected to the past by a series of infinitesmal steps (The Law of Mind) a past cannot be wholly past.

Lykaon sits back and spreads his arms wide
Achilles catches him by the foot and slings him in the river Scamander
 to drift
Xanthus chief river of the Trojan plain free blossoming meadows
 and murmuring waters of Scamander

Charles and Juliette Peirce find themselves owning property in order to secure a bourgeois existence. The house fronts on the old Milford Road, which follows the contour of the Delaware River from Port Jervis to Milford. The scenery and delightful summer climate have made the nearby Delaware Water Gap a delightful summer resort.

ALEXANDER POPE: Consult the Genius of the Place in all;
 That tells the Waters or to rise or fall,
 Or helps th'ambitious Hill the Heav'ns to
 scale—

MS 1611: He resides at his wife's country seat 'Arisbe,' near Milford, Pa., where he has a free school of philosophy, furnishing remunerative employment to such students as desire it. He also exercises the professions of chemist and engineer.

We are almost here but in a false position. There is no artificial grotto with an aquatic effect (plates of looking glass in an obscure part of the roof and sides of the cave, every object multiplied), no busts of Homer and Virgil to stimulate a visitor's thought. The picturesque in its late American stage is awkward and cut up. Something is wrong with the scale. Where are the visitors?

Arisbe imagined as a business transaction. The free school never materializes. The end of the Survey salary is shocking. Staring it in the face, the material, the unreal real thing that is in money enters into language. Recklessly they acquire more land, apple and nut orchards, a slate quarry. Both of them are very nervous very often very ill.

An authentic modern tragedy if we think of gold as being money.

A capitalist who loses everything is hurled headlong into the enormous wave of a money-fed river.

Forced to earn their support on what he could gain by various temporary means, Peirce produced an extraordinary number and variety of book reviews and essays (often anonymously) for a variety of journals, including the *Nation*, the *Monist*, and *Popular Science Monthly*. He gave occasional lectures, tutored students privately, worked on translations from the French and the German, collaborated on various encyclopedias and dictionaries (he composed most of the definitions on logic, mathematics, mechanics, astronomy, astrology, weights, measures, and all words relating to universities for W. D. Whitney's *Century Dictionary* and most of the articles on logic for J. M. Baldwin's *Dictionary of Philosophy and Psychology*), served as a consulting chemical engineer for the St. Lawrence Power Company, gave lessons in elocution to Episcopal ministers, developed an invention for electrolytic bleaching, concocted a "Genuine Imitation/Cologne Water," joined well-heeled fellow members of the Century Club in New York in a venture to produce cheap domestic lighting from acetylene gas with a generator he invented and patented. But the national economic collapse during the 1890s left him bankrupt. Even the Century Club expelled him around 1898. After 1900 Peirce gave up trying to earn his living either by teaching or by science pure and applied and became the first American to list his profession as that of logician: a "bucolic logician," as he put it.

MS 1613: **Occupation**, Digestion psycho- and physio-logical.
Positions or Offices held since leaving the University, with dates,
Was once on the Commission to Examine the Mints
Gave lectures at Bryn Mahr (I forget how to spell it)
The rest weren't worth a fig, far less a date

Membership in Scientific or other learned Societies, Have been an Honorary Member of the Athenaeum Club in London and the Garde Voltaire (I am not at all sure of remembering the name) in Paris.

I don't amount to a row of pins (according to any such more or <u>any</u> mode of estimation) The distinctions of which I am proudest is the devotion of friends, especially my wife & several women who I have never seen and probably never shall see.

While outlining the Pragmatic Principle in the *North American Review*, October (1871), he first coined the term *pragmatism*, but it went unrecognized or unacknowledged until William James publicly used the word in a lecture at Berkeley in 1898, titled "Philosophical Conceptions and Practical Results." James said he was presenting "the principle of Peirce, the principle of pragmatism." Their ideas on the definition and principle were never identical. In 1903, after attending Peirce's Lowell Lectures, James referred to the current thought of his friend as "—flashes of light relieved against Cimmerian darkness." In 1905, Peirce, in a paper titled "What Pragmatism Is," announced the birth of the word pragma<u>ti</u>cism, a name "which is ugly enough to keep it safe from kidnappers."

How are ideals maintained in the long story of responsibility? Secret.

The genteel American tradition is not to kill an original: we only remove the embarrassment.

MS 1611: **Honors Conferred**, Never any, nor any encouragement or aid of any kind or description in my life work, excepting a splendid series of magnificent promises.
Chief Subject of Research, Logic.
Where Chiefly Published, Not published except in slight fragments. See Schröeder's Logik.
Researches in Progress, In logic will continue as long as I retain my faculties & can afford pen and ink.

For the latter third of his life this philosopher's philosopher who once yearned to be hired as a professor *somewhere* drew and wrote (according to his own calculations) over 2,000 words, diagrams, algebraic formulas and/or existential graphs a day. His unpublished writings (including his correspondence) come to more than 100,000 pages.

Perhaps Peirce banished himself for logic's sake.

Juliette remains exactly who she never says she is she already burned her boats.

MS 1644: The robberies which have been going on at Arisbe Park, the large house of Madame Juliette Peirce on the Milford road, have reached a stage where drastic action is being sought. Sporadic burglaries and petty thieveries have annoyed Mme. Peirce for several years, despite attempts to stop them and have frequently reached a stage where this talented lady, the widow of Charles Sanders Peirce the famous scientist, fears for her life.

In speaking of the recent robberies Mme. Peirce states that a very valuable ermine coat, with costly lining was stolen and as it represented a large amount of money and as well was valued for its usefulness, she feels its loss keenly. [THE MILFORD DISPATCH: *Mme. Peirce's home robbed of valuables.*]

Each of the 38 reels in the microfilm edition has the same brief preface far more brightly lit than the photocopied body:

> This microfilm prepared during the years 1963–1966 with the cooperation of the Houghton Library and the Photographic Service of the Harvard University Library, includes all of the Peirce papers in the custody of the Harvard Department of Philosophy except a certain body of correspondence, personal and professional. It includes drafts of some but not all of Peirce's published writings, for many of which no manuscripts are extant. The papers here reproduced were for the most part acquired from Peirce's widow in the winter of 1914–15, less than a year after his death.

The arrangers, cataloguers, editors, and custodians don't give Juliette's name, nor do they tell us the Department of Philosophy probably paid her at the most five hundred dollars for the lot. She had tried unsuccessfully to interest Yale University in taking on Arisbe, possibly as a memorial to her husband, but got no response. After her death Gifford Pinchot's lawyer wrote to Yale, Harvard, and Columbia to ask if they were interested in acquiring Peirce's remaining books, papers, and scientific instruments. They weren't.

MS 1644: Mrs. Juliette Pierce has donated to the Milford Fire Depart. $20. from the $45. she netted the past summer telling fortunes. The balance has been given for various purposes. Mrs. Peirce was sorry the goal she aspired to was not reached but periodic attacks of bronchitis have precluded giving as much time as usual to fortune telling. [THE MILFORD DISPATCH.]

Between 1931 and 1935 Harvard published the first six volumes of what was hopefully called *The Collected Papers of Charles Sanders Peirce*. The general plan was for ten volumes, but money ran out after volume six. All the work for this edition was accomplished by a junior instructor and a graduate student volunteer. While the secondary scholarship on Peirce's work was steadily growing, Arisbe had no plumbing and no heat. Only two rooms remained furnished. Juliette lived in one of them alone with her husband's portrait, his unwanted scientific equipment, the remains of his book collection, other memorabilia (including his ashes in a silver urn), and a set of china. She died in October 1935, under "circumstances not suitable to sustain life or dignify death," according to the doctor who attended her. Trees and lilac bushes around the house had grown so high it was invisible from the road only 50 feet away. The property was left empty for two years until it was auctioned in 1936 for $3,600. Arisbe's new owners lit a bonfire in the neglected front garden and burned whatever relics burglers hadn't already carried off.

This was before the age of tag sales.

THOMAS WENTWORTH HIGGINSON: Look to the physical aspect of your manuscript, and prepare your page so neatly that it shall allure instead of repelling. Use good pens, black ink, nice white paper and plenty of it. Do not emulate "paper-sparing Pope," whose chaotic manuscript of the "Iliad," written chiefly on the backs of letters, still remains in the British Museum. If your document be slovenly, the presumption is that its literary execution is the same, Pope to the contrary, notwithstanding. ["Advice to a young Contributor," *Atlantic Monthly*, April, 1862.]

On the fifteenth of April 1862, Emily Dickinson sent a first letter to her future editor, probably in response to his "Advice." She enclosed four poems, including "We play at Paste—," and a separate card bearing her name.

Lewis Mumford noted in *The Brown Decades: A Study of the Arts in America 1865–1895* (1931) that the publication of Peirce's manuscripts had lagged for lack of a few thousand dollars to guarantee the initial expenses of his "Collected Works" and compared the situation to the concealment of Emily Dickinson's manuscripts by overzealous guardians. Martin Gardner wondered in *Logical Machines and Diagrams* (1982) if Peirce harbored unconscious compulsions toward cloudy writing that would enable him to complain later of his critics' inability to understand him. In "Communication, Semiotic Continuity, and The Margins of the Peircian Text" (1997), Mary Keeler and Christian Kloesel tell us the secondary literature on Peirce demonstrates that only the hardiest scholars have made use of his manuscripts and even then only by way of photocopies, and that his work is unpublishable in print form. I wonder why manuscripts are so underestimated in all academic disciplines, including science, mathematics, linguistics, semiology. It's 1999

> I will print you a syllabus
>
> Continuity probability even
>
> the predictability of drift

1910 Sep 13 It is my duty to investigate Modality more closely

A certain existing man _might_ be attacked without defending himself

A person may dream that Theodore Roosevelt attacks him

———— dream

Field of may-be T. R.

MS 1644:

(iii) Designated page "Husband's Demise April 18"
Full name Charles Sanders Peirce

One of our last conversation, I remember started with him that he could not recover physically by hard mentale work & in refusing to let him have more paper to write, but when he complained his pains were so great & writing would easing his pains, then I complied. The doctor had left opiats to aliviate his great suffering but he refused to take. In handing me his last writings in stating my best is finished & will make a revolution in science, life will be easy for you and we are gone to travell again. Then he requested me to pick him out a book of Dickens to relax from hard work at random I handed him *Dombey* & he remarked when finished I reading that it was the only book of Dickens he knew not ending so gloomy. I was hopefull that he would recover again he also predicted that great war again.

I was most hopeful he would

Constraint is a secondness
swimming out to sea Europe
Between an interpretant and
its object in playspace the
heart's free interim Macbeth's
crude sacrilege deeper even
Spent those last years not
writing his paper on misery
I remember all the time now
remember the brood the fret

Iliadic heroism another situation

of unstable identity Polydorus

comes onstage he has appeared

in a dream to Hecuba the outer

covering of his body remnant of

Cloth wrung out soft wool left stray

Hecuba and chorus address the

shield as tomb so memory does

wash over holy ablution water

Change wounds Hector tumbles

in the dust but the wife of Hector

has not heard she is inside what

fate metes out this and this dactyl

Achilles has come by land Ilios

Chorus of Thessalonian women

rush from beyond the famous land

of evening your torches blazing

Cold rushes little feet acting out

Let him down gently no don't
ask who I am it is still night and
invading armies don't you see
elements of her hurt her child
enters the world suffused with
his fate O my Thetis unchecked cry
the hidden fate of things to be
If you were human you would
seize spear and sword to rout
ruin lust lechery *humanum est*
errare Patroclus' armor three times
he charges with the force of a
running war god brute Apollo

Strip away Patroclus' armor

Achilles-Patroclus' helmet

crusted in horsehair off too

But the ink is scarcely dry

Ramping brute force know

Hector was the third slayer

Actuality is something brute

Unspelled Firstness is first

Move the shuttle-thread give

ghostly instruction ferryman

O patiently people being
blown to bits one hand
clutching bandages next
bit proverb and byword

Through mined copyhold
we are all here Realism
Is hidden escape possible
One mind as what-is-not

1999

Sorting Facts

- *The FACTORY OF FACTS.*
- *Filming facts. Sorting facts. Disseminating facts. Agitating with facts. Propaganda with Facts. Fists made of facts.*
- *Lightning flashes of facts.*
- *Mountains of facts.*
- *Hurricanes of facts.*
- *And individual little factlets.*
- *Against film-sorcery.*
- *Against film-mystification.*
- *For the genuine cinematification of the worker-peasant. USSR.*

—Dziga Vertov, 1926

I

I was originally asked to contribute an essay for a collection called *Beyond Document: Essays on Nonfiction Film,* edited by Charles Warren, with an Introduction by Stanley Cavell, because of a book I once wrote about Emily Dickinson's poetry. Although this seemed a strange reason to assume I could write about nonfiction film, I was drawn to the project because of the fact of my husband's death and my wish to find a way to document his life and work.

David von Schlegell was a second-generation American with a German name. He was born in St. Louis in 1920. His German name embarrassed him, especially the "von," but he didn't change it, maybe because he was an only child. The family moved east shortly after his birth when his father got a job teaching painting at the Art Students League in New York City. His mother's first name was Alice, but people called her Bae (pronounced Bay). She also drew and painted. The three of them loved the Atlantic Ocean, especially the Maine coast at Ogunquit where they spent each summer. As a boy, David designed sailboats.

When he was in his teens he built his own and called it Stormy. He hoped to become a yacht designer or an architect, but he was young and healthy enough to be cannon fodder, so from 1943 to 1945 he served as a bomber pilot and armament-systems officer in the Eighth Air Force. Until he died and was cremated he had a large scar on his left arm from where he was shot while piloting a B-17 in the fiery skies over Emden in Germany. The bullet shattered his wrist, but he managed to bring the bomber back to home base in England. Three other crew members were wounded also. It could be said this wound just above his left hand saved his life, because he was hospitalized for several months and then honorably discharged. But the war wounded him in ways he could never recover. After the war he studied painting with his father at the Art Students League. He painted for many years, then switched suddenly to sculpture. He was a shy person. His art was influenced by Russian Constructivism and various American boat designers. He worked in wood, steel, and aluminum, and usually built his own pieces. His best-known sculptures were designed in the 1960s and early 1970s. I didn't meet him until 1965 when he was forty-five and I already loved his sculpture. We lived together for twenty-seven years, most of them by Long Island Sound. Toward the end of his life he had to stop sailing because of severe arthritis in his knees, but he could still row. I liked to watch how he feathered the oars to glide back. Little whirlpools formed where the oar blades tipped under: their entry clean as their exit. These are only some facts. He had a stroke and died three days later on Monday, October 5, 1992, at 5 a.m. Those last days in the hospital were a horror. He was fully conscious, but words failed. He couldn't speak or write. He tried to communicate by gestures. We couldn't interpret them. He kept making the gesture of pointing. In physical space we couldn't see what he saw. He couldn't guide a pencil or form a coherent signal. François Truffaut says that for a filmmaker the basic problem is how to express oneself by purely visual means. The same could be said for a sculptor, except that for two days and three nights in the hospital I don't think David saw what "visual means" meant. Without words what are facts? His eyes seemed to know. His hand squeezed mine. What did he

mean? In my writing, I have often explored ideas of what constitutes an official version of events as opposed to a former version in imminent danger of being lost.

Sorting word-facts I only know an apparition. Scribble grammar has no neighbor. In the name of reason I need to record something because I am a survivor in this ocean.

That's why I agreed to meddle in a foreign discipline.

It's almost next October. In Connecticut we call warm days in October Indian summer. In an interview with Phillipe Sollers, Jean-Luc Godard, referring to *Hail Mary*, cited a passage from Antonin Artaud: "I want soul to be body, so they won't be able to say that the body is soul, because it will be the soul which is body." Godard said this helped him to explain things to his film technicians.[1]

Surely nonfiction filmmakers sometimes work intuitively by factual telepathy. I call poetry *factual telepathy*.

II

The French documentary filmmaker, photographer, and traveler, Chris Marker, was a poet first. Marker's twenty-eight-minute *La Jetée*, written and photographed during the early 1960s, imagines a third world war. A man, marked by an image from his childhood, travels through some intertranslational fragmented mirror-memory to the original line of fracture no translation will pacify. Many pilots, men and women, survived, though they didn't survive, collective military service during World War II. *La Jetée* (1962) and *Sans Soleil* (1982) are haunted by indwelling flames of spirit. In the beginning of each Marker film jet planes escape the eye of the camera. One is overhead roaring murder. We see the other being concealed under the flight deck of an aircraft carrier. *La Jetée* is called a ciné-roman; *Sans Soleil* a documentary.

1 The interview is printed in Jean-Luc Godard's "Hail Mary": *Women and the Sacred in Film*, ed. Maryel Locke and Charles Warren (Southern Illinois University Press, 1993).

III

Life, Life

In 1927 one of Vladimir Mayakovsky's directives for a Constructivist Poetics of Revolution was: "Let's drop all this gibberish about unfurling 'the epic canvas' during a period of war on the barricades—your canvas will be torn to shreds on all sides."[2] Dziga Vertov certainly agreed. Both were iconoclastic image-makers, though this may be an oxymoron. Oxymorons are incongruous; they mimic and contradict. Iconoclastic image-makers and oxymorons parody habitual thought patterns while marking a site of convergence and conflict: split-repetition, acceleration, reverse motion.

"Revolutionary cinema's path of development has been found," Vertov declared boldly in 1929. "It leads past the heads of film actors and beyond the studio roof, into life, into genuine reality, full of its own drama and detective plots." He considered Mayakovsky's aesthetics of poetry to be closely identified with his own aspirations for radical

2 Quoted in *Kino-Eye: The Writings of Dziga Vertov*, ed. Annette Michelson, trans. Kevin O'Brien (University of California Press, 1984).

change in film production: change that would emphasize the primacy of the "factual." The essence of fact was to be found in the poetry of reality; in material objects.

Vertov's debut in cinema prophetically involved a fall. The poet-filmmaker-documentarist ordered his cameraman to shoot him as he jumped off the roof of a one-and-a-half story summer house. The cameraman was instructed to record Vertov's leap so that all of his real thoughts while falling would be visible on film. Vertov hoped to show that while the ordinary human eye can't ever see what a person is really thinking or feeling during the immediate chaos of violent motion, the camera's technical eye, oscillating between presence and absence, can frame and arrest that person with thoughts in place. Accelerated motion, recalled from a distance of constructed stillness, can recuperate the hiddenness and mystery of this "visible" world.

Is it sense perception or depiction I see "thinking"?

A still photo in *Kino-Eye: The Writings of Dziga Vertov* shows the dapper realist, non-acting, quick-change artist, wearing a white cotton shirt, sleeves folded to the elbows, a wristwatch, casual slacks, white socks, and elegant white shoes, on a day before World War II. Vertov's right hand touches the crown of his head, as if to measure his position inside the space-time of a film frame. His left arm is reaching forward, probably for balance. He is posing while falling upright and cautiously smiling. From this perspective he appears to be an enlightened materialist.

He could be thinking "I told you so," looking out.

In 1934 an older and more subdued enthusiast of realism noted in his journal: "Several years have now passed since Mayakovsky's death. In every area of our life tremendous changes have taken place. And only the script departments continue as before to defend their hackneyed principles against the incursion of poetic filmmakers. The will to produce poetic film, and particularly poetic documentary, still runs up against a wall of perplexity and indifference. It generates panic. Spreads fear." Recalling Mayakovsky's immense energy, and his own hunger to

create, Vertov tersely wrote: "We who work in documentary poetic film are dying for work."

"Document [fr. LL *documentum* official paper, fr. L, lesson, example, fr. *docere* to teach + -*mentum* -ment—more at DOCILE]" "Document verb transitive," *Webster's Third New International Dictionary* (1971):

> doc-u-ment 1 obs: TEACH, SCHOOL, INSTRUCT 2: to evidence by documents: furnish documentary evidence of 3: to furnish with documents 4a: to furnish (a ship) with ship's papers as required by law for the manifesting of ownership and cargo b: to annex to (a bill of exchange) the shipment documents—see DOCUMEN-TARY BILL 5a: to provide with factual or substantial support for statements made or a hypothesis proposed esp: to equip with exact references to authoritative supporting information b: to construct or produce (as a movie or novel) with a high proportion of details closely reproducing authentic situations or events.

Under "documentary adj." the compilers, assemblers, or typographers have set the words "FACTUAL, OBJECTIVE, REPRESEN-TATIONAL" in caps.

Editorial use of split sequences, "disruptive-associative montage," emphasis on the mysterious patternment and subliminal structures of images (icons), sensitivity to the sound shape (even in a silent film) of each pictured event, awareness of the time-mystery of simultaneous phenomena (co-occurrence and deployment)—I am an American poet writing in the English language. I have loved watching films all my life. I work in the poetic documentary form, but didn't realize it until I tried to find a way to write an essay about two films by Chris Marker.

On January 17, 1937, Vertov asked himself: "Is it possible that I too am acting out a role? The role of seeker after film truth? Do I truly seek truth? Perhaps this too is a mask, which I myself don't realize?"

IV
1941!—a hole in history
—Emmanuel Levinas

The title of *Sans Soleil* is taken from a song cycle by Mussorgsky. Toward the end of the film the narrator imagines a time traveler from the year 4001, "when the human brain has reached the era of full employment." The traveler is a third-worlder of Time. He tells us Mussorgsky's songs are still sung in the 40th century. I read once that the magic of Mussorgsky rises from a sort of catastrophe. Most of *Sans Soleil's* footage was shot in Japan during the early 1970s, but shades of the dead of Hiroshima and Nagasaki hover at the margins because what is the chaos of fire to Memory? The films of Andrei Tarkovsky are also imprinted by signal recollections of our soils and losses. *Ivan's Childhood* (1962) and *Mirror* (1974), are classified as fictional films in video-rental stores, though they incessantly and insistently document the somber confines of experience during the 1940s. In *Sculpting in Time: Reflections on the Cinema* (1986) Tarkovsky examines his position in an aesthetics of film, always wondering weaving measuring intentionalities of consciousness: problems, paradoxes, time-space, dream-time, unexpected necessity, cinematic possibility. What *is* a film, he keeps asking.

- Fact?
- Forms inside a box?
- Imprinted time?
- Time in the form of fact?
- Recorded life?
- Anonymous truth?
- The print of thought?

V

Night trains air raids fall out shelters
—Sandor Krasna, 1982.

Sans Soleil opens with an idyllic pastoral sequence. Three children are walking along a country road in Iceland. The camera's knowing eye plucked them out of place and bygone time shortly before a volcano buried their village under ash. Through the medium of film, we watch them passing through the past again. A woman's voiceover tells us the film's editor surrounded or sheltered this particular sequence with black leader. She speaks from inside the black until the next sequence of shots, when the jet plane sinks into the hold of a destroyer or aircraft carrier.

Bearer of lethal invisible material

only an event or nonevent lowering along the scopic field of light or flight in a world flooded with facts.

La Jetée, composed almost completely of photo stills, begins abruptly with a violent out-of-field-movement-sound-image, the roar of revving and hovering jet engines. Sometimes I think I hear sirens, until the whine or scream of aviation doubles and dissolves into cathedral music: voices in a choir sing passages from the *Russian Liturgy of the Good Saturday*. In northern Russia, Iceland, and other northern places, the sun never goes out of sight in summer. *La Jetée's* aborted soundtrack takeoff evokes technicist and eschatological worldviews.

Immediately time could be going either way.

Sabbath. Beginning of the world to this day. The end of darkness, even in the first of *Genesis* all will of God all sum of mortal obedience. How fearfully without transition a moving image becomes a view of things according to machine assemblage. "My films are my children." Genres and methods are means washing over the projector's original

phantom photogram. Firstness can only be feeling. Vertovian theory of the interval. What if a film never reaches the screen because viewers walk away?

Return to the intrusive camera for shelter.

Marker's list of credits calls *La Jetée* a "ciné-roman," but the camera's preliminary concentration on real signal towers, real runways, real airport machinery, real modernist utilitarian airport architecture, suggests a nonfiction representation of fact: socialist realism versus documentary invention.

"Ceci est l'histoire d'un homme marqué par une image d'enfance."

Concerning a voice through air

it takes space to fold time in feeling

Often in the moving time of speech some spoken words get lost. A voiceover is omnidirectional, though we read from left to right. White intertitles form lines on the circumscribed skin of a screen. Superimposed subtitles form a third chain of translation: a foreign message from someone to someone foreign. "This is the story of a man, marked by an image from childhood." Words written in English tell me the same thing twice, though through another haunted vista and approach. In 1948, just after World War II, Laurence Olivier produced, directed, and starred in *Hamlet*. Olivier's voiceover introduction to the film was a single sentence spliced to an intertitle-quotation from one of Hamlet's soliloquies: "This is the tragedy of a man who could not make up his mind."

In act 1, scene 1, Horatio sees the ghost of Hamlet's father armed, but with the visor of his helmet up. The protagonist of *La Jetée* has been granted to watch, as a child, his own death. The unknown woman, object of his wish, subject of his gaze, sometimes calls him her "Ghost." "*Hamlet*. Farewell, dear mother. *King*. Thy loving father, Hamlet. *Hamlet*.

My mother. Father and mother is man and wife, man and wife is one flesh; so my mother. Come, for England."

He loses her to look for her. Escape into air from living underwater, she could be his mother glimmering into sight

if a bird beats the air must it oh

oh must it not resound

across the moving surface of time, a dark wing the hauntedness all that is in the other stream of consciousness. "So oft it chances in particular men." Now whisper about his eyes being stone. Different visor masks. The uneasy distinction. Turned aside by a look he must go back. Her face is a prisoner of Love.

A boy and his parents have come to the main jetty at Orly, the Paris airport, on a Sunday before World War III, to watch the planes taking off. A little family stands together, facing away from the camera. It's unclear if "the child whose story we are telling" is the child who has his back to us in two still shots. The off-screen narrative voice adopts the royal we when telling the story. Image track and soundtrack don't quite connect. Did the boy at the guardrail inside the film frame become the marked man? His story will survive the madness to come because of his obsession with an image he is *bound* to remember. Who or what binds him? Something he saw on that primal Sunday he looked the other way. We see a young woman standing alone at the right corner of the jetty directly under the early morning or late-afternoon sun. There is always a time when day and night are equal. She must have turned, because in another shot we see her face. Glancing our way her expression is hard to determine. Her pensive gaze is wary tender innocent dangerous. She may be remembering beckoning staring apprehending responding reflecting or deflecting his look.

The uncertainty of appearance in a phrase universe.

The subject of Marker's ciné-roman is unable to forget "the sudden roar" [*overhead long shot*] dark underbelly of a plane in the air after takeoff. "The woman's gesture la geste de la femme" [Oh no!—Look out!—Keep away!—Come here quickly!], her fists thrown up against her face stifling [*out of it*] a laugh. Meeting the actor-Ghost she could be trying to stop *ha* escape. Her fingers spread open [*visage selvedge*] both shield and express. "Les clameurs des gens …" He veers to the left "et que cet instant …" Oh quickly! "Where [is] the soul?" [and beautiful] How is it contrived? "L'homme qui l'avait suivi depuis le camp souterrain—" [*run FLIGHT-LEFT reach out HAWK-WING-ARM*] What are your hands thrown up against? Did he give himself away? [*I do not ask you who you are not.*] Where did the protagonist go? [*there is no crowd, only the faces of that couple who may be his parents*] everyone is looking somewhere else [*turned away from the runway not facing the camera*]. >Guardrail in half-light [*a plane on the ground arriving or departing*] Sirens. {ellipse [Now] spliced on a land of promise <but now> There are no moorings in conversation. [Where is your soul? [-] "a crumbling body."

 Fall fall my entire weight <bow>

VI

I showed views of Russia: Moscow, the Kremlin, the coronation—and some scenes of France. The Tsar professed great interest and asked many questions concerning the mechanism. I explained, and offered him a fragment of film. He held it up to the light, looking through it, and passed the strip from hand to hand. He thanked me and wished me success with the Lumière invention in Russia.
—Felix Mesguich, 1897[3]

1962. *Ivan's Childhood* opens, before the credits, with the solitary song of an unseen bird and a child's sunlit peacetime dream-image of a woman, his mother, smiling. The film, based on "Ivan," a popular wartime short story by Vladimir Bogomolov, had been poorly produced at the Mosfilm Studios when Andrei Tarkovsky, only recently graduated from the Institute of Cinematography, remade it. "I am simply in love with the subject. I was his age when the war began. His situation is that of my generation," he later wrote. He took the visual dream imagery for Ivan's first dream from one of his own early memories of summer in the Ukraine by the Dnieper river, before World War II. We see Ivan's face

3 Quoted in Jay Leyda, *Kino: A History of the Russian and Soviet Film* (Macmillan, 1960, new ed. 1973).

behind a spiderweb between the branches of a tree. Ivan sees a butterfly and follows it. The camera sweeps and pans over the forest, over the sandy bank of a river. His mother comes into view carrying a pail of water from the well. He runs to meet her. She sets the pail down. He dips his face in the water to get cool. "Mum, there's a cuckoo!" he tells her. She raises her arm over her forehead as if to wipe away sweat and listens with him. Her loving expression is the essence, the very play, of happiness. No voiceover settles linear sequentiality, though sounds do refer to what we see. In a standard pastoral fusion of music, bird songs, and running water, Ivan's high boyish laughter, repeated and repeated, acts as a pivot. Speech represents logical human contact. In *Ivan's Childhood*, spontaneous acoustic signals of delight are hints of imminent reversal. Laughter uncannily suggests a coming breach.

Ivan's image of happiness has no black leader for shelter.

More than twenty million Russians died between 1941 and 1945. Some of the worst fighting of the war took place in the Ukraine between the Dniester and the Dnieper. Ivan was only dreaming. His mother's happy prewar expression cuts to terror. This look wakes him up. Now it is outside-inside freezing winter cramped shelter. *Now* is brute fact. Now he is dressed in a ragged padded jacket and cap. He is hiding in a shed or ruin then slogging through a swamp through blackened stumps and thickets. He has no mother. Death outstripped her life and will cut his memory out soon. In wartime she is foreign to representation. She only returns in dreams. When her son stops sleeping she will leave no trace. In Bogomolov's story, Lieutenant Galtsev is Ivan's witness. Nikolai Burlyaev, then a schoolboy in Moscow, acts the role of the skinny twelve-year-old orphaned reconnaissance scout. Many actors made screen tests for the part. Tarkovsky later wrote: "I had noticed Kolya, the future Ivan, when I was still a student. It is no exaggeration to say that my acquaintance with him decided my attitude to the filming."[4] The director doesn't explain what he means by this. The young actor

4 Andrei Tarkovsky, *Sculpting in Time*, trans. Kitty Hunter-Blair (University of Texas Press, 1986), 33. Further citations are given with the abbreviation ST.

who plays Galtsev reminds me of David, who was only twenty-three during the time he was a second lieutenant. In *La Jetée* the boy who may become the man marked by a memory from childhood may or may not be an actor. The three blond children in *Sans Soleil* are three blond children living in Iceland. According to the voiceover, spoken by a woman, the cameraman, who may or may not have been Marker, wasn't shooting a film at the time. He captured their images while on his travels because they represented for him the image of happiness. Footage of black volcanic ash covering their village, near the end of the film, was shot later by another documentarist. Still later *Sans Soleil's* semifictional narrator-cinematographer-correspondent tells his semi-fictional feminine voiceover: "History advances, plugging its memory as one plugs one's ears ... A moment stopped would burn like a flame of film blocked before the furnace of the projector."

VII

In the middle of this warm prewar Sunday, where he could now stay.
—Chris Marker, *La Jetée*

Yesterday words could come between the distance. Frame light, for example. All living draw near. Knowing no data no some-thing then something. No never and no opposite occident orient. Film with jumps and quick cuts. Dissolves and slide effects. Real chalk. Burnt-out ruins. Without weariness. Without our working conditions. When our forces hadn't been thrown.

What is valid documentary? In the long struggle who transmits the Diaspora?

Kolya, the future Ivan, David, my future husband, pick up the receiver. Real children on a peacetime morning before ruin. No sequence of dust fire smoldering ash. Just back to morning. The June of Everything.

Where in the flame does a film stop time?

VIII

Morning is the time of Midnight. Artificial Day

Some of my earliest memories are film memories confused with facts.

During the 1940s, the confusion or juxtaposition between living truth or acting life, always a part of the double and paradoxical nature of movie-going, involved a guilty reading-effect for American children whose fathers were away fighting as opposed to traveling in Europe Africa the South Pacific.

Murder with clock striking cat scurrying woman screaming.

Historical or geographical accident isolated us from the cold reality of mud and hunger. We were spectators chewing popcorn in a second darkness out of daylight looking at film-fact on one side of the screen not the other sides of oceans.

Superimposition of time: cinema-time immediate-time.

A film you love when you are young is never what you know you saw. Apparently cinema helps to reduce the distortion between a "dear" father and a "dead" father. It's the scene of horror the camera returns to, never the daughter.

"But we are lucky."

In fact space is imaginary.

During the 1940s, children in Cambridge, Massachusetts, went to the University Movie Theater on Saturday morning at 10 a.m. We saw newsreels, cartoons, previews of coming attractions, and a double feature.

We didn't talk. We divided the crime from the scene of it.

IX
Acts and Monuments.

In wartime zoo animals get scarce. Human destiny in the space of money. This world of fatherlands is covered in wounds. Subjects await their colonists. Trying to escape being crushed by a propeller I was searching for someone else. A wing flew open. The image through death.

All the war in the nonacted cinema.

BOMBER SUBMARINE BATTLESHIP NIGHT-ATTACK FIRE-BOMB INFANTRY TORPEDO DOODLE BUG KAMI-KAZE: The camera may move along the sidewalk it's still a picture. GESTAPO HIMMLER HITLER GÖRING BAMBI TARZAN JANE: What Eurydice? Love is illusory.

"Can I piece the falling together?"

"David or Ivan."

"Oh it's you."

Banished from the Land of Children.

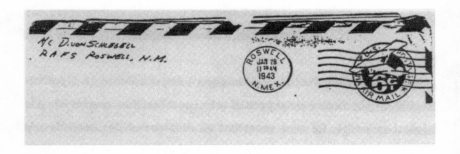

X
The Negative of Time

Dear Bae & Bill—
 Your nice long letter came today, Bae. You asked about the country
here. It is bleak and barren. It is real desert with none of the mountains
we had around Oxnard. However, it is good country for flying and the
weather is great. There are amazing sunrises. I think New Mexico is fa-
mous for them. The sky is full of bright colors. Orange, pink, and green.
It is really amazing. We take off in the morning as soon as it is light
and it is a very dramatic sight. Last week my instructor and three of
us cadets took a cross-country to Dallas, Texas, for navigation practice.
Dallas is about five hundred miles away. Cross-country trips like that
are a lot like a cruise in a boat. Of course a cruise would be nicer. But
when we get into bigger airplanes and they have a range of thousands
of miles which they can travel in a relatively short time it will be better.

XI

This soil'd world
—Walt Whitman, "Reconciliation"

 "Don't be worried by the sound of 'test pilot,'" David wrote home
to his father and mother in 1943. "It is nothing glamorous or exciting
like the movies make it sound. There are perfectly routine checks which
must be made on all the airplanes at certain intervals. That is all there
is to it." What he was really learning to do he learned to leave out. Less
than a year later he was flying B-17s or "Flying Fortresses" on bombing
missions over Germany in what military strategists, historians, and war
buffs refer to as "the European Theater of War." Each letter a soldier
wrote home from the "Theater" was inspected first by War Department
censors. On the march only a language of remains gets past. All lost
material in nonacted newsreels here is the real, the coverless.

On September 7, 1938, Dziga Vertov listed among forbidden battle techniques of a documentarist: "Substituting the appearance of truth for truth itself."

Since David died I can look at photographs of him, though I still haven't been able to look at the video copy of a home movie his daughter sent us in 1991. It was filmed by his first wife's uncle during a summer in the 1950s. Bae was still alive. She died October 9, 1965, so I never met her. Here she sits on a garden chair in Ogunquit in summer. She is reading, knitting, or watching her granddaughter, Lisa. Judging from family photograph albums, her husband was usually surrounded by admiring painting students and fellow artists. In this homemade film Bae is a widow in her sixties. I remember that in our last summer together David couldn't look at the recovered black-and-white-film documentation of her moving image without crying. Sometimes he and Lisa's mother are playing in the sand with their daughter. Sometimes he stands at the door of his studio then goes inside. He designed the building himself. Now it has been torn down. I can only perceive its imprint or trace. Lisa remembers listening to the noise of waves breaking over pebbles in the cove at night, how tides pulled them under, how they swirled and regrouped in the drift and came back.

I imagine the noise as fixity gathering like a heartbeat, steady and sure.

I have pushed the videocassette box onto the bookshelf near your desk, out of sight. Because the camera operates at sixteen frames per second for old home movies, and speed is silent. Because your moving image would rupture the suture of sound projection. Because there is no acoustic parallel, nor is concord possible. "*The bad old days*"; mocking scramble for cover torn labor.

October 5, 1993, October of meeting nowhere.

On January 21, 1924, Vladimir Ilich Lenin suffered a massive stroke. He died that evening at 6:50. We close the mouth and the eyes of the dead and arrange their bodies so they look as if they are sleeping peacefully or resting before we burn, bury, or seal them up.

Lenin's body lay in his sickroom at Gorki on a sheet-draped table surrounded by flowers and fir branches. During the night friends, colleagues, and relatives stood guard over his remains. The following day his body was placed in a coffin lined with red cloth, a small red pillow under his head. Pallbearers and mourners carried the coffin to the train and boarded it. When the train reached Moscow, where the dead leader was to lie in state, the route to the Trade Union House with its Hall of Columns was lined with troops. The temperature was forty degrees below zero, but crowds were gathered on streets, rooftops, balconies, everywhere. The hall was draped with black and red ribbons, black banners hung from the ceilings. The coffin was carried from the train by Kalinin, Bukharin, Tomsky, Kamenev, Stalin, Rudzutak, Zinoviev, and Rykov. Over half a million people filed by his bier between January 23 and 26. Outside the temperatures were freezing, yet they stood for hours night and day waiting for a chance to look. In *Lenin Lives! The Lenin Cult in Soviet Russia*, Nina Tumarkin describes Lenin's bizarre progress from mortal revolutionary hero to embalmed cult-icon under glass. It wasn't easy; there were technical and scientific embalming problems, competitions for best sarcophagus designs, committees. In November 1930 the granite porphyry and labradorite mausoleum holding the transparent coffin opened to the public.

"Modern tombs are a skeptical affair ... the ancient sculptors have left us nothing to say in regard to the great, final contrast." When Henry James wrote this he was referring to the art of stone, not the art of moving pictures.

Throughout 1933, eagerly or devotedly following Lenin's instruction that "the production of new films inspired by Communist ideas and reflecting Soviet reality should begin with the newsreel," Vertov labored to produce *Three Songs about Lenin*, commissioned for the tenth anniversary of their leader's death. In preparation he and Elizaveta Svilova searched through "archival, cinematheque and unprocessed footage" in various cities including Tiflis, Kiev, and Baku, for moving images of the living Lenin that might have been overlooked by newsreel editors. "In each instance the brunt of the work involved in exploring gigantic amounts of archive footage fell on Svilova's shoulders. For the tenth anniversary of Lenin's death she particularly distinguished herself, when, through a painstaking examination of hundreds of thousands of feet of film in various archives and storehouses, she not only located shots essential for [the project] but reported finding, in addition, ten original negatives that render the living Ilyich on film." With the help of a new sound engineer, P. Shtro, they were able, during one brief climactic section, to transfer Lenin's voice to film. Utilitarian pragmatism, iconoclasm, constructivism, pomposity, sentimentalism, modernity, archaism, and strident nationalism can all be located in this cinematographic memorial with its vivid musical score by I. Shaporin.

"FIRST SONG (hand lettered) 'Under a Black Veil My Face ...'"[5]
Vertov and Svilova collated their newly collected archival documentary material with other footage already gathered between 1919 and 1924 by the Council of Three, or Kinoki (the third member of the triumvirate was the cameraman, Vertov's brother, Mikhail Kaufman). This was juxtaposed with ethnographic segments photographed by D. Sourenski, M.

5 Annette Michelson, "The Kinetic Icon in the Work of Mourning: Prolegomena to the Analysis of a Textual System," *October* 52 (Spring 1990).

Magidson, and B. Monastyrsky, of women, almost completely shrouded under layers of clothing, from the eastern areas of the Soviet Union. Sometimes, these walking mummies joyfully fling off the veils covering their faces, for the camera. Other women are shown learning to shoot rifles, entering workers' clubs, learning to read, learning to operate heavy machinery.

Three Songs about Lenin was produced in 1933 during the unsettling period of transition between silent film and film with synchronous sound. For the first two Songs it's as if two realities are being unified and falsified by the controlling musical score and instructional titles superimposed. By the third Song the materialist conception of history is no longer a hypothesis but a scientifically demonstrated proposition with an understanding of the potentials of the microphone. On the level of subject matter the internalized danger situation of a lost love-object is being projected, printed, and distributed throughout.

Sound effects seesaw through artifices of montage.

Turkish, Turkmen, and Uzbek folk songs about Lenin are hailing a worldview that the old materialism could not satisfy. Late nineteenth-century Romanticism, Siegfried's funeral music from Wagner's *Götterdammerung*, is hailing a delayed reaction to Hegel's faith in human reason. The practical telecommunication of the mid-twentieth century is hailing. "Hey, you there!"

December 1932, an efficient machine interrupted by the assassination of Kirov. Other people against the wall. All this behind-the-scenes in the World Market. "Hey, you there!"

Lenin's insistent communicativeness.

"How many times here in the Red Square—" / "—did we hear him speak?"

In the middle of the second Song there is a sequence where the Founder of the Soviet Union, in the very act of haranguing the masses with his raised arm, interrupts the officious narrative commentary. As if he really could be projecting his aggressive instincts on the restrictions

of cinematographic plausibility, Lenin, mouthpiece source and limit of realism, talks.

Stress the importance of triumph. Poignancy of its imagos.

Learning to talk is a complicated process. The child's growing skill between two realist poles, hostile impulses as well as "bad" internal objects; a little demon of melodrama. Helping figures quickly blossom in the creative surge of aesthetic necessity. Yes the triumph of split-off illusion no the ambush and defeat.

Some of the mourners are acting looking back.

"THIRD SONG (hand lettered) 'In Moscow ...' / 'Ah, in the great city of stone ...' / 'On the square stands a "tent" ...' / 'The "tent" where Lenin lies ...'" We see workers inspired by "The Country's First Great Electrificator Lenin," laboring joyfully in huge hydroelectric plants, in factories, on collective farms. "'Machinery is now the weapon ...' / 'OUR OIL!' / 'OUR COAL!' / 'OUR METAL!' / 'Our mighty Baltic-White Sea Canal ...' / 'Lenin, we go FORWARD!'" While the message may be that Leninist-Communism is liberating, particularly so for women, Annette Michelson demonstrates in "The Kinetic Icon in the Work of Mourning: Prolegomena to the Analysis of a Textual System," ways in which this film she calls "a veritable iconostasis" draws its subliminal visionary force by working in and around the ancient Russian tradition, through music, iconography, and literature, of anonymous female oral lamentation at funerals and burial ceremonies.

If, as Melanie Klein says, following Freud, mourning is the pain experienced in the slow process of testing reality, *Three Songs about Lenin* is a cinematographic embodiment of the fluid and passing states, the interaction and interjection, between sorrow and distress. This innovative postrevolutionary cinematic memorial to the father of the socialist motherland, by use of the camera's eye, may bring into arbitrary relief the patient mitigation of hatred by love. But why do women in moving pictures so often serve as representations of the extension of love united

before strife, at the same time they are being "caught unawares" by the camera's point of view?

Writing this essay I have no clear idea what value there can be in a fragment of concrete reality in itself multiple and always at the mercy of a national and personal identity. The real time of emotion isn't musical time or background noise of civilization or continuity of exposed film. You can always tell memory, not the coverings it closes first.

Three Songs about Lenin runs forward by half removes into those early blacklist days, wonderfully without defense.

Defense as it appears in fortresses and humans.

La Jetée is made up almost entirely of stills. It opens with a lowering sun, departing planes, and World War III about to begin. Marker's use of photograms and freeze frames in this film that calls itself a fiction is a compelling documentation of the interaction and multiple connections perceived separately and at once between lyric poetry and murderous history. That's the secret meaning. I knew it by telepathy in 1948 when I was eleven and first saw the movie of *Hamlet*. André Bazin says in "Theater and Cinema": "When a character moves off screen, we accept the fact he is out of sight, but he continues to exist in his own capacity at some other place in the decor which is hidden from us. There are no wings to the screen."[6]

Chris Marker's filmography lists a twenty-six-minute video, "Tarkovski '86," as part of a longer work called *Zapping Zone*. I haven't been able to see it, but I noticed his name on the list of credits at the end of the ponderously titled *The Genius, The Man, The Legend: Andrei Tarkovsky*, produced by the Swedish Film Institute in 1988.

Tarkovsky directed a stage production of *Hamlet* in 1976. "To begin with, it's a family, a closely knit family, they mustn't have the slightest

6 André Bazin, *What Is Cinema?*, ed. and trans. Hugh Gray (University of California Press, 1967).

inkling of all that lies ahead of them. They are very protective of each other, very dear to each other, they are all together. And that makes them happy!" he wrote in reference to Ophelia, Laertes, and Polonius in act 1, scene 3.[7]

The Russian director Andrei Tarkovsky often mixed documentary footage with fiction. He scattered professional actors, stagehands, friends, and family members throughout his films just as he arbitrarily blended time periods with international and domestic situations. The project he variously titled, *A White, White Day, Atonement, Redemption, Why Are You Standing So Far Away*, even *Martyrology*, was to include fragments of straight interviews between his mother, Maria Ivanova, who had once been an actress, and himself, until he abandoned this early cinema-vérite approach and replaced the interview format with acted scenes. *Mirror* is partially based on his memories and her memories of life before, during, and after the war. The actress Margarita Terekhova plays both his wife and his mother, while Maria Ivanova is herself and acts her mother. Ignat Daniltsev plays Tarkovsky's son Ignat (really Andriuska) and Alexi (Andrei himself) as a boy. Oleg Yankovsky is the director's film father, while his real father's poems are read offscreen by Arseny himself. Real or acting, the characters have the same reflection in whichever mirror serves as camera for the filmmaker for his cinematographer. They can pass back and forth from one to the other but that's what movie acting is because there are no wings to the screen any soul can be the body.

Distant woods beautiful auspicious morning at evening a sudden west wind soughing through white flowering meadow.
Facts are perceptions of surfaces.

In *Sculpting in Time*, Tarkovsky writes about his problems beginning *Mirror*. First it was to be a novella about the wartime evacuation, with the plot centering on a military instructor at his school. During the

7 Andrei Tarkovsky, *Time within Time: The Diaries, 1970–1986*, trans. Kitty Hunter-Blair (Verso, 1993).

second version of the script the idea of the interview with his mother took precedence, "but the incident ... continued to torment me, and lived on in my memory until it had become a minor episode of the film." He abandoned the second version because he continued to feel he was missing an essential vision or fact or memory that would raise the project above the level of lyrical autobiography. The constantly changing quality of this work in progress confirmed his feeling that scenario is fragile and constantly changes with the material as well as with qualities individual actors bring to it. This improvisational way of working continued throughout the filming and editing stages. At some point he decided to include newsreel shots, though he seems to have been worried about the combination of acted and documentary sequences. He gathered found footage intending to use it, but the collection represented only isolated fragments lacking the single time-sense he wanted. So, just as Vertov and Svilova had done while preparing *Three Songs about Lenin*, he continued searching, until the day he came across a sequence showing Soviet soldiers crossing Lake Sivash. "Suddenly— quite unheard of for a newsreel—here was a record of one of the most dramatic moments in the history of the Soviet advance of 1943. It was a unique piece; I could hardly believe that such an enormous footage of film should have been spent recording one single event continuously observed. It had clearly been filmed by a gifted camera-man. When, on the screen before me, there appeared, as if coming out of nothing, these people shattered by the fearful, inhuman effort of that tragic moment of history, I knew that this episode had to become the centre, the very essence, heart, nerve of this picture that had started off merely as my intimate lyrical memories." The army cameraman who filmed this extraordinary document was killed the same day he shot the footage. Tarkovsky doesn't give us his name. I haven't been able to find it in any writing about the film. Most of the young soldiers were killed also. The Soviet chief of State Cinema advised him to remove the sequence from the wider selection of documentary intervals or detours because the scene showed too much suffering.

When, almost halfway through the film, the director begins to introduce the various black-and-white newsreel documentary inserts, they telescope together, binding his memory-time of youth to the actual geopolitical chain of violence, seemingly everywhere during the second half of the twentieth century. The archival inserts are sometimes shown at a slower speed, sometimes with "wild recording" faked later.

Sent-back poems from the invisible side of events.

The newsreel filmed by the anonymous cameraman at Lake Sivash acts as an open parenthesis for the tragicomic autobiographical episode in which evacuated boys, at target practice in an icy outdoor rifle range, play a cruel joke on their shell-shocked military instructor. He has no name either.

In fact authentic documentary material blighted the hearts of children all over the world who came to consciousness enveloped by threatened futurity, during the non-nuclear and then nuclear 1940s. We were alert to the subliminal disjunction between actual and fictional cinematographic realism shown in theaters (never called cinemas) because no one had television at home. When I said that in Cambridge, on Saturdays at 10 a.m., the weekly ritual for children at the University Movie Theater consisted of a newsreel, a cartoon, previews, the main feature, and a serial, I left out the intermission. The curtain came down, as if this were a play, and much to our disgust, perhaps because it dem-

onstrated in fact there were wings to the screen, a real man—comedian or magician, his name didn't matter, we never knew it—walked onstage with a blackboard and other props. We scorned him for interrupting our absorption in ritual. We scorned him for being human. "Let's get on with the show! Let's get on with the show!" I chanted with the crowd firing tickets, spitballs, and popcorn in his direction, no matter that some of us had been sobbing over the death of noble animals in *My Friend Flicka* or *Bob, Son of Battle* not ten minutes earlier. During wartime, quantities of aggressive impulses nullified our terror of the danger of disruption and released our obsessional defense mechanisms. We needed to show triumph, so we persecuted this mortal parenthesis with hoots and jeers. Saturday after Saturday he recited the number lists and little miracles that made up his repertoire of tricks or jokes, until the lights dimmed, he carried his props offstage to the margins from whence he came, and the curtain rose revealing the screen. The soul had returned to the body, the main feature could resume.

According to the narrator of *Sans Soleil*, the baffling part of the Japanese Shinto ritual of Dondo-yaki is that circle of little boys we see shouting and beating the litter of scraps of burnt ornaments or votive offerings with long sticks after the flames have died down. They tell him it's to chase away the moles. He sees it as a small intimate service.

In English *mole* can mean, aside from a burrowing mammal, a mound or massive work formed of masonry and large stones or earth laid in the sea as a pier or breakwater. Thoreau calls a pier a "noble mole" because the sea is silent but as waves wash against and around it they sound and sound is language.

Specimen Days, published in 1882, consists of extracts from notebooks Walt Whitman kept between 1862 and 1865 when he was visiting sick and wounded soldiers on the field and in hospitals around Washington, D.C. There are other sequences in *Specimen Days* he calls memoranda, later added in Camden, New Jersey, where the poet moved after suffering

his first paralytic stroke. One, "pencill'd ... one warm October noon," titled "Cedar-Plums Like—Names," is about the problem he had naming the book. In a footnote marked by an asterisk he provides a list of suggested and rejected titles. There are thirty-five. "Then reader dear, in conclusion, as to the point of the name for the present collection, let us be satisfied to have a name—something to identify and bind it together, to concrete all its vegetable, mineral, personal memoranda, abrupt raids of criticism, crude gossip of philosophy, varied sands clumps—without bothering ourselves because certain pages do not present themselves to you or me as coming under their own name with entire fitness or amiability." As if to stifle his own egotism, he adds, in parenthesis: "(It is a profound, vexatious, never-explicable matter—this of names. I have been exercised deeply about it my whole life.)"[8]

Children know by precognition how precariously names cling to civilization. In order to qualify for language they must stifle unrelenting internalization. "We have a message for you—our spirits being out of body." Images have countries whose streets they cannot fathom. Immense stretches of ocean up to this frame the screen.

"I just dreamed of you mama. By the way when did father leave us?"

"1935, why?"

Mirror: *The Newsreel Sequences*

history does run backward through endless generations of murderers. The Spanish Civil War zooms in on us because in cinema people do talk from the grave

eating away at character because public evaluation is troublesome and wants autobiographical fiction. No the camera pulls away from corresponding impressions lyric pulls away. No the benign circle shed

8 Walt Whitman, *Complete Poetry and Collected Prose*, ed. Justin Kaplan (Library of America, 1982).

also. Time itself running through though shot not smoothly but by jolt by static energy. Checking the cost. No the collision of one objective nonacted group shot with another.

No by the very facts.

A woman walks quickly down a city sidewalk carrying a long pane of broken glass. It's a window not a mirror. Bombs are being dropped from planes. Do they fly across the screen from left to right because we read in that direction? Cut to bombs exploding though we only hear singing. Two women, one carrying a bouquet of flowers, run for cover. Other citizens are seeking shelter. Theater for whom? Some half glance at the camera as they hurry in

meanwhile the angry retrospective nostalgia of flamenco music on the soundtrack reiterates the place of Spain while bridging the transition between acted and nonacted scenes. As if by impasse of idealization cinema can reestablish security and life itself and song will soothe we will be soothed to silently watch these incessant relentless negative retrievements this debris rayed over.

Frantic grown-ups are evacuating groups of children probably from Madrid. It's a question of security but who will love them don't that's the substitute part. All the pain of the world is concentrated in this place crammed with people dear to each other. He tries to comfort his mother before going. His father kisses and kisses him. What do you see camera?

Shouts and not memorized.

Some children haul heavy suitcases, some wear identification badges, some kiss their relations good-bye, some set off eagerly some are sobbing. A young boy uses a large white pocket handkerchief to wipe away his tears. Cries of love and alarm on the soundtrack fade into an air-raid siren, factory whistle, or is it the whistle of a train approaching.

We are as real and near as cinema.

A little girl, half-turned away holding her doll, smiles shyly. When the ambiguous siren or engine wails its warning she turns directly toward the camera. Medium close-up her expression changing to a mixture of astonishment or terror. This child is not acting. Perhaps she knows what the young actor in *Ivan's Childhood* pretends he knows.

Her look pierces the mask of western culture.

(Almost forty years later, in June, 1972, a terrified Phan Thi Kin Phuc, napalmed in error by a South Vietnamese bomber, will come running naked down a road, having torn off her burning clothing.

She is running toward the camera's single eye.)

A man without wings swings slantingly into view through free space mute sky

1 2 3 4 5 6 seconds of silent soundtrack before liturgical music through fade-in to a certain point then tapering emitting wave notes risen from years of other powers. Balancing and hovering he is swinging in a basket as if re-entrance is easy. Swings in again coming home so it's a picture projected through time subtler than poems or a letter because he is working on it. Found footage shown at slower speed here is power. A tremendous stratosphere spinnaker so weightless after the weighty Spanish evacuation sequence hovers preparing for lift-off well he needs no map to return if fiction angel astronaut returning to home base as if he merely floated out of sight for fun as if reentrance is possible and surely there are to be anchorage mooring helpers waiting. Star boat USSR

resembles a light sail of great speed used on yachts when running before the wind, spinnaker because a yacht called *Sphinx* carried such a sail in 1866. Utilitarian loveliness, a huge bubble of nylon pulling tons of boat through water, but sometimes relentless swinging and thrashing shakes the rig out of her tugging

now the spinnaker is drawing now the long chase ahead. Coming next will be other newsreel footage of young soldiers slogging through mud and shallow water not doing well exhausted though one or two smile wanly at the camera

I wish you could see this film. Sometimes I recognize you inside it so scared and young always among those Soviet soldiers who are crossing Lake Sivash why should there be twice as many sick as wounded

you float back to me everything inexpressible

aerodynamic repair experiment for the freshly washed white star boat USSR getting ashore to let you sleep well. Light sail of great spread used on yachts when running before the wind.
Once you could cover my hand completely with your palm.

A huge bubble of nylon pulling tons of boat through skywater swinging and thrashing relentless threatening to shake the rig out now tugging water now touched by science now drawing silence inside the long chase ahead.
Scenes like this men use

clinging vine method to hang on filling out running before the wind but here there is no yacht and open ocean is air. The effect is the same flying-jib out astride the small boom so spinnaker to get north. Smaller balloons circle and touch the mother one as satellites do then sacred chorus singing sanctus sanctus. All is well. Melody for a while. Melodies antedate languages they do not grow old. A peaceful weightless wingless furlough one or two other balloons revolve around these smaller powers after peace.

One aerialist sailor attached by a string to a satellite balloon floats in and down across the screen from right to left where are his supports as child attached to a mother? As if he were returning home again a crowd to watch and applaud so from heaven he smiles. Where are you systems of planets around us? Drifting out of sight away out of the frame of the screen behind the wings. Annihilation is the deep chaos answer sheets and white film turmoil. It's a separation wish to be carried out also as if to silence of ether. Irrationality of speech to surrender the beauty of this voyage without baggage to shed earth. Because our fathers have not kept their word. Artificers and builders convey to one another someone was thought to be worthy. Colorlessness prefigures a connection when the unconscious mind mirrors love-partners who are in absolute contrast but by early influence that the child had had time her impressions of her father may have been shaken if there ever was a way to translate the *feeling* of image-juxtaposition in these words moving from left to right across this sheet of paper.

Nicely coordinated teamwork between camera crew director actors *Mirror* the private life.

The sea is a theater.

Steerage toward redemptive bourgeois historical resolution what music to windward probably unaware of rocks the motion of waves the swelling fold how quickly the sail becomes a contorted mass of fabric.

Sequences touched off by and surrounding the originary memory of the military instructor without a name. His overanxiousness to keep all his pupils safe. He is a teacher and then about the worry that so perfectly matches these restless boundaries of realism.

Come tell us *young* man.

We can't hear him crying his excessive sorrow because of the world. He has resigned himself in phobia projections and defenses for love. Nothing can remove that split in the film it's too close the masters have been mixed. Double the safe place death. You can see the dramatic force of this central counterpoint ellipse. You know the joke of the boy who tosses the dummy hand-grenade onto the boards. You know the instruc-

tor will become the nerve to throw himself down in order to save his young pupils (he is a teacher he thinks he would die for them that sense of omnipotence).

(You hear his heartbeat louder and louder sometimes to the point of martyrdom

Of course the hand-grenade never explodes though his beating heart does change to the beating of drums to a drum-roll marshaling. Poor man this excess of activity no nurse by his side no friend to assist him in his struggles. Some are so young and already representative of current events we are bound to confront

juxtaposed with the newsreel footage, shot by the anonymous cameraman. Soldiers of the Soviet Army slogging through the shallow water and mud flats of Lake Sivash, the "Putrid Sea," in the Russian advance of 1943. During the final shots of this sequence the auteur-director's father, the poet Arseny Tarkovsky's voiceover recitation of his Whitmanesque poem "Life Life" lends a piercing sadness to these sepia image-traces of patience, fortitude, desperate fatigue, legs stiff from damp and chill, young faces looking blankly at the eye of the camera, the steady, silent,

progress forward across seemingly endless shallows. Some of the men are hauling a barge carrying wheels and guns so heavy what could ever be more unlike the floating stratosphere sequence but its the same war. *No need / To be afraid of death at seventeen / Nor yet at seventy.* Noise of water sloshing synchronized later no extraneous breathing or irrelevant sound-wave energy. *Reality and light / Exist, but neither death nor darkness.* Floating currency. All of us are on the sea-shore now. Drum roll percussion echo reverberation. *And I am one of those who haul the nets / When a shoal of immortality comes in.* Who are the oldest principal officers? *Live in the house—and the house will stand. / I will call up any century, / Go into it and build myself a house.* Almost everyone keeps walking, continually proceeding.

The next newsreel footage inserts, juxtaposed with another memory sequence, the young Leningrad blockade orphan and his evacuee companions playing in snow, date from 1945 and after. Antitank guns at night. A banner flapping and snapping. Documentarist shooting dead Nazi. A man with a crutch cowering in a makeshift bomb shelter he could nearly be weeping.

Ardmore Airforce Base
Ardmore, OKLA
Monday, April 12, 1945

Dear Bae & Bill

A little while ago I heard the terrible news about the President's death. What a blow to the world!

This has been an exciting night. There has been a thunderstorm and there were cyclones all around us. But things are quiet now and everything will be OK.

Americans exploded the first atomic bomb at Alamogordo, New Mexico, July 16, 1945 at sunrise. Heat from the blast fused the surrounding desert sand to glass.

Was the next quick newsreel sequence in *Mirror* shot shortly before 8:15 a.m., August 6, 1945? Are those young fliers in the cockpit piloting the *Enola Gay*? Are they on their mission to explode the secret uranium weapon known as Little Boy?

(A little boy who survived Hiroshima remembered the moment the bomb fell, a red dragonfly, the sound of a B-29, his brother reaching out to catch a dragonfly and a flash: "It's strange, those fragmentary scenes remain fixed in my mind like photographs.")

We could be seeing footage from a later test at Bikini Island in the Pacific; in that one some G.I.s were lethally exposed. Maybe the fireball mushroom cloud is from the plutonium one the United States army exploded over Nagasaki on August 9, 1945.

Cut. Gunfire. Flak. Roar. Smoke. Chinese political rally hands waving totalitarian saluting. Sheets of glass framing portraits of Mao. Little icon-busts of Mao. Books leaflets. Mao's little red book. His face on the cover. The Sino-Soviet split. Soviet soldiers forming a human chain to keep oriental peoples back. Some of them shove forward waving photos of Mao. A vast political outdoor ceremony somewhere probably China.

In *La Jetée* and *Mirror*, also in *Sans Soleil*, one finds images associated with, or rising from, Hiroshima. I don't think you can grasp the hauntedness in all of them without understanding this central surrender of soul, in its nuclear plight forgetting and refusing to forget.

The immense indifference of history. The crushing hold of memory's abiding present. Compared to facts words are only nets. We go on hauling in what traces of affirmation we can catch. Action is the movement of memory searching for a lost attachment a make-believe settlement. A screen is a sort of mole or sea wall. It keeps spirit back.

Thus in silence, in dreams' projections,
—Walt Whitman, "The Wound-Dresser"

124

XII

Because I know that time is always time
And place is always and only place
—T. S. Eliot, "Ash-Wednesday"

This is the epigraph to the English-language version of *Sans Soleil*, released for distribution in the United States in 1982. Documentary and experimental films have a hard time being distributed in North America. Sadly, these films seem to reach only a cosmopolitan coterie of filmmakers, artists, photographers, and film scholars. It's the same situation with experimental poetry. Books and magazines of or about non-mainstream poetry are consigned chiefly to small-press distribution networks or cooperatives, and few bookstores order them.

I thought first about writing something on documentaries about poets because I remembered the recent PBS *Voices and Visions* series, now subtitled for distribution: "A Television Course on Modern American Poetry." The series consists of thirteen one-hour video programs "presenting the life and work of major American poets." I was curious why most of them seemed so flat, though the word "major" was an alert. After watching them all again, this time taking notes, I couldn't think of anything to say. Mike Cartmell, a Canadian filmmaker, suggested I look at *Sans Soleil*. He described it as an autobiographical work about a French filmmaker with an assumed name. *Sans Soleil* wasn't about poetry; it was poetry, he said. I had just finished writing *The Birth-mark: Unsettling the Wilderness in American Literary History*. Marker collided with birth-mark, the assumed name struck home.

XIII

"So, montage is conflict." Several years ago I plucked this quotation from Eisenstein's "The Cinematographic Principle and the Ideogram" to use as an epigraph to an essay about Charles Olson's *Call Me Ishmael: A Study of Melville*. Franklin D. Roosevelt's sudden death shocked

Olson into completing the book he had been unable to pull together for years. Now he started over, cutting, juxtaposing and compressing his material in a radically new way. It was finished "before the 1st A-bomb, 1st week that August." August 6, 1945, marked a point in time after which nothing could be the same. A few months later Olson resigned his government positions (member of the Office of War Information in Washington and Director of the Foreign Nationalities Division of the Democratic National Committee). Olson's critical study of *Moby-Dick* marked his own delayed beginning as a poet.

Short cuts, mixed credits, news items, archival material, nonfictitious science, science fiction, pulp fiction, travel narratives, epigraphs, ballads, and passages from the Bible represent the delayed beginning of Herman Melville's *Moby-Dick*. First the effusive dedication to Hawthorne, next the "Etymology" and "Extracts" sections. Aside from the dedication, and possibly even there, all of these scattered particles of fact and or fable meet in the word-event *whale*.

Sans Soleil has a delayed beginning. Marker's film bares the device of its structure first. Credits, quotations, shots filmed by himself and others are spliced and surrounded with black leader. Even the title comes in three languages and colors. For a filmmaker a camera is a screen within a screen; so is a word to a poet. Shots of a Japanese temple consecrated to cats begin and end the main body of Marker's *Sunless* cycle. A couple has come to display an inscribed wooden slat in the cat cemetery in order to protect their missing cat Tora. We see rows of enigmatic porcelain cats, each with one paw raised, as if to deliver some incommunicable communication. Rituals for recovering lost or dead animals occur throughout the movie.

Herman Melville, Emily Dickinson, and Walt Whitman were all using montage before it was a word for a working method. Their writing practice (varied though it was) involved comparing and linking fragments or shots, selecting fragments for scenes, reducing multitudes

(chapters or stanzas) and shots (lines and single words) to correlate with one another, constantly interweaving traces of the past to overcome restrictions of temporal framing. The influence Whitman had on Vertov through Mayakovsky is well known. Is the Melville who wrote *Typee, Omoo, Redburn,* "The Encantadas," and "Benito Cereno," a travel writer, a beachcomber, a reporter, or a poet? *Moby-Dick* is a poetic documentary fiction on a grand scale. Often I think of Dickinson's handwritten manuscripts as "Drawings in motion. Blueprints in motion. Plans for the future. The theater of relativity of the screen." With an important difference: if kino-eye signifies, among other things, the conquest of space—"I am kino-eye, I am a mechanical eye. I, a machine, show you the world only as I can see it"—Dickinson's pen-eye aims at the conquest of mechanical reproduction. It seems after reaching the age of consent she refused to be photographed.

Seventeenth- and eighteenth-century American Puritan theologians and historians like Roger Williams, Anne Bradstreet, and Cotton Mather were obsessed with anagrams. Seventeenth-century American Puritans were iconoclasts and animists at once. Ralph Waldo Emerson, Herman Melville, Emily Dickinson, T. S. Eliot, H. D., Marianne Moore, William Carlos Williams, Wallace Stevens, Charles Olson, and John Cage are among many North American writers who inherit this feeling for letters as colliding image-objects and divine messages. "Association, so far as the word stands for an effect, is between THINGS THOUGHT OF—it is THINGS, not ideas, which are associated in the mind. We ought to talk of the association of objects, not the association of ideas"—William James. "If he [the author] make of his volume a mole whereon the waves of Silence may break it is well"—Henry David Thoreau. Needing to translate words into THINGS THOUGHT OF could be the mark of a North American poet

if marks of scattered hues in October sunsets geographically here can ever be translated into English.

Walter Benjamin was also attracted to the idea that single letters in a word or name could be rearranged to cabalistically reveal a hidden purpose. "My thinking relates to theology the way a blotter does to ink. It is soaked through with it. If one were to go by the blotter, though, nothing of what has been written would remain."[9] It's sad to read that one of the reasons given for Benjamin's suicide in 1940 was his reluctance to emigrate to the United States.

Here he didn't expect to go anywhere.

A mark is the face of a fact. A letter is naked matter breaking from form from meaning. An anagram defies linear logic. Any letter of the alphabet may contain its particular indwelling spirit. A mark is a dynamic cut. Dynamic cutting is a highly stylized form of editing. Sequences get magpied together from optical surprises, invisible but omnipresent verbal flashes, flashes of facts. A documentary work is an attempt to recapture someone something somewhere looking back. Looking back, Orpheus was the first known documentarist: Orpheus, or Lot's wife.

> *Wavering between the profit and the loss*
> *In this brief transit where the dreams cross*
> —T. S. Eliot, "Ash-Wednesday"

An epigraph is an afterthought. Usually it follows the title of a work. An epigraph is second sight. Severed from its original position, replaced at a foreign margin, the magpied quotation now suggests a theme or acts as talisman. Magpies are pied: mostly black with white patches and white tail stripes. Harbingers of ill omen, they tend to be associated with thresholds and secret ministry. In Ireland, if we saw any, my mother taught us to count quickly: "One is for sorrow, two is for joy, three for a marriage, and four for a boy." The word magpie also refers to the black

9 Walter Benjamin. "N [Re the Theory of Knowledge. Theory of Progress]," trans. Leigh Hafrey and Richard Sieburth, in *Benjamin, Philosophy, Aesthetics, History*, ed. Gary Smith (University of Chicago Press, 1989).

and white ceremonial dress of an Anglican bishop. In captivity magpies imitate human speech. An early English dictionary describes these members of the jay family as "the cleverest, the most grotesque, the most musical of crows." In 1852, *Webster's American Dictionary of the English Language* bluntly defines magpie: "a chattering bird of the crow tribe."

> *Among twenty snowy mountains,*
> *The only moving thing*
> *Was the eye of the blackbird.*
> —Wallace Stevens, "Thirteen Ways
> of Looking at a Blackbird"

People say the magpie has a spot of blood of the devil on its tongue. People who like anagrams are usually attracted to epigraphs.

XIV

L'éloignement des pays répare en quelque sorte la trop grande proximité des temps.
—Racine, *Seconde Préface à Bazajet*

Marker's epigraph to the original French version of *Sans Soleil* is lifted from Racine's second preface to *Bazajet*, one of the seventeenth-century dramatist's least-known works in English. *Bazajet* is a Turkish tragedy set in a seraglio. The magpied lines are the second part of a point Racine was making. "On peut dire que le respect que l'on a pour les héros augmente à mesure qu'ils s'éloignent de nous: *major e longinquo reverentia*." [We may say the respect that we harbor for heroes increases in proportion to their distance from us.] What Marker didn't let in or cut out contains in itself a quotation without marks lifted by Racine from the *Annals* of the Roman historian Tacitus.

For Roland Barthes the essence of the Racinian eros is sight. In both *La Jetée* and *Sans Soleil* sight is privileged. The image takes the place of the thing. Erotic scenes could be hallucinations. "I see her,

she saw me, she knows that I see her, she drops me her glance, just an angle, when it is still possible to act as though it was not addressed to me, and at the end the real glance straightforward that lasted a 24th of a second, the length of a film frame." In *La Jetée* and *Sans Soleil* as in a play by Racine, glances are the equivalents of interviews. A look can be an embrace or a wound. Even the gaze of statues.

XV

Laertes: *A document in madness: thoughts and remembrance fitted.*

The Capgras syndrome is rare. A patient believes that a person, usually closely related to her, has been replaced by an exact double. When it was first described in 1923 by Capgras and Reboul-Lachaux, they titled it *l'illusion des sosies*. In French, the term *sosie* comes from Plautus's *Amphitryon*. There the god Mercury assumes the appearance of Sosie, Amphitryon's servant, thus becoming his double.

Sans Soleil is supposed to be the autobiographical account of a traveling filmmaker named Sandor Krasna. The narrating voiceover is an anonymous woman, perhaps a film editor, a liaison officer, or a sister, remembering letters and camera footage mailed to her from faraway places by a documentarist who is or was a roving reporter. He could be an editor, collaborator, lover, teacher, student, brother, "Sandor Krasna," whatever. There is the suggestion that "he," as she always calls him (the credit list at the end supplies the name Krasna), has gone away somewhere, possibly forever. She (the credits say "Florence Delay") says what she says he wrote shows what she says he shot. We aren't sure who is real or imaginary; on the other hand, we understand him to be the cinematographer Chris Marker. Marker's filmography—*Lettre de Sibérie* (1957), *Cuba Si* (1961), *Le Joli Mai* (1962), *La Bataille des Dix Millions* (1970)—beckons his audience in the direction of cinema-verité. Chris Marker: Marxist cinematographer, always on the wing, not to be glimpsed except in flight, doesn't like to be photographed.

Marker's practice of cutting, isolating, grafting, and synthesizing music, languages, machine noises, musical synthesizers, and quotations (Marlon Brando's voice from *Apocalypse Now*) depends on invisible verbal flashes, optical surprises, and split images. Ophelia's mad song evokes Jean Simmons in Olivier's *Hamlet*, although another woman's face is singing. Here Marker introduces what looks like a solarized image. To solarize a shot you reexpose it to light, so solarizing is double exposure. We see what is happening electronically on a machine that separates the darks into lights: we see the process. This sequence recalls the editing sequence from Vertov's *The Man with the Movie Camera* (a classic nonfiction film) at the same time it begins "Krasna's" meditation on, and recollection of, a pilgrimage he made to the sites in San Francisco where Hitchcock's *Vertigo* (a classic mystery film) was shot. The fictional nonfiction filmmaker inserts footage from Hitchcock's earlier fictional movie filmed during the 1950s on location in a city (San Francisco) once almost buried under ash by earthquake and fire. One sequence or mininarrative leads by indirection into another sequence. Meanwhile the unseen narrator repairs or restores psychic reality and its relation to external reality, though we are never really certain who has collected, edited, and marked each shot or short cut.

The American-released version of *Sans Soleil* is narrated in English by Alexandra Stewart. Languages bear particular canny or uncanny acoustical patterns, historical scars. At times her narrative voiceover seems exaggerated in its accentlessness to the point where it impinges on the otherwise wonderfully varied polyphonic soundtrack. Recently I was able to see a showing of Marker's *Le Mystère Kuomiko* (1965), also filmed in Tokyo. I now notice ways in which the memory of this earlier time in Japan crops up in *Sans Soleil*, but I see the resemblance and hear the echoes belatedly. Viewers of *Vertigo*, along with Scotty (James Stewart), don't know, until three quarters of the way through the film, that Judy (Kim Novak) was impersonating Madeleine (Kim Novak). Could it be that the real Kuomiko in the cinema-verité version is a double for Hélène Chatelain (who may or may not be a professional

actress), even if she doesn't speak in the ciné-roman *La Jetée*? Where is
Kuomiko in the Tokyo of *Sans Soleil*? That's a later mystery. The Ginza
owl is here, moving his eyes as usual, the bullet train is here, right- and
left-wing radicals are here, but Kuomiko is not. The real Florence De-
lay is a French novelist, while "Florence Delay" could be here, editing
Krasna's movie. Gavin Elster edits Madeleine's story (through Judy) in
Vertigo. The absent cinematographer could be Delay's double except we
know the unseen woman is a figment of Marker's imagination. In 1965
Kuomiko is really a young Japanese woman (perhaps a professional
actress now) who speaks fluent French. Her beautiful voiceover is one of
the striking elements of the Mystery that bears her name. Kim Novak's
two voices as Madeleine and Judy are essential double effects in *Vertigo*.
Perhaps the spoken and named voices of Delay and Stewart coappear
by chance operation. My favorite sequence in *Sans Soleil* weaves in and
around the Hitchcock movie. Here, the person who claims to have seen
Vertigo nineteen times shows by subterfuge how that film's spiral of time
reoccurs in *La Jetée*. So for an English-speaking viewer of *La Jetée*, *The
Kuomiko Mystery*, and *Sans Soleil*, the ghostly presence of two women,
their trace, is in Stewart's accentless narrative voice.

Often *Sans Soleil* seems to be largely about footage shot somewhere else. This is a film of quotations, outtakes, retakes, tape delays, failed military coups, dead pilots, and ghostly warriors. Everything is acted out on the borderline that divides introjection and incorporation. A double is a facsimile. Is *Sans Soleil's* Sandor Krasna a reflected Gavin Elster?

XVI
Film–Truth

Dziga Vertov and Chris Marker are pseudonyms.

Denis Kaufman was born in 1896 in Bialystock, then a part of the Russian Empire, now a part of Poland. His father was a bookmaker and bibliophile. I can't find information on his mother. In 1915 when he was still a child he moved with his family to Moscow. In 1917 he enrolled in the Psychoneurological Institute (special interest in human perception). The same year he organized "The Laboratory of Hearing" and experimented with sound recording. He also wrote a science-fiction novel since lost. In 1917 Kaufman abandoned his name at the threshold of his working life in film.

Christian François Bouche-Villeneuve was probably born in the Paris suburb of Neuilly-sur-Seine in 1921, possibly to a Russian mother and an American father. Other possibilities for a birthplace are Ulan Bator in Mongolia, or Belville, the Arab quarter of Paris. One bibliographic entry I found says "his early life is shrouded in mystery, much of it perpetrated by the filmmaker himself." During World War II he may have served as a resistance fighter during the occupation of France, some accounts claim he also joined the United States Army as a parachutist—he says he didn't. After the war Marker played music in bars until joining the staff of *Esprit*. He contributed poetry, political commentary, music criticism, short stories, and film essays to the influential Marxist-oriented Catholic journal. He also wrote a wartime aviation novel that has been compared to Saint-Exupéry's *Vol de Nuit* and *Pilote de Guerre*. Marker was founder, editor, and writer of the Planet series of travelogues for Editions de Seuil, which blended impressionistic

journalism and still photography. Marker turned to documentary film-making in the 1950s.

These are only some facts.

Somewhere else I read his surname may simply be a reference to magic markers, because they highlight or mark a text at the same time you can see through it.

Sans Soleil could be a rejection of the documentary form. But what about Japan, Amilcar Cabral, and the historical context? A recent flier for a Marker retrospective at the Museum of Modern Art in New York says he discarded his baptismal name to assume the pseudonym bestowed by his friend and coworker Alain Resnais. In France a filmmaker named Christian François Bouche-Villeneuve would not be foreign, he would be French. In America a person named Chris Marker could be from any place.

The German Anschluss of Austria occurred in 1938. In 1938 Japanese and Soviet forces fought in the Far East, the Munich Conference divided up Czechoslovakia, and the Japanese announced a "New Order in East Asia." In 1938 Dziga Vertov made an entry in his notebook. "You cannot describe a house on fire until the actual event takes place. Perhaps there will be no fire. Either you'll have to deny the description as a fiction, or burn the house in accordance with the script. Then, however, it will no longer be a newsreel, but the ordinary acted film with sets and actors." In 1938, Bouche-Villeneuve, then seventeen, probably hadn't even thought about changing his name. Nothing is accidental. Murder is a cipher in the word "Marker."

XVII

"The first image he told me about was of three children on a road in Iceland in 1965." She remembers into the black.

The image we see is of what she says he shot or saw. It doesn't matter who is the author. The image is one of the loveliest I ever remember

seeing on film. I can't say why it is so haunting, only that silence has something to do with it. Three children are moving in color but there isn't any soundtrack now. They are blonde and the sun lights their hair from behind. Wind blowing their hair is all. The woman's hair in *La Jetée* is blown by the wind. Two of the children here are definitely girls, the other could be a boy, I'm not sure. The tallest, in the center, gives a shy, quick, furtive look toward the cameraman. All three are moving forward hand in hand, and they seem to be laughing. They could be playing a game, or they could be leading the tall one along to show her something. It's not clear who is leading who following. Just as it's not clear in *La Jetée* if the woman's smile is welcoming or warning. Silence and green fields that resemble ones I remember in Ireland. Salt air of the sea. A lyric fragment cut away. Simply peace and no evidence. They are spirits.

For Vertov, Tarkovsky, and Marker, an image introduced once as a hint or possible symbol may in another context contradict its intended leitmotif. The moment of looking is an arrest.

A minute is a minute a second front. *"One day I'll have to put it alone at the beginning of a film at the end of a long piece of black leader. If they don't see happiness at least they'll see the black leader."*

XVIII

1929. *The Man with the Movie Camera*. A dynamic tension of citizens moving forward somewhere in a large Soviet city I take to be Moscow, although it's really synthesized from Moscow, Kiev, and Odessa. The material production of life itself in a stranger stasis of silence. These trains and trolleys so flush with smoke and passengers; this young woman waking up, washing herself in her room, pulling up her stockings, fastening her bra. Silence makes it like a dream. Blinking eyes and blinking shutters. The other young woman so poor (in spite of Socialism) she has spent the night on a park bench vagrant and shy. Did physical fitness make that group of women exercising on a concrete platform happy? Did the magician juggling hoops and prestidigitating a mouse ever pass his tricks on to someone else? What are those child spectators in the audience laughing and looking at? Surely not their sure obliteration accelerated second by second. A train moves in from the background it fills the screen. Dark shapes of people then apparitions soon. Silent recesses as if they haven't been leveled already by hard usage by coordinating retrospect.

If a trace is the insertion of words in time, this time what *is* is the wordless acceleration of formal development combined with buoyant enthusiasm.

Disaster is coming; they can't see nor know what we know now.

1982. Dziga Vertov's *The Man with the Movie Camera* is iconoclastic, revolutionary, tectonic, alert. Chris Marker is a man with a movie camera traveling in the wake of World War II. In *Sans Soleil* we sense the failure of revolutionary enthusiasm. "Poetry is born of insecurity," says Marker's voiceover persona, referring to the Japanese habit of living for appearance.

XIX

The off-screen person speaking and writing through her voice. Three children holding hands. A woman's hand touching the railing of a ferry. Other fragments of sound without words through thought mirror the military instructor's beating heart without having to translate an author's creative stockpile from past to present. "I'm just back from Hokkaido, the northern island." Now we know he means Japan. Passengers are sleeping on the benches of the ferry. Shots of their arms thrown over their faces in sleep. They could be dead and wounded. Sight of so many sleeping so randomly drifting. He thinks *"of a past or future war. Night trains air raids fallout shelters."*

The title of *Sans Soleil* comes after the first three images. The next is of a foghorn on the side of a ferry going somewhere. It is almost sunless. No narration. The sound of the ship's engine resembles the noise of a heart beating. A heart is an engine. When your heart stops there is nothing. No color no sun no sound no time. The entrance of the Ghost in Olivier's *Hamlet* is marked by a heartbeat sound effect suggesting a drumbeat. Now as then it's dawn. We see a shot of a woman's hand resting on the rail of the ferry. She has a watch on her wrist, her other hand touches the railing lightly. She appears to be talking to someone and turns in his direction. The direction is the same one the ship is moving in, toward the right-hand frame of the film. The children of the introduction were walking the opposite way.

Something at the margin between thought and sound is somewhere else. The message arrives as a departure. All thoughts are winged. *La Jetée* forms a sound within sound that is other than jetty. *Sans Soleil* says one thing, "Sunless" means the same but not exactly.

So many hyphens and parentheses surround him.

That road and that place. Restructuring quickening joy to light through editing until destiny reverses division. Human beauty and human clarity carry the force of a reproach. Short cut and black leader. Mili-

tary aircraft under the deck of a destroyer. Ethics or aesthetic contrast. Writing is a cutting from inside to paper. Nonfiction footage conveys the world outside. Military background imagery. Too bad for the children.

Another nonfiction attempt at realism.

Ophelia: They say the owl was a baker's daughter. Lord, we know what we are, but know not what we may be.

All people captured on film are ghosts. They appear and do not appear. "Be thou, Spirit fierce, / My spirit! Be thou me, impetuous one! / Drive my dead thoughts over the universe" Shelley wrote in "Ode to the West Wind." Emerson, in the essay called "Language," says we are like travelers using the cinders of a volcano to roast their eggs. The woman is reading Marker's written multiple-changeover commentary with practiced utterance. Words are the symbols of spirits. The deer and the dear run away.

After the Third War was there resistance? What happens in current revolutionary institutions when films and tapes rot?

Ivan has gone to reconnoiter in the "dead, flooded forest." Mother of dreams come cover your son's staring photograph.

invisible colliding phenomena.

I entered crazily into the spectacle into the image taking in my arms what is
ing to die as Nietzsche did when on January 23, 1889
anagram and each splitting element
I entered crazily into the spectacle into the image taking in my arms what is is
going to die as Nietzsche did when on January 23, 1889
The obscurity of what I felt you felt
There may be a number of messages in
There may be a number of messages in
I entered crazily into the spectacle into the image taking in my arms what i
going to die as Nietzsche did when on January 23, 1889
painting. Nevertheless, I love the view
The obscurity of what I felt you felt

The reality of chance. A choice of masks. Political leadership wasn't always an appropriate focus for analysis. Amilcar Cabral approached life dialectically. In his absence he is far from clear. There is a vast literature even during the armed phase.

The poverty of reality in a world market. Viewpoint web-camera equipment.

Editing historical necessity at a periphery.

Blank the crack and mark no language or predator camera can recover. Remember.

1994. *Facsimile*

The village of Pavlovskoe near Moscow. A screening. The small place is filled with peasant men and women and workers from a nearby factory. *Kinopravda* is being shown, without musical accompaniment. The noise of the projector can be heard. On the screen a train speeds past. A young girl appears, walking straight toward the camera. Suddenly a scream is heard in the hall. A woman runs toward the girl on the screen. She's weeping, with her arms stretched out before her. She calls the girl by name. But the girl disappears. On the screen the train rushes by once more. The lights are turned on in the hall. The woman is carried out unconscious. "What's going on?" a worker-correspondent asks. One of the viewers answers: "It's kino-eye. They filmed the girl while she was still alive. Not long ago she fell ill and died. The woman running toward the screen was her mother"

—Dziga Vertov

Refused mourning or melancholia here is the camera the film the projector.

1996

Frame Structures

THE SECOND OLDEST VIEW OF BUFFALO.

PUBLISHED IN PHILADELPHIA, 1845, FROM AN ORIGINAL SKETCH BY LT. JESSE D. ELLIOTT, ACCOMPANYING HIS REPORT TO THE
SECRETARY OF THE NAVY ON THE CAPTURE OF THE DETROIT AND CALEDONIA, DATED BLACK ROCK, OCT. 9, 1812.

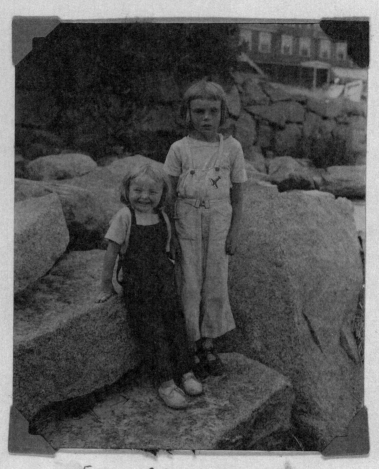

Fanny Sukey circa 1945 ?

Flanders

On Sunday, December 7, 1941, I went with my father to the zoo in Delaware Park even now so many years after there is always for me the fact of this treasured memory of togetherness before he enlisted in the army and went away to Europe. On that Sunday in Buffalo the usually docile polar bears roved restlessly back and forth around the simulated rocks caves and waterfall designed to keep brute force fenced off even by menace of embrace so many zoo animals are accounted fierce. I recall there were three though I could be wrong because I was a deep and nervous child with the north wind of the fairy story ringing in my ears as well as direct perception. Three bears running around rocks as if to show how modern rationalism springs from barbarism and with such noise to call out boldly boldly ventured is half won. Three bears splashing each other and others gathered at the iron railing as though we hadn't been enjoying liberty its checks and balances. Daddy held on tightly to my hand because animals do communicate in a state resembling dissociation so a prepared people will rid the settlement of ice deities identified with rivers they cause animism. Everyone talking of war in those days. Enough to weigh against love. Animals sense something about ruin I think he said our human spirits being partly immaterial at that prefigured time though we didn't know then how free will carries us past to be distance waiting for another meeting a true relation.

Historical imagination gathers in the missing

Primitive Notions I

John Adams comes in second.

After his appointment as President of the Continental Board of War and Ordance, the constitutional lawyer helped Thomas Jefferson and Benjamin Franklin to draft a Declaration of Independence in the service of liberty and equality. His not being able to see why no one who is not an owner can be recognized by law to be a possessor

a parent figure scattered among others in favor of disobedience. "Well goodbye and don't forget me."

In 1779 Adams was chosen as minister plenipotentiary for negotiating a treaty of peace and another treaty of commerce with Great Britain. He remained in Europe for several years with his two sons, John Quincy and Charles, for company. Abigail Adams was left behind in Braintree, Massachusetts, with their daughter Nabby, and youngest son Thomas. Most of the absent statesman's business abroad was divided between London and Paris though Adams also spent some months in the Netherlands where he had been authorized to conduct similar diplomatic arrangements. After months of negotiations, memorials, categorical answers, ceremonial visits, "innumerable vexations," travels between cities and provinces, even an illness so severe he lay in a coma for five days, his Dutch mission succeeded remarkably well. On February 26, 1782, the Provincial states of Friesland voted to instruct their deputies in the States General to recognize the United States as an independent government. On March 28, the other states of Holland followed suit. On April 19, the States General of the United Netherlands resolved "that Mr. Adams shall be admitted and acknowledged in Quality of Envoy of the United States of North America to their High Mightinesses, as he is admitted and acknowledged by the present." In September 1782, the Dutch treaty was formally approved, signed, and sealed, along with a treaty of amity and commerce. "My loan," Adams wrote in relation to the commerce part, "is considered not only as a new one but as entering deep into the essence of all the present political systems of the world, and no man dares engage in it, until it is clearly determined what characters are to bear rule and what system is to prevail in this country."

A flow of capital from the Netherlands across the Atlantic Ocean follows.

Bailment

In 1792 a group of wealthy gentlemen, members of six Dutch banking houses based in Amsterdam, pooled their money to found a real estate consortium known as the Holland Land Company. Five commissioners, Wilhelm Willink, Nicolaas Van Staphorst, Christiaan Van

Eeghen, Hendrick Vollenhoven, and R. J. Schimmelpennick, under the directorship of Stadnitski and Son, represented the six houses. Together they agreed to purchase huge undeveloped tracts, then referred to as "wild lands," in the central and western parts of New York and Pennsylvania as a business speculation. While the consortium pledged their reputation, through sales of stock in American securities, to Dutch citizens at home for the recovery of capital with the largest attainable profit possible, a smaller Club of Three (Van Eeghen, Ten Cate, and Vollenhoven) managed land ventures abroad. Their plan was to sell the wild lands to multitudes of German, Scottish, and Irish settlers, many of them poor and desperate, who were also rushing, under nobody's auspices, crossing from one field of force to another field of force.

In relation to relief not to be treated as hollow and a negative.

How many Netherlanders actually bought these shares? The records are scant. Most remained bracketed with the original purchasers, or their heirs. Other more general Holland Land Company manuscripts have been carefully preserved here and in Amsterdam. Eventually the Company acquired and surveyed five and a half million acres in central and western New York and Pennsylvania. The Dutch gentlemen bankers, now absentee landlords, left the management of these vast back country tracts in the hands of a few carefully selected agents responsible for surveying the holdings, then selling them at retail, often on credit, to settlers. Theophile Cazenove, a Dutch entrepreneurial protégé of Sadnitski, was sent across the ocean bearing letters of introduction to various well-heeled American gentlemen bankers, among them Andrew Craigie in New York. Other special agents followed, including Paul Busti, an Italian resident of Holland and brother-in-law of Vollenhoven's banking partner. Even before the American Revolution proprietors of early settlement were buying backlands to hold for a rise in value.

Federalism: its breadth and all-embracing perspective. Lines represent the limits of bodies encompassed by the eye.

Floating loans

Joseph Ellicott, sometimes called "the father of Buffalo," was born in Bucks County, Pennsylvania, in 1760 to Quaker parents from England. The Holland Land Company tested him first as an explorer in the East Allegheny region. Next they had him surveying lands around the Genesee River until in 1800 he was appointed by Paul Busti to serve as agent for the Dutch in the Genesee for six years. Two years later Ellicott's agency was increased to include all Dutch holdings in western New York. By the summer of 1802, largely due to this surveyor's aggressively acquisitive talents, the western portion of New York State was set off as an independent county. Between civil and criminal dollar windfalls the life of common law is experience. For the next twenty-one years, often heroically improvising, Ellicott as company surveyor and resident subagent controlled land sales, tenant relations, the location of counties, towns, villages, and political negotiations with the state legislature. Until his forced retirement in 1821 he wielded immense political influence over thousands of settlers many of them debtors. I learned about him from out-of-print records and journals published by local antiquarian societies.

Land speculators, surveyors, promoters, publicists, and primitive judges were extraordinarily free in terms of strategic flight into the wilderness. If one sticks to the letter, now where are their names indexed? The only detailed study focused on the ground, the base, the frame, of prevailing social and economic systems in the backlands of western Pennsylvania and upper western New York State during the heady days of the early Republic, I have been able to find this summer, is *The Holland Land Company*, by Paul Demund Evans, published by the Buffalo Historical Society in 1924. Evans's book went out of print long ago but it's still in the stacks of the Sterling Memorial Library. According to the recall card on the back jacket *The Holland Land Company* has been taken out four times since 1977 in spite of the flowering of New Historicism.

In most towns in New York State there were no hearses until around 1830. The dead were borne on a shoulder bier sometimes for many miles.

Members of the funeral procession carried staffs, halberts, badges of authority while they walked to the accompaniment of a tolling bell to the grave. Theophile Cazenove, Paul Busti, Robert Morris, Jan Linklaen, Gerrit Boon, David A. Ogden, Judge Wilson, Joseph Ellicott, and the problem of distance.

I was never sure what my father was doing in the army. Then I was never sure of anything what with his rushing away our changing cities and World War banging at windows the boundless phenomena of madness. I remember him coming back to Buffalo from basic training by snapshot once or twice in a uniform. Absence is always present in a picture in its right relation. There is a split then how to act. Laws are relations among individuals.

When Theophile Cazenove reached America in 1789, he realized that Philadelphia was the best scene for his operations because the future of American funds, federal and state, depended on the actions of the federal government. Pavements were in wider space and getting social satisfaction he carried along a letter of introduction from his backers in Amsterdam to Andrew Craigie in New York. The Van Staphorts told Craigie their envoy came to America "to gratify his thirst after knowledge in order to become better acquainted with the Genius of their Government and the objects of their growing commerce."

In the cold drama of moral lucidity there is primitive reason just as in the calm dicta of moral lucidity there is personal reason.

Women and children experience war and its nightmare. Their wardreams share with dreams of other kinds that they are occurrences full of blown sand seaward foam in which disappearance fields expression. If fire drives out fire so does pity pity beside

variant unabridged bits, mortal and menacing, anything but pliable and apart.

Clouds must have come under the western edge of the old suspension bridge. Debris thrown down during construction has nearly filled the intervening ever-flowing current

architecture of paved distances prolonged into the sealed cars speeding along Scajaquada Creek Expressway to the suburbs.

Craigie Circle

In 1942 my mother, younger sister Fanny, and I left Buffalo to live in Cambridge, Massachusetts, so we would be close to her aunt and uncle who lived near Harvard Square, and to my father's sister and father in Boston. We moved into a ground floor apartment at 6 Craigie Circle. Craigie Circle is a small dead-end road where Craigie and Berkeley streets intersect near Huron Avenue. Huron refers either to an Indian tribe or to the second largest of the Great Lakes the one just north of Lake Erie or to both at once. Berkeley is named for the Anglo-Irish bishop and philosopher author of *Principles of Human Knowledge* among many other works and Craigie for Andrew Craigie whose activities as Apothecary-General of the Revolutionary Army and other speculations made him rich for a time. Probably Andrew was Cazenove's New York contact and even if Craigie was another Andrew coincidence produces an optical ghost or guess so here he is now. After the revolution, Vassall House (the largest mansion on Tory Row) built in 1759 by John Vassall, a Loyalist who returned to England during the Revolution, was renamed Craigie when Mr. and Mrs. Craigie acquired it. Tory Row (previously the King's Highway) became Brattle Street. The banker died bankrupt but his widow, Elizabeth Nancy Shaw Craigie from Nantucket (now bald but wearing a turban and perpetually studying Spinoza), managed to hang on to her home. Some Vassalls are buried in Cambridge churchyard under a stone inscribed with picture-writing ((a goblet and a sun)) (((Vas-sol)))). Mrs. Craigie supported herself by letting rooms. In 1837 when Henry Wadsworth Longfellow, the newly appointed Smith Professor of French and Spanish at Harvard College, became one of her lodgers, he rented the room once occupied by George

Washington (another parent figure) at the beginning of the Revolution when he planned and commanded the siege of Boston. Longfellow was an early pioneer in establishing modern languages as a discipline in American education but whatever contribution the poet-professor made to anything had been relegated to minor (even laughingstock) status by contemporary critical theorists of both Cambridges during the 1930s and 1940s. When I. A. Richards (affectionately called I.A.R. by initiates in reference to *Coleridge* ((S.T.C.)) *on Imagination*) whose early managerial replotting of the literary ground plan in *Principles of Literary Criticism* (1924), *Practical Criticism: A Study of Literary Judgment* (1929), and currently *Basic English and its Use* (1943), sagely observed, "few things are worse than *Hiawatha* or *The Black Cat*, *Lorna Doone*, or *Le Crime de Sylvestre Bonnard*," and used "In the Churchyard at Cambridge" ("a stock exercise in provincial sanctimony") as graphic illustration of an extremely bad poem in the pages of *Practical Criticism*; it was all over for the first author on I.A.R.'s proscribed list for the time being. The waters of the Atlantic closed over the Wreck of the Hesperus. Once, after quoting the French proverb, "it is not enough to be a great man—you must also come at the right time," Longfellow is said to have paused before adding, "this is particularly true of authors."

"Between the dark and the daylight / When the night is beginning to lower, / Comes a pause in the day's occupations / That is known as the Children's Hour." During the 1940s in what seemed to be a running gag at faculty gatherings "children's" became "cocktail" as if the mere word-change brought all adults involved in the machinery of aesthetic distinctions happily together in order to exchange signals somehow beyond our apprehension the implication being children of modernists were perfectly free to get lost at six.

"Daddy loved animals more than people," is still a family saying. In 1945, after he came back from the war, we had two dachshunds because he couldn't bear to be without a dog. The first one Waddy, short for Wadsworth Longfellow, marked the correspondence between waddling and

poetry. Waddy was followed by Minny, short for Minnehaha Laughing Water, because she peed everywhere and we couldn't train her; uncontrollable literary production encompassed unsuccessful bowel training. Even if the real Minnehaha does almost nothing in *The Song of Hiawatha* the poem itself has inspired more parodies than any other in the English language.

In 1843, when Longfellow married Frances Elizabeth Appleton, her father, a wealthy Boston industrialist, bought Craigie House and eight acres of meadow adjoining it for the couple. In 1943 the meadows were almost all houses or paved over because privacy depends on a one-sided way. Craigie House renamed Longfellow hadn't been ideally rearranged as a museum it was only half over. Henry Longfellow Dana was living in one part of the house, with a lover, while Charles and Helen Hopkinson (also Longfellow descendants) often occupied the other. A caretaker (the position traditionally went to a poet or a Divinity School student) lived in the attic. Sometimes the three of us had Sunday dinner with the Hopkinsons usually after accompanying Aunt Muriel (referred to by children on her block as "the witch," she had been one of the first women to earn a degree from Trinity College, Dublin) and vague Arthur Darby Nock (bachelor scholar of ancient history known for standing on his head naked in his rooms at Eliot House; when he died he requested that he be buried at Aunt Muriel's feet so they remain close in Mount Auburn Cemetery) to hear Uncle Willy deliver his weekly sermon at Harvard's Memorial Chapel. (Her name was Muriel Bennett when she met Willard Sperry at Oxford where he was a Rhodes scholar. They married and moved to Fall River, Massachusetts, where he became a Congregational minister. Fall River was horribly dull except for Lizzie Borden a neighbor they remembered peering into their daughter Henrietta's pram. Thankfully they left Fall River quickly because he became Dean of the Harvard Theological School and moved to Cambridge where my mother came to visit them and met my father before the war.) When such Sundays loomed into view Fanny and I sat at the front of Memorial Chapel beside the great person of great-aunt

Muriel. She tried every covert trick in her book to make us laugh out loud while great-uncle Willy wrapped in his great black robe was going on about something holy oh she was serious in regard to us and all the people listening. Later we might sit in the dining room of Longfellow House eating lunch on one side of a roped-off area while the resident poet-caretaker guided sightseers single-file along the other side of the barrier pointing out ornaments, furnishings, portraits, structural details; as if we were ghosts. If private space is the space of private writing, objects must be arranged in position (witnesses and vanishing points) not looking both ways at once. Something about nature "nice" children good manners in architecture. Space is a frame we map ourselves in.

When B. F. Skinner asks, "Why write sonnets rather than maxims, aphorisms, letters, or short essays? What is to be gained from dancing in chains?" the father of American Behaviorism is referring to Shakespeare's sonnet 129 and I. A. Richards's "Jakobson's Shakespeare: the Subliminal Structures of a Sonnet," at once. I found Skinner's essay published in *I. A. Richards: Essays in his Honor.* "The linguist's 'deep structure,' like Freud's 'depth psychology,' is a spatial metaphor which serves several functions. It is useful in referring to the visibility of behavioral processes and their effects and the role played by visibility in the determination of behavior; it should not, of course, be used to suggest that an analysis is profound rather than superficial." This section of the behaviorial psychologist's conclusion is enclosed in parentheses. A footnote says the paper's preparation was funded by a Career Award from the National Institutes of Mental Health. Fanny remembers her fear of open spaces between Berkeley and Huron because somewhere close to us the Skinners' daughters were being brought up in boxes. When the boxes called air-cribs were put outside for air she thought she saw internal objects. I must have blocked them out.

Between Berkeley Street and Brattle some meticulous gardens still remained among lawns abandoned to children some even wilder patches of weed and brush. In those early days language was always

changing. Faded words fell like dead leaves in a closed circle moving toward the mind but we didn't know we were born because deep down there is no history. Boundaries interlinking public and private are very well, precaution and policy, thought is arranged over this, the property of *h* (breath without sound) comes between *g* and *t* (sound without breath) in daughter slaughter laughter. Letters launched into space rush one child to the next, more or less at large, acting wolves and tigers, colliding with landowners (by subterfuge). By controlled experiment B(urrhus), F(rederic) Skinner proved pigeons could play Ping-Pong. Not behaving. Not earning a living. Not to be afraid of everything passing those buildings; the obstinate repetition of doors and windows. No, there were footpaths we used as shortcuts going from home to school and home again. "This is the forest primeval. The murmuring pines and the hemlocks, / Bearded with moss, and in garments green, indistinct in the twilight," half-forgotten neighboring backlands recover breaks and zigzags, ranges of feeling, little maneuvers in distance perception. "Where is the thatch-roofed village, the home of Acadian farmers,—"

Berkeley, Brattle, Craigie, Buckingham, Huron; it was Nathaniel Hawthorne who passed on the Acadian story of feminine faithfulness and wandering that became *Evangeline,* he heard it from a friend who heard it from Mrs. George Haliburton, a French Canadian deported from Nova Scotia, along with three thousand fellow Acadians, in 1755. Mrs. Haliburton was living in exile in Boston when she told the story. *Evangeline* is the first long poem in North American literature inspired by New World themes, stories, and history to live beyond the time frame of its composition. "Who except wretched schoolchildren now reads Longfellow?" asks Ludwig Lewisohn in *Expression in America,* as if rapid reading is really divination. Evangeline, daughter of Acadie, a kindred spirit of Saint Eulalie patroness of landless sailors, loses her lover Gabriel during the prevailing disorder the tumult and stir of embarking.

"Eveline! Evvy!"
"I am writing a series of epiclets—ten—for a paper ... I call the series *Dubliners* to betray the soul of that hemiplegia or paralysis which

many consider a city." "Eveline" is the fourth story in *Dubliners* though James Joyce wrote it second after he finished writing "The Sisters" and met Nora Barnacle in 1904. Eveline's lover Frank is a sailor, he will rescue her from home; they will be exiles together and live in Argentina. "Come!—" he calls to her. All the seas of the world tumble about Eveline's heart she cannot or will not leave home because of a promise to her dead mother. He rushes beyond the barrier and calls her to follow. Systems preserve and nurse their traditions. "So unto separate ships were Basil and Gabriel carried. / While in despair on the shore Evangeline stood with her father." My mother, Mary Manning, was born in Dublin, in 1905. When she was a child her father was almost always living in another country and his father before him.

"—Derevaun Seraun! Derevaun Seraun!"

Nigeria was named for the Royal Niger Company, a private organization established to meet the requirements of British trade along Africa's third largest river during the European "scramble for Africa" of the 1880s. In 1900 French, German, and English possessions in that part of West Africa were demarcated after much quarreling. Ensuing complications (wars with various Muslim rulers in the interior, disputes on the western frontier with France) were finally too much for the resources of a private company to handle. The word "royal" was dropped and the company surrendered its charter, transferring all political rights to the crown. Irony is saying one thing while meaning another. Nigeria became another British "protectorate."

Fitzmaurice Manning (1871–1920) was Anglo-Irish and a younger son. In the schema of colonialism he didn't have many career options neither did his father a colonel in the British army who first served at Halifax in Nova Scotia and later at the British army camp in the Curragh, County Kildare. His father also died young, leaving a shabby genteel widow with several shabby genteel children. In 1885 the European powers partioned what land was still theoretically unclaimed in the African continent. The British occupation of Nigeria began in earnest in 1897. Trained as a doctor my grandfather was one of those members of the

Colonial Service assigned "to open the country for civilized occupation." I still have his copy of Swinburne's poems. He has signed his name on the flyleaf inside: "F. Manning, Lagos. 1897." In 1903 the capital city of Kano, a walled fortified town then under the control of a Muslim sultan, was defeated by a British assault. I think that's where he worked most of the time. My grandmother went on several visits to see him there though she never took the children; sickness, mortality and the heat. In a sepia photograph the couple are standing in a field in front of the hospital at Kano. It's a long building like ones in *The African Queen* and various other fiction films. Seen at a distance their expressions are hard to determine. Both wear wide-brimmed sunhats. He is tall, very thin, and somewhat stooped. But he has a way of standing with one knee bent and his right foot turned in just the way my mother and I stand sometimes. Once every two years he came home to Dublin on leave for six months. My mother says her mother loved another man anyway but he was a Catholic so Susan Bennett married Protestant Fitzmaurice Manning on the rebound. When she died in her eighties the other man's picture was beside her bed. If this is true I wonder if anyone has paid attention to the many marginal markings in *Swinburne,* the only book of his I have seen over here. "Yea, hope at highest and all her fruit, / And time at fullest and all his dower, / I had given you surely, and life to boot, / Were we once made one for a single hour. / But now, you are twain, you are cloven apart, / Flesh of his flesh, but heart of my heart; / And deep in one is the bitter root, / And sweet for one is the lifelong flower." He has underlined "flesh" "flesh" and "heart of my heart" and drawn a pencil slash down the right hand margin of this stanza from "The Triumph of Time." Their marriage produced two daughters and a son. Irrelevant, eccentric, cross; when he did come home he drank and was bad tempered so they didn't miss him when he left again. Leaving leaving arriving arriving. Even a civilized person will kick a door whatever the policy if modernity surrounds every threshold point of contact. She remembers one summer he was home and they were all together visiting Fitzmaurice relations in Kerry. Three telegrams were delivered by donkey cart. Her father and his two brothers packed and left immediately. It was August, 1914.

"NIGERIA, A British protectorate in West Africa occupying the lower basin of the Niger and the country between that river and Lake Chad, including the Fula empire (*i.e.* the Hausa States) and the greater part of Bornu. It embraces most of the territory in the square formed by the meridians of 3° and 14° E. and the parallels of 4° and 14° N., and has an area of about 338,000 sq. m. The protectorate is bounded W., N. and N.E. by French possessions (Dahomey, Upper Senegal and Niger colony, and Chad territory), S.E. by the German colony of Cameroon and S. by the Atlantic." This is how volume XIX MUN to ODDFEL-LOWS of the eleventh edition of the *Encyclopaedia Britannica* puts it three years before uncontrollable modernity before the whole world goes wild.

"NIGER, a great river of West Africa, inferior only to the Congo and Nile among the rivers of the continent, and the only river in Africa which, by means of its tributary the Benue, affords a waterway uninterrupted by rapids, and available for shallow-draught steamers to the far interior. NIAGARA, a river of North America, running northward from Lake Erie to Lake Ontario, and carrying the discharge of all the Laurentian or Great Lakes, except Lake Ontario."

Clans and individuals adopt the name of animals cities seldom do. Prefaces are usually afterimages.

Lackawanna could be be considered the offshoot of an instinct for preservation because orders from European countries for steel products during the First World War turned what had been a company steel town or labor camp consisting of Poles, Russians, Hungarians, Italians, Bulgarians, Spaniards, and Arabs into a sub-city of Buffalo named for a company. Most of the steelworkers were from Eastern Europe. They poured in hoping to go home sometime. A crowd of fifty thousand people jammed the meadow in Delaware Park, after Woodrow Wilson's declaration of war on April 2, 1917, because three thousand local conscripts were bound the other way. To say goodbye

During the 1850s when the Niagara's water power was harnessed and the city's position between action and desire guaranteed its preeminence as the major inland port in the United States, Buffalo was a rail center and highway crossroads for hauling tonnages of grain, limestone, coal, iron, ore, lumber, petroleum, and railroad cars all over the place. Many materials of everyday life were made of iron in Buffalo. In 1851 the first rail line, operated by the Delaware, Lackawanna and Western Railroad Company, linked Buffalo with the coal fields of the southern tier of the state and three years after this the Buffalo and Pittsburgh Railroad connected to the coal fields of western Pennsylvania so the iron trade really took off. Soon comes electricity and the Great National Exchange. Wars have also been good for the city. In *High Hopes: The Rise and Decline of Buffalo, New York*, Mark Goodman shows how the Civil War strengthened commerce thus giving birth to industry while the Spanish-American War inspired patriotic fervor thus giving birth to the Pan American Exposition of 1901 where displays of electricity, particularly the Electric Tower, attracted thousands of summer visitors and President McKinley was assassinated by an anarchist. The assassin, Leon Czolgosz, told police the words of Emma Goldman set him on fire.

I knew the story of Fanny Appleton Longfellow's death by fire, on the 4th of July, 1861, because of a little blue parasol in my American grandfather's apartment. She had taken it along to shade her face from the sun when she went out to Quincy earlier the same summer to visit my great-grandparents. They kept her sunshade as a memento. Eventually it came to my grandmother Fanny Quincy, maybe because of her name. When she died young, Grandpa took it with him to Louisburg Square. Mary Elizabeth Manning Howe Adams passed along Francis Elizabeth Appleton Longfellow's faded and tattered sunshade to the National Park Service in 1995. The Park Service manages the Longfellow House now it is a museum.

Independence Day. She is sitting near an open window in the family library. There is a meadow outside where her children often play. It's midsummer they are probably around somewhere. She has cut small locks of hair from her two younger daughters is using sealing wax to close these souvenirs of love in boxes. Two doctrines materialism and spiritualism. The objects which surround my body those which are near to my body frame a simple idea of time. As shadows wait on the sun so a shot soul falling shot leaves its body fathomless to draw it out. The armies are tired of their terrible mismanagement not counting the missing. Envelopes and boxes are often metaphorically linked with motherly contrivance. Domesticity is in her hands so of course these are arranged; picked for her children's children to touch and be touched. Quickly quickly it has all been too easy. Wisdom is a defense and money is a defense. Knowledge knowledge to the last grain of economic innocence. Will you come back so far to show us the cost? You ask if the universe only exists in thought, creative and subtle? Flame is not impalpable. She is using a lighted match to melt the wax has already begun to recover the refuse. Don't you remember the essence of English idealism? The wax is here just so things *are*.

A spark from a match maybe hot wax ignites her flowing muslin summer dress. Her husband, sleeping in his study nearby, his custom always, hears short phrases not words. Compare the phenomenon of sleeping with the phenomenon of burning. I suppose him a great distance off in pastures detached from memory. Enveloped in flame she runs into vision a succession of static images a single unbroken movement under her breath "dead woman" she bats at wing strokes. Arcadia Accadia L'Acadie sea birds clang. Why can't he see that the loved object will perish? Well we don't see dark spaces between film frames, why, because of persistence of vision. God's sun-clothed bride wades backward white petticoat tabernacle body as in a dream I perceive distance a great way off. She grips him. Print your symptoms of melancholia on a sheet of paper in a singsong manner now get better. He tries. Tries to

smother the flames by wrapping her in any near cloth object such as a mat or rug. Fire badly burns his face and hands but he would rather be burned than buried. Long ago open fireplaces invited guests to enjoy the warmth of huge wood fires; candles and primitive lamps provided some escape from the immediacy of lived experience. Stricken out of the cloud-folds of her garment shaken she suffers intensely for a short time then gets put to sleep with ether so she wakes up briefly, calm and free of pain. Edenic mapping of the New World Acadie. Softly softly hear the noise of distant falls of many wars and wars for national independence.

In 1920 my Irish grandfather was discharged from the British Colonial Service and came home to Ireland for good: "disabled from war wounds" is how my mother puts it but World War I was over and the few other people who know anything about him say "alcoholism." When he died in Dublin after a short illness or something else he was forty-nine. The children were sent away during this illness or whatever it was. The surface of life closed over his impecunious unutterable case; so the effect is secrecy though not in the sense of a crime. I wish I knew him as an adequate over-the-sea relation but I only imagine distancing maneuvers. In one torn photograph he is standing alone wearing a heavy overcoat in the back garden at 35 Wellington Place. It's a haggard profile shot. Sometimes my ninety-year-old mother lives over her life as if I were the other Susan Manning. Sometimes her father comes close and close. So there are two images. Two phases of thought many miles apart. She remembers a few wood carvings he brought home with him their strangeness. Fragmentary deities indwelling spirits of the dead, wraiths, a mask in one piece, soft wood black-red ocher white coating, eyelets pierced in the wood, another ancestor ritual figure, oak blackened by fire; she says when everything was still to come he wanted to be in the arts he was just miscast. She has kept a few of his early pencil sketches as if pieces of tenderness chipped off by a hair's breadth.

I hope you cleared the threshold, lived on into it, to yourself.

When we lived on Craigie Circle, Mary Manning (Howe) was already the Irish author of three plays, *Youth's the Season?*, *Storm Over Wicklow*, and *Happy Families*. In Buffalo she wrote a novel called *Mount Venus*. She was also the drama director for both the Idler Club at Radcliffe College, then a place for the daughters of educated men, and the Harvard Dramatic Club, because their regular director, a man, was overseas in the fighting. I can't remember the first play she directed but I remember the Agassiz Theatre and how frivolous the name Idler seemed in wartime most of all the heavy curtain in itself a spectacle whose task it was to open at a certain moment in connection with distancing tactics directed by my mother. Her thought over here mapping the deep area where no stage set was ever permanent actors being one character then another according to movements she blocked out. Actors speaking correctly from memory. Trying to separate and distinguish what *is* recollection as detached from memory keeping falsity hidden. The smell of make-up the shrouded sets and props.

During the early 1930s when my father was a graduate student at Harvard Law School, he was one of a special group Professor Felix Frankfurter referred to as "my boys." Frankfurter's role as interpreter of the Court and the Constitution, and advisor to President Roosevelt, partly depended on the work of these students, disciples, and protégés, who later, through his influence, obtained crucial positions in New Deal Washington and came to be known as "Hot Dogs." Frankfurter also had academic dogs. When Buffalo University, inspired and advised by Frankfurter, was establishing a law school, Louis Jaffe, Ernest Griswold, and my father were more or less ordered there in 1937. When Justice Oliver Wendell Holmes, Jr., died in 1935 his papers had been placed in charge of his executor John Gorham Palfrey. Palfrey made them available to Felix Frankfurter because Frankfurter was Holmes's original choice to write his authorized biography. In 1939 Frankfurter was appointed to the Supreme Court of the United States and no longer had the time or inclination to undertake the monumental task of sorting

through his wordy predecessor's papers so he chose my father, who had been Holmes's law clerk and secretary in 1933–34, to do the job. Most of the papers were at Harvard and after he came home from serving overseas in 1946 we never went back to Buffalo. Frankfurter must have helped to arrange his appointment to the Harvard Law School, where he joined the teaching faculty as the first Charles Warren Professor in the History of American Law. Griswold was also recalled from Buffalo. He became the Dean, and Louis Jaffe followed in their wake. As well as teaching, my father immediately began work on the biography he may not have had time nor inclination to write. Considerate and reasonable with a streak of radicalism, he was a man of common sense, a lover of learning, able and good. But something in him, unexorcised though caged for the short range, made him work without rest, never letting on to those close to him what the cost might be. When he died, suddenly and unexpectedly in 1967, he was only sixty. "From the first I was subject to pressures to have Mark get on with his work on Holmes," Griswold somewhat regretfully noted at the memorial service. G. Edward White, in the bibliographic essay appended to *Justice Oliver Wendell Holmes: Law and the Inner Self* (1993), refers to my father as "Felix Frankfurter's 'authorized' narrator of the legend of Holmes."

Touched With Fire: The Civil War Letters and Diary of Oliver Wendell Holmes, Jr., 1861–1864, edited by Mark DeWolfe Howe, was published by Harvard University Press in 1947. When the Second World War was over the male director of Harvard's Dramatic Club also returned to Radcliffe and my mother was out of work until the first real Brattle Theatre (not cinema) began. We left the apartment on Craigie Circle, moved to a house on Appleton Street, and my sister Helen was born.

Once every week my father visited his mother's eccentric widowed sister, Mabel Davis. By 1947 she was was more than eccentric. She lived in Boston in a suite at the rapidly decaying residential Hotel Lenox, lovingly cared for by an elderly French seamstress who had been with her for over forty years, most of them spent in Argentina, where her

husband, Walter Gould Davis, was the director of the Argentine Me-
teorological Service. Aunt Mabel no longer remembered any of our
names but she was, in her own oblique way, sharp as a tack. Each week
with utmost civility she greeted the nephew whose name she had for-
gotten with the same salutation: "Give me your paw Attorney at Law."

The Proving Years (1963) is the second volume of my father's au-
thorized biography of Oliver Wendell Holmes, Jr. He called the first
chapter "The Stars and the Plough" probably because that's the title of
The Plough and the Stars. Sean O'Casey's play about the Easter Rising,
named for the symbol on the flag of the Irish citizen army, is one of my
mother's favorites. The stars are the ideal the plough reality. I guess my
father meant to put reality first.

The Angel in the Library
Antiquarianism is as old as historical writing even if Francis Bacon
in *The Advancement of Learning* defines antiquities as: "history defaced
or some remnants of history which have casually escaped the shipwreck
of time." The patriotic zeal of local antiquarian scholarship is often doc-
trinal it confirms a community's need to flatter current misconceptions.
According to genteel tradition Buffalo could be a mispronunciation for
"beau-fleuve" because French trappers traders and Jesuit missionaries
were the first European settlers to stop in common identity where the
present breaks in. In *Gibbon and His Roman Empire*, David P. Jordan
shows the ways *The Decline and Fall of the Roman Empire* was partially
built on the research of sceptics and historical Pyrrhonists outside the
universities. Pyrrhonists were usually proud to be called amateurs. Often
their research developed out of a need to classify their own collections of
coins, statues, vases, inscriptions, emblems, etc.; and the work demanded
new tactics. Gibbon calls the literary results of the labors of these dil-
ettante researchers the "subsidiary rays" of history. The best known
defender of uncertainty in history, Pierre Bayle, depended heavily on
the work of antiquarians. Studies of medals and inscriptions were more
reliable less subject to human corruption, he felt. Bayle's first idea wasn't

to write an encyclopedia of knowledge rather he hoped to produce a record of mistakes. On May 22, 1692, he told a friend: "I formed a plan to compose a *Critical Dictionary* which would contain a collection of the mistakes which have been made by compilers of dictionaries as well as other writers, and which would summarize under each name of a man or a city the mistakes concerning that man or that city." Bayle's *Historical and Critical Dictionary* follows the spirit of coordination's lead rather than a definite plan. Trivial curiosities and nonsensical subjects are kernels to be collated like tunes for a fact while important matters are neglected. A perfect history is "unacceptable to all sects and nations; for it is a sign that the writer neither flatters nor spares any of them." This sceptical aphorism can be found under the heading "An Explanation Concerning Obscenities."

Documentary histories, registers, and catalogues, often lovingly gathered by local amateurs, tend to be filed, boxed, sheltered: shut up. What is it about *documents* that seems to require their relegation to the bedroom (a private place) as if they were bourgeois Victorian women? Honored, looked to for advice, shielded from the rabble by guardians of "tradition" / "aesthetic taste," available only to particular researchers (husbands or bachelor machines) and caretakers (librarians cataloguers secretaries) so long as they are desirable (readable not too tattered) capable of bearing children (articles chapters books) rearing them (aiding research), they remain sheltered at home (museum collections libraries). Recently while backtracking through the authorized edition of John Adams's *Diaries* I was struck by a reproduction of an early American painting, "Congress Voting Independence," and thought I might use it on the cover of this book. A footnote cited "Congress Voting Independence: The Trumbull and Pine-Savage Paintings," by James M. Mulcahy in the *Pennsylvania Magazine of History and Biography*, 80: 74–9 (January 1956). When I went in search of it in the stacks in Sterling I found the right shelf but all issues of the periodical had been removed to the Franklin Collection Room, a place so far unknown to me, a room on the second floor. Here Yale University's custodians of early American

culture sequester whatever back issues of periodicals, local histories, antiquarian studies, bibliographies, even obliquely concern Benjamin Franklin or Philadelphia I'm not sure which because so many people consider both man and city as ideal stand-ins for America's Age of Reason. Franklin often veiled himself under an array of allegorical aliases ("Father Abraham," "Silence Doogood," "a certain public-spirited Gentleman," "the clean plain old Man with white Locks") as if he already felt the snooping future and must artfully prepare his face in advance. The materials are arranged according to a certain scheme of order I couldn't make out. A librarian, seated near the entrance at a desk piled high with papers and catalogues, asked me to produce credentials i.e., write my university affiliation on a list along with my reason for being there. I produced the required proof of professional departmentalization so she brought me the "Congress Voting Independence" piece. Mulcahy referred to two other articles by someone called Hart. I decided to continue postponing my cover idea because it was a hot midsummer day the Benjamin Franklin Room doesn't have air conditioning and the librarian looked impatient. I knew that even if one of the Harts was in *The Pennsylvania Magazine of History and Biography*, XXIX (1905) I would still have to locate the room where bound volumes of *The Proceedings of the Massachusetts Historical Society* are currently being sheltered from the public gaze, to find the other.

Borne on the bier with white and bristly beard

My American grandfather, Mark Antony DeWolfe Howe (1864–1960), was an antiquarian. In the 1940s the term "antiquarian" already suggested faded secondhand bookshops and useless scholarship. Mark Antony was named for his father Mark Antony DeWolfe Howe (1808–1895). This primal Mark Antony, somewhat scornfully referred to as "The Bishop" by his three Bostonian grandchildren (two atheists one Jungian), was ordained into the Episcopal ministry in the early 1830s, and served as rector in various churches in Boston, Roxbury, and Philadelphia, until his election as the first Episcopal bishop of central Pennsylvania in 1871. The robed and bearded patriarch I knew from

photographs was the author of two antiquarian volumes: *Memoirs of the Life and Services of the Rt. Rev. Alonzo Potter, D.D., LL.D., Bishop of the Protestant Episcopal Church in The Diocese of Pennsylvania*, and *The Life and Labors of Bishop Hare: Apostle to the Sioux.* In mid-life he altered d'Wolf by capitalizing the D, dropping the apostrophe, and adding two e's. "For tone" he is said to have said. In family memoirs and genealogies "for tone" is invariably set off by quotation marks. Marks are signals. Soldiers at a distance send watchwords across intervals. The curtain has risen another war is beginning. When Theodora Goujaud d'Wolf Colt a family poet ("poetess") hired experts to trace the origin of her family name, the experts came up with a coat of arms and motto: Vincit Qui Patitur—He Conquers Who Endures.

What made the Bishop positively primitive to liberal modernists was his excessive nineteenth-century predilection for getting and spending (three wives eighteen children). He and his wives had many more sons than daughters for some reason most of the daughters didn't survive anyway. Julia, Anna, Antoinette, and Helen Maria all lived for only a year or less; Louise was ten when something took her off. There was also another Mark Antony DeWolfe Howe between Grandpa and his father. The first one came from the second marriage. Born in 1848 buried in 1850 he is interred under a miscarved gravestone as "Marcuo." My grandfather was the fourth of five children born to the third wife, Eliza Whitney, daughter of an inventor and manufacturer of railway-car wheels. By then his father was fifty-six and his mother thirty-seven so to his Bostonian grandchildren the first Mark Antony was always posthumous. Eroticism inevitably strode forward into any conversation if his name came up as it often did behind Grandpa's back. Biblical fecundity rendered the Bishop foreign; more than foreign, wolfishly funny. To prime things to the brim they knew that when his first wife (eight years of marriage five children) died in 1841 on the Island of Santa Cruz (now St. Croix), her body was preserved in a cask of spirits and shipped home for burial.

Th'expence of Spirit in a waste of shame

Lustful and manifest in action, men in the early d'Wolf and Howe families were generally sea captains, privateers, slave traders; some involved in the China trade, others in whaling; most sailed out of Bristol, Rhode Island. Balthasar d'Wolf first shows up on this side of the Atlantic (no one knows where he came from) when he is hauled into court in Lyme, Connecticut, for smoking in public. Edward d'Wolf fought in King Philip's War. In 1779, Simon the son of Mark Antony d'Wolf and Abigail Potter died at sea with Mark Antony d'Wolf, Jr. In 1791 the first federal grand jury in Rhode Island charged another son, James d'Wolf, with throwing a female African slave overboard during the Middle Passage because she was sick with smallpox. George Howe traced the court documents when he was writing *Mount Hope: A New England Chronicle* (1959). "... James d'Wolf, not having the fear of God before his eyes, but being moved and seduced by the instigation of the Devil ... did feloniously, willfully and of his malice aforethought, with his hands clinch and seize in and upon the body of said Negro woman ... and did push, cast and throw her out of said vessel into the Sea and waters of the Ocean, whereby and whereupon she then and there instantly sank, drowned and died." "Captain Jim" already had a reputation for having slaves thrown over the side. He enjoyed cutting their hands off at the wrist personally, if they clung to the taffrails. So he lay low until 1795, when a more lenient district attorney nol-prossed the case. When this murderous ancestor could finally afford to buy his own slave ship he christened her *Sukey*. Sukey is my nickname. No one in the family, except my father, ever called me Susan, and he only did after he came home from the war and only if he was angry. To Grandpa I was always Sukey. Two people are speaking a language unknown to each other, I hear only a confused noise. Can you understand the nonsense they are talking? Captain Jim's sister, my great great great grandmother Abigail, married Perly Howe. Three of their sons were lost together at sea along with her sister Lydia's two boys in 1801 when the ship *Lavinia*, almost home, after circling the globe trading Yankee goods for furs of the North Pacific and then exchanging fur for china in China, broke up

in a snowstorm off Cape Cod. Abigail's brother Simon's son committed suicide somewhere on the Slave Coast. His brother, John d'Wolf, "Norwest John," another early venture capitalist, sailed to Russia by way of Alaska. He spent time in New Archangel, Kamchatka, before crossing Siberia on a sled in winter. Even if Captain John d'Wolf isn't the fictional Captain Robert Walton in Mary Shelley's *Frankenstein*, he married Mary Melvill [*sic*], Herman Melville's aunt, and so made his way into the "The Affidavit" chapter of *Moby-Dick*. His first cousin John "Squire" Howe was the "Bishop's" father. Squires, bankers, commodores, architects, actors, and bishops were a later by-product generally they only spent summers in Bristol. Grandpa, often referred to as the "Dean of Boston letters" or the fictional "late George Apley" because he encompassed the essence of what it meant to be Bostonian, was not Bostonian. His immediate family constellation occupied a large decaying farmhouse by the sea in Bristol called *Weetamoe*, until he married Fanny Quincy and escaped into genteel American idealism.

Several years ago while I was working on another essay I ran across Weetamoo, squaw-sachem of the Wampanoags, Queen of Pocasset (now Tiverton), wife of Wamsutta the son of Massasoit, and sister-in-law of the Narragansett sachem, Metacomet (King Philip to the colonial militia), in Mary Rowlandson's *The Soveraignty & Goodness of God, Together, with the Faithfulness of His Promises Displayed*. Rowlandson was taken captive during what has come to be known as King Philip's War (1675–77). In that war, Captain Benjamin Church "Mad in pursuit, and in possession so; Had, having, and in quest to have, extreme," with members of the colonial militia tracked Metacomet-Philip "past reason hunted, and no sooner had, / Past reason hated as a swallowed bait," into a swamp near Mount Hope (Montaup Pappasquash Bristol) and beheaded him. Metacomet's head was exhibited on a pole in Plymouth (thirty-five miles west) for twenty-five years. His body was quartered and each separate piece hung up on four separate trees; I don't know where or for how long. Weetamoo escaped the murderous Christian soldiers again and again until on August 6, 1676, she was drowned while

trying to float by raft to her kingdom of Pocasset. The tide washed her body up on land that eventually became the Howe farm.

The art of surveying has no definite historical beginning though the Chinese knew the value of the lodestone and in Egypt the tomb of Menna at Thebes has a representation of two men in chains measuring a field of corn. Narrative voices of landowners map a past which is established. The person taking possession talks of the lure and loot long after the shock of first assault. Mow(e) rhymes visually with how(e) and aurally with moo. Of course there would be mowed lawns around the house because the soul is conceived to be a facsimile of the body. Fields where cows graze are closer to primordial verbal material. During the American Revolution when the British War Office issued a guidebook for troops who were coming over to bring the disobedient colonies to heel, its author confused the Wampanoag sachem, Metacomet, with Spanish King Philip. "Bristol is remarkable for King Philip of Spain having a palace nearby and being killed in it." In the nineteenth century *Weetamoe* was a working farm owned by gentleman farmers. Just think of your ears as eyes over mirrors Weetamoo.

Cinder of the lexical drift

"The Dean of Boston Letters" didn't write serious histories, his enthusiasms were indeterminate, he was a dabbler and a dilettante. During the 1940s, masculinity, work, and progress overwhelmingly signified to me quarreling, disconnectedness, aggression. Grandpa, nicknamed by his children "Wayne" after Mad Anthony Wayne, a dead boxing champion, was one of life's noncombatants. I remember him as tender, domestic, androgynous. I guess Wayne was a way to set him apart from my father Mark, sometimes referred to by friends as "the Last Puritan" after a character in George Santayana's novel. Mark DeWolfe Howe was born in Boston in 1906. "Antony" was dropped as an expense of spirit in a waste of shame. To Bostonian ears the tone was wrong. In Shakespeare's *Antony and Cleopatra*, Antony exhibits both a lack of economy and positive *mis*behavior. If Cleopatra is the personification of lust he is under her

influence. Whatever the reason proper Bostonians frowned on names with too many vowels particularly vowel endings. The Bishop might have protested but he was dead. I may have mixed up some of these sordidly spectacular relatives but this is the general genealogical picture, a postmodern version. It could be called a record of mistakes.

Irish American English

Almost every Sunday during the war years, Fanny and I traveled with our mother from Cambridge to Boston by subway. We got off at the Charles Street station. The station was above ground because it was the first stop after crossing the river. Rising across the water Boston represented the distinction between nature and corporation. A finite old world, an ordered sequence of buildings, all peculiarly blank on Sunday. Even then I knew my father escaped by marrying my mother even if he only made it across the Charles River via Buffalo to Cambridge. The façade of the Charles Street Jail reinforced the effect of enclosure. We saw the barred windows but never felons though we knew they were *behind* on secret grounds. The iron railings suggested that legal procedure is grounded in vengeance.

We walked along Charles Street to Pinckney and on up the hill to Grandpa's apartment, the ground floor and basement, at 16 Louisburg Square. After his death Aunt Helen wrote a book, more or less about him, called *The Gentle Americans 1864–1960: Biography of a Breed.* She referred to this work as a "daughter's documentary." Like her two brothers she was restless under the constraints of genteel tradition in Boston. She was trying to escape parental and cultural benevolence until, quite unexpectedly and with shocking suddenness, her mother died in April 1933. It was understood by everyone, including herself, that she see her father through the catastrophe by remaining in the neighborhood at least, her brothers had more important things to do. During the war years, though she traveled a lot, she had a small apartment just around the corner on Pinckney Street. My father and his mother were so close he confined their love to a space inside himself and almost never spoke of her to us even after he came home from Europe though I know he

saw her in my sister and could take this daughter as representing his mother's quietness; a light of recognition he believed in. This first Fanny Quincy Howe wrote essays too, but anonymously. Her first published collection *The Notion Counter: Notes About Nothing by Nobody*, was followed by *Small Wares*. Though I do have several thin volumes, *Wensley: A Story Without A Moral*, *Charicles: A Dramatic Poem*, and *Lyteria: A Dramatic Poem* by Edmund and Josiah Quincy none of her essays were passed along to us; before Aunt Helen's book I had no idea she wrote anything. In 1977, The Feminist Press published *The Maimie Papers* consisting of letters from Maimie Pinzer, a reformed prostitute, to my grandmother. This book is still popular in sociology and women's studies departments of universities because it provides a sociocultural record of that historically inarticulate subculture, or so the editors say. There are no letters from Fanny Quincy Howe to Maimie Pinzer, they must have been lost or thrown out by Maimie or someone in her family. The introduction swiftly provides a standardized version of a "proper Bostonian" before hastening on to the "multi-dimensioned" persona of Maimie. Ruth Rosen, one of the editors, says "Mrs. Howe became a diary for her." What wounds Fanny had ever received, what the two women might have had in common; the courage they might have built in each other isn't the point the editors of this correspondence hope to make. "How did working-class women live during a period of history characterized by great industrial exploitation and institutionalized sexism," is what Rosen and her fellow editors are after. "The Maimie Project," as it was called at first, intended to address this question.

Maimie was my mother's nickname in Ireland, in the United States people call her Molly. She says that if our father's mother had been around in 1935 he would never have been allowed to marry her because in those days, in Boston, being Irish meant she wasn't good enough. It went without saying if the Howes were snobs Quincys were worse because it was through Quincys the Boston Howes were related to a President of the United States, a President of Harvard College, two mayors of Boston, etc., etc., but that was long ago. Now there was no money and only one male Quincy left, Cousin Edmund, who did nothing,

some of the time in Italy, some of the time in an indescribably gloomy apartment near the Charles River. Mabel and Helen, my grandmother's two older sisters, were still alive, but they lost their proper names when they married, and during the 1940s both of them were rapidly losing their wits. My mother often refers to the Quincys as "innocents." Not American cultural innocents, worthless in a scheming world in the sense of being fools, but honest. No, she means nuts. "All the Quincy china is cracked" is still one of her best aphorisms.

The curious thing about my grandfather's apartment was getting into it. We climbed the front steps to the principal entrance on the first floor. Once inside you could tell a single family used to live there because of the narrow hallway with its curving staircase and gracefully carved banister. This lowest hall at the base of the stairwell held the trace of another order of living forever closed to those of us coming in *now*, and that is the way we travel from periphery to center, guided by immediate experience and common sense to a new arrangement so we never merely stay in place. The door to Grandpa's apartment was in back where it was dark. Since the first floor was the second in terms of his complete living space, and living rooms in Louisburg Square had bay windows facing the street, his visitors must reach that public gathering place by walking through the bedroom, and the first thing you saw in this intimate space, normally closed to the public in genteel domestic arrangements of the 1940s, was a massive curtained double bed just like the one in the Doré illustrations for "Little Red Riding Hood." If a house is a stage for the theater of the family this was a stage within a stage because the mattress was so high off the ground it could have been a platform and the four mahogany bedposts had curtains though I don't think he ever pulled them shut. It was the bed he was born in at *Weetamoe* as long ago as the same year Abraham Lincoln was assassinated. Imagine three bourgeois women bringing eighteen children into the world on that small stage. Sometimes children take a long time arriving. Screams and pre-verbal cries vast interior dimness.

Telepsychology. We have always been in contact with one another, keeping on never letting go, no distance as to time, nothing such as liberty because we are in the field of history.

What are you crying for, Great-Grandmother?

For all the ruin so intolerably sad.

But we have plenty to eat. We are lucky to be living in the United States, so very new and very old, lucky to be in the new part. Everything is clearer now we have electric light.

You must go on as if I was an open door. Go right on through me I can't answer all your questions.

Beyond the bedroom was the living room at the front facing the Square. It was a long large room filled with all sorts of novels, histories, biographies, dictionaries, encyclopedias, portraits, third-rate nineteenth century landscapes, statues, busts, a model of the Parthenon under glass, a grand piano, stacks of musical scores, and furniture from any time frame except contemporary. There my grandfather held court surrounded by all his loved antiques and objets d'art as numerous as they were various, most of them slightly battered or faded. Except the portrait of his wife, that he did get restored, so that the cerulean and Prussian blues of it sounded the note of one who died early before she or the paint could crack like her sisters. There was never any question Grandpa would marry again. Just as there was never any question he would punish Fanny and me in place of our absent father even if he was supposed to.

The thing I remember more than anything else in the apartment is an elaborately carved ivory pagoda under glass in the basement dining room. I don't know whatever happened to it. I think it was donated to

a museum by Aunt Helen but I don't know which one. Uncle Quincy and my father are long since dead and no one ever consulted my mother though Grandpa came to live with us when he was very old, after his Irish housekeeper Mary Lawrence died. It was my mother who read The Lord is my Shepherd and sat beside him holding his hand when he was dying. Maybe she is right about the Howe and Quincy snobbery. Was she fatally Irish? Was "Mamie" Manning now "Molly" Howe peculiarly suspect because she wasn't a *paid* housekeeper? "O Dark Rosaleen, / the trouble you're seein', / Sure they're turnin' you into a / black Magdalene," by someone anonymous is the epigraph to her first novel, *Mount Venus*.

Delay in glass

In my memory the transparent cabinet is nearly five feet tall though breakable so it's in arrest on a small table made for the purpose of holding both because the exquisite pagoda, mythic and legendary, coexists with glass. It must have been acquired in China by a predatory d'Wolf or an entrepreneurial Quincy and brought back to Bristol or Boston as loot. I don't know how or why it arrives at Louisburg Square. Each fantastically carved stage or floor of the pagoda consists of a miniature room with a door but even the walls are open as a sieve is. A tiny ivory bell hangs in each entrance. If there is a sudden vibration in the dining room on our side of being, if someone speaks too suddenly, even a draft from the window is enough, all the skeletal bells shake as if the present can coexist in thin paper dress. Writing from perception to recollection I imagine a carved human figure at the door on each landing, semitransparent. Innocency. A pure past that returns to itself unattackable in the framework. Restoration. The light of twelve must be one or separate from what it merely represents stepping into the heart of metaphysics.

House in glass with steel structure

Look down a perspective of twenty centuries. Idealism a mirror where everything disappears to nothing Realism [Fragment / slash / quotation]. Etienne Jules Marey the inventor of chronophotography

wanted to cut time so it could become representable. Intuition is a mirror five fathoms retrospect easel to screen. The International Peace Bridge to Fort Erie, Ontario, was opened in 1927 as a memorial to a hundred years of U.S.-Canadian peace. Some things the origin of property for instance hold on by drift or design. Poems reflect the play of light its shadows on the mirror its splinters. In the *Bacchae* radical ecstatic dancers carry fire on their heads, it is so itself it doesn't burn them. The lost pardon. The good parent. Mother alone the father absent. There are so many things left out of *Hamlet*. Laertes speaks in meter everywhere. Why does Ophelia and only Ophelia speak prose in Act IV scene v? Stranger she sees more than earthly beauty. Irrationalist extant pieces before and after colonization surrounded by general rules phenomena phenomena from rules if we consider signs rather than causes—Bishop Berkeley (1734) *Principles of Human Knowledge*. Nor is the ghost allowed to step forward a muffled form the only trace left in order to grip us calling collective retribution after World War I. Give him a ladder to do archival research. One day after Cold War politics of the postwar world there is a door into the recent past of Modernism. Now draw a trajectory in imagination where logic and mathematics meet the materials of art. Canvas, paper, pencil, color, frame, title—

fifteenth of October, 1764, as I sat mus

efooted friars were singing vespers in t

demon darkened intelle

e decline and fall of the city first started t

ocables

moment of conception are recorded;

in the close of evening, as I sat

al the place and

y

fteenth of Octc

musing in the C

rs, while they we

er on the ruins of

Memoirs.

Benjamin Franklin tells us to lose no time, be always employed in something useful. He is the economic father of the United States inventive and unbridled. The essential part of any invention is distance and connectedness. We pass each other pieces of paper. A sheet of paper, a roll of film, the frame structure. Conceptual projects of the 1960s and 1970s combined windows, mirrors, garbage, photographs, video, dance, tape recordings, rope, steel, yarn, nails, cars, machines just about anything. Some minimalist sculptors started out painters or poets or vice versa. Cold War sadism was in full swing, all at large in the fiery impossibilty of Vietnam. According to Pyrrho of Elis since nothing can be known the only proper attitude is imperturbability. Pyrrho of Elis, here is infantile anxiety. While I am writing pieces of childhood come away. How do I put the pieces back?

Mirror axis

One day while riding in the forest Joseph Ellicott, "our Romulus," stops at a natural junction of east-west transportation routes from the Hudson Mohawk Valley to the Great Lakes, and pointing to the lake and river just visible through trees assures his riding companion, Mrs. James Brisbane, that a city "designed by nature for the great emporium of the Western World will arise at the mouth of Buffaloe creek and the country contiguous thereto." He renames the village New Amsterdam although members of the Seneca nation living there under British protection since 1780, along with other traders, trappers, and farmers, already refer to the settlement as Buffalo Creek, probably because herds of buffalo once inhabited salt licks in the area.

This place is called by the natives Teuh-sce-whe-aok. These lines I transmit to you from the point of impact throughout every snowing difficulty are certified by surveyors chain-bearers artists and authors walking the world keeping Field Notes. A representation of all the hills and valleys they pass, all rivers creeks and runs. This goes on forever as far as precapitalist Utopia because the Niagara River constitutes part of the boundary between the United States and Canada. Now throw the pebble farther out to the voluble level of totemism.

In 1808, realizing the importance of the location of this struggling frontier settlement at the far northwestern corner of New York State, the managing agent and surveyor for the Holland Land Company in Genesee County drafted plans for an elaborately baroque city, based on Major Pierre Charles L'Enfant's design for Washington D.C., and the gardens at Versailles. Streets, avenues, and terraces named for Amerindian tribes (Mohawk, Huron, Chippewa, Seneca, Onondaga, Oneida, Delaware, Missiaga) birds and animals (Swan, Crow, Eagle, Elk) for the most part paved, would be linked by radiating boulevards named for the directors of the Holland Land Company (Stadnitski, Vollenhoven, Casenovea [*sic*], Busti, Van Staphorst), with public squares at each intersection. Outer lot No. 104 was reserved for his personal use: "a noble manor, one hundred acres of land between Eagle and Swan streets and from Main nearly to Jefferson street, almost enough for a principality in Germany...." The bachelor surveyor proposed to build his house and gardens at the semicircular plot where Vollenhoven, Stadnitski, Van Staphorst avenues north and south converged. At night double lines of light would run out from Niagara Circle into the surrounding darkness. In his mind's eye (according to Professor Ellicott Evans, LL.D.) Joseph Ellicott saw a populous and wealthy future he was all wrapped up in it. Nervous against his coming removal he planned to bequeath this possible masterpiece of landscape architecture to the citizens of New Amsterdam / Buffalo as a place of public resort. Over his dead body.

"Adieu, adieu." Just to reach across.

In 1809 all the arrangements had been made for the building when the village commissioners put an end to the plan by running a street along the main westerly end of the lot, cutting directly through the semi-circle, and isolating the small piece of greensward that remained. "Mr. Ellicott always held that the act of the Commissioners had been illegal—they had no authority to run a street of more than four rods width. The stones were removed. I believe they were used in building the jail...." Old Ellicott could even have a handkerchief in his hand, and hold it to his ear, as if he could still feel the poison there, as if it were still seeping.

176

Flinders

Its hard to know where to begin.

In the old days when the world was in a better frame and wishing still helped, a mother and a father had two little girls. They loved them with all the love parents feel for their children. The brute force is Buffalo because of its position as a way station whose primary function is the movement of goods from east to west and vice versa in dark reaches before soldiers come foraging. Close by lies a great forest approaching Modernism my early poems project aggression.

1995

There Are Not Leaves Enough to Crown to Cover to Crown to Cover

For me there was no silence before armies.

I was born in Boston Massachusetts on June 10th, 1937, to an Irish mother and an American father. My mother had come to Boston on a short visit two years earlier. My father had never been to Europe. She is a wit and he was a scholar. They met at a dinner party when her earring dropped into his soup.

By 1937 the Nazi dictatorship was well-established in Germany. All dissenting political parties had been liquidated and Concentration camps had already been set up to hold political prisoners. The Berlin-Rome axis was a year old. So was the Spanish Civil War. On April 25th Franco's Lufftwaffe pilots bombed the village of Guernica. That November Hitler and the leaders of his armed forces made secret plans to invade Austria, Czechoslovakia, Poland, and Russia.

In the summer of 1938 my mother and I were staying with my grand-mother, uncle, aunt, great-aunts, cousins, and friends in Ireland, and I had just learned to walk, when Czechoslovakia was dismembered by Hitler, Ribbentrop, Mussolini, Chamberlain, and Daladier, during the Conference and Agreement at Munich. That October we sailed home on a ship crowded with refugees fleeing various countries in Europe.

When I was two the German army invaded Poland and World War II began in the West.

The fledgling Republic of Ireland distrusted England with good reason, and remained neutral during the struggle. But there was the Battle of the Atlantic to be won, so we couldn't cross the sea again until after 1945. That half of the family was temporarily cut off.

In Buffalo New York, where we lived at first, we seemed to be safe. We were there when my sister was born and the Japanese bombed Pearl Harbor.

Now there were armies in the west called East.

American fathers marched off into the hot Chronicle of global struggle but mothers were left. Our law-professor father, a man of pure principles, quickly included violence in his principles, put on a soldier suit and disappeared with the others into the thick of the threat to the east called West.

> Buffalo
> 12. 7. 41
>
> > (Late afternoon light.)
> > (Going to meet him in snow.)
> HE
> > (Comes through the hall door.)
> The research of scholars, lawyers, investigators, judges
> Demands!
>
> > SHE
> >
> > (With her arms around his neck
> > whispers.)
>
> Herod had all the little children murdered!
>
> It is dark
> The floor is ice

they stand on the edge of a hole singing—

In Rama
Rachel weeping for her children

refuses
to be comforted

because they *are* not.

Malice dominates the history of Power and Progress. History is the record of winners. Documents were written by the Masters. But fright is formed by what we see not by what they say.

From 1939 until 1946 in news photographs, day after day I saw signs of culture exploding into murder. Shots of children being herded into trucks by hideous helmeted conquerors—shots of children who were orphaned and lost—shots of the emaciated bodies of Jews dumped into mass graves on top of more emaciated bodies—nameless numberless men women and children, uprooted in a world almost demented. God had abandoned them to history's sovereign Necessity.

If to see is to have at a distance, I had so many dead Innocents distance was abolished. Substance broke loose from the domain of time and obedient intention. I became part of the ruin. In the blank skies over Europe I was Strife represented.

Things overlap in space and are hidden. Those black and white picture shots—moving or fixed—were a subversive generation. "The hawk, with his long claws / Pulled down the stones. / The dove, with her rough bill / Brought me them home."

Buffalo roam in herds
up the broad streets connected by boulevards

and fences

 their eyes are ancient and a thousand years
 too old

 hear murder throng their muting

 Old as time in the center of a room
 doubt is spun

 and measured

 Throned wrath
 I know your worth

 a chain of parks encircles the city

Pain is nailed to the landscape in time. Bombs are seeds of Science and the sun.

2,000 years ago the dictator Creon said to Antigone who was the daughter of Oedipus and Jocasta: "Go to the dead and love them."

Life opens into conceptless perspectives. Language surrounds Chaos.

During World War II my father's letters were a sign he was safe. A miniature photographic negative of his handwritten message was reproduced by the army and a microfilm copy forwarded to us. In the top left-hand corner someone always stamped PASSED BY EXAMINER.

This is my historical consciousness. I have no choice in it. In my poetry time and again, questions of assigning *the cause* of history dictate the sound of what is thought.

 Summary of fleeting summary
 Pseudonym cast across empty

 Peak proud heart

 Majestic caparisoned cloud cumuli

East sweeps hewn flank

Scion on a ledge of Constitution
Wedged sequences of system

Causeway of faint famed city
Human ferocity

Dim mirror Naught formula

archaic hallucinatory laughter

Kneel to intellect in our work
Chaos cast cold intellect back

Poetry brings similitude and representation to configurations waiting from forever to be spoken. North Americans have tended to confuse human fate with their own salvation. In this I am North American. "We are coming Father Abraham, three hundred thousand more," sang the Union troops at Gettysburg.

I write to break out into perfect primeval Consent. I wish I could tenderly lift from the dark side of history, voices. that are anonymous, slighted—inarticulate.

1990

Where Should
the Commander Be

For in the heart of the super-industrialized American, or the busily self-industrializing Russian, there still remains a nostalgia of infinite horizons, of fields, of plains and deserts. Individual or nation attaining the heart of mechanization and yet marrying it to our peasant and farmer yesterday.

The nostalgia of "big trails," "fighting caravans," "covered wagons" and the endless breadth of "old man rivers." ...

This nostalgia cries out for horizontal space.
—Sergei Eisenstein, "The Dynamic Square" (1930)

So, montage is conflict.
—Sergei Eisenstein, "The Cinematographic Principle and the Ideogram" (1929)

During the first week of August 1945, in the middle of the journey of his life, Charles Olson, after years of devoted and diligent attention to the life and writing of Herman Melville, finished *Call Me Ishmael.* Earlier, Olson had published "Lear and Moby Dick" (1938) in the first issue of Dorothy Norman's magazine *Twice a Year.* In 1939 Olson had completed the required course work for a Ph.D. in American Civilization, at Harvard, but he left an academic career to write a book on Melville. Later he abandoned the four-hundred-page manuscript.

In 1941 Olson moved to New York and Washington to work for the Democratic Administration, and soon became the assistant chief of the Office of War Information's Foreign Language Division. In May 1944, he resigned from that position, and moved to Key West. A year later he

was back in Washington between jobs and unsure of what to do next. When President Roosevelt died in April 1945, Olson, who no longer felt any particular allegiance to the Democratic Party under Truman's leadership, turned his back on a political future. Now he composed this classic of American Studies in only five months. Olson's "FIRST FACT is prologue," written last, began with a synthesis:

> Herman Melville was born in New York August 1st, 1819, and on the 12th of that month the *Essex*, a well-found whaler of 238 tons, sailed from Nantucket with George Pollard, Jr. as captain, Owen Chase and Matthew Joy mates, 6 of her complement of 20 men Negroes, bound for the Pacific Ocean, victualled and provided for two years and a half. —*Call Me Ishmael*

This external information underscores the potent influence of a subject on its compositional structure.

> Publish my own Soul August my father's month
>
> August 1st XLIV
>
> I am the
> Child, Jupiter
> *furens*—Ocean's
> Child; I am
> Round Rock Shoal
>
> I am the one from whom the Kouretes
> bang their platters
>
> August 7th, LXIV
> —*The Maximus Poems*

It took thirty-five Augusts for this passionate, ambitious, conflicted man to draw the hero-poet out of himself. Then Olson-Ishmael-Maximus subjugated while yielding to subjugation, and captured while freeing, the protean splendour of Herman Melville's restless, hieroglyphical nature. Life opens onto work. Through long study and great love for another author, Olson reached his own—"I am." There, shed of enticings, he stood free of, and contemporary with, his Soul's cold

fire-father, a Captain among hunters, an "original aboriginal" mediator-Moses; the author of the book called *Moby-Dick*.

> ... immediately that Macbeth murders the King he strides hugely
> forward into the mystery. —*Call Me Ishmael*

—

Call Me Ishmael is divided into five acts called "Parts" in accordance with the basic structure of tragic drama. By subtle repetition Olson structured his book so that the distance and trajectory of separate events assume a mathematical relationship inside the wider rhythm of the whole. Real events (facts) are interconnected by ties and links to a deep inner theme of composition as *conflict*.

> *There is no art outside conflict.* Art as a process.
> As in the collision of the arrow-like flight of Gothic vaults with the inexorable law of gravity.
> In the clash of the hero with the turns of fate in a tragedy.
> In the functional purpose of a building with the conditions of soil and building materials.
> In the conquering rhythms of verse over the dead metrics of the canons of versification.
> Everywhere—struggle. A stabilization born from the clash of opposites. —Eisenstein, *Film Essays*

Olson's book is spiritually akin to Lawrence's *Studies in Classic American Literature*, and Williams's *In The American Grain*. He was close to Edward Dahlberg at the time, and is said to have been strongly influenced by *Can These Bones Live*. Similar ideas and images do occur, but Dahlberg's dismal book is there and we are here. The austere structure of *Call Me Ishmael* reaches into our future. That structure is suggested everywhere in Eisenstein's writing and cinematography.

> We, our epoch—*sharply ideal* and *intellectual*—could not read the content of a shot without, before all else, having read its ideological nature, and therefore find in the *juxtaposition of shots an arrangement of a new qualitative element*, a new *image*, a new *understanding*.
> —"Dickens, Griffith, and the Film Today." *Film Form*

The spatial expressiveness of much of Olson's writing is seldom emphasized enough. It is evident here, in his first book, even on the page of Contents. This feeling for seeing in a poem, is Olson's innovation. Acute visual sensitivity separates *The Maximus Poems* from *The Cantos* and *Paterson*. This is strange, because Olson built his idea of Projective Verse on the length of a line, and the poet's breath. *Maximus* is for viewing. Eisenstein's principle of visual counterpoint sets Olson's writing on edge. Delicate perceptual intuition, apparent from the beginning, forced its own integrity of precision on a naturally omnivorous consciousness. At his best, Olson lets words and groups of words, even letter arrangements and spelling accidentals shoot suggestions at each other, as if each page were a canvas and the motion of words—reality across surface. Optical effects, seemingly chance encounters of letters, are a bridge. Through a screen of juxtaposition one dynamic image may be visible. At his worst, he forgets all this and the poetry goes slack. Olson understood (in spite of what he said) that words, punctuation marks, and sets of words, like a film director's sets and props, are sometimes wiser than the author. I don't know of another American poet whose work shows the *pictorial handwriting* of his dreams to such a degree. He is stuck with this care born from passion. It has nothing to do with the clever optical dynamism of Concrete Poetry. For Olson,

> space has a stubborn way of sticking to Americans, penetrating
> all the way in, accompanying them…. Trajectory. We must go over
> space, or we wither. —*Call Me Ishmael*

—

Pudovkin's visual montage links a man and his gaze to the sights that surround him. Collisions and combinations of images and rhythms, mysterious adjacencies and ambiguities are tied together in a common denominator. Then understanding serves the imagination. A critic's dialogue with the thinking of writing should be a clarification and understanding that an author's major meanings are often unspoken. At the threshold of academicism and poetry—sympathy is passionate morality. *Call Me Ishmael* is SPACE in which Charles Olson, an outcast from the world of art in name only, integrates Melville into himself.

You can see the prose stepping off. *—Call Me Ishmael*

Olson later wrote in "Human Universe," "There are laws, that is to say, the human universe is as discoverable as that other. And as definable." (*Selected Writings*, p. 53—endnote) His first book shows that we see everything and nothing in laws. Artists bow to no order. In a duel of emulation one figure eternally confronts another. Sympathy/ Antipathy. The conflict is projected into space. Emancipation of a subject from body and destiny is a never-never play of resemblance and rivalry. Each minute of the world is passing and realities are shifting. We learn the simplest things last. The beauty of irregularity and counterpoint (conflict) envelops documentation, definition, and culture's closed reason.

—

Brit

> Consider, once more, the universal cannibalism of the sea; all whose creatures prey upon each other, carrying on eternal war since the world began.
>
> *—Moby-Dick*, Chapter 58

PART I is FACT *—Call Me Ishmael*

On November 20th, 1820—a morning of fine clear weather—a spermacetti bull whale struck the *Essex* head on, twice, and destroyed her. Twenty sailors were thus forced to set out in three light open boats for the coast of South America 2,000 miles away. As the men began to sicken and die, the starving survivors resorted to cannibalism. Owen Chase's *Narrative of the Most Extraordinary and Distressing Shipwreck of the Whale-Ship Essex, of Nantucket, etc.* is representative of a popular tradition in American literature that began in 1682 with Mary Rowlandson's account of her Captivity and Restoration during King Philip's War. Melville was fascinated by the Chase narrative, and his curiosity extended to the later lives of the sailors who for a time had lived on human flesh. He was particularly interested in Chase himself, and Captain Pollard. Charles Olson felt that Chase's *Narrative* was a key to the structural volition of

Moby-Dick. His short, fragmented montage of a book takes cannibalism to be the first American fact.

> It is cannibalism. Even Ishmael, the orphan who survives the destruction, cries out: "I myself am a savage, owing no allegiance but to the King of Cannibals; and ready at any moment to rebel against him."
> —*Call Me Ishmael*

In 1939 Olson read Freud's *Moses and Monotheism*. Freud's book was crucial to *Call Me Ishmael*, and to much of his later writing. Closer to home, in American history, the political and religious underpinning of Colonialism and Capitalism as exploitation of workers in a "Book of the Law of the Blood." Explorers, conquistadors, ministers, priests, pioneers, hunters and industrialists had, "Like Ahab, American, one aim: lordship over nature."

> with what violence benevolence is bought
> what cost in gesture justice brings
> what wrongs domestic rights involve
> what stalks
> this silence
> what pudor pejorocracy affronts
> how awe, night-rest and neighborhood can rot
> what breeds where dirtiness is law
> what crawls
> below —"The Kingfishers," II

Melville lived our people's wrong. He knew our history and wrote our myth and methodology. In 1945 Olson felt terror of eternal vengeance swelling under the ocean of Industrial Progress. What predatory force crawls below Science?

> Melville did his job. He calculated, and cast Ahab. BIG, first of all. ENERGY, next. PURPOSE: lordship over nature. SPEED: of the brain. DIRECTION: vengeance. COST: the people, the Crew.
> Ahab is the FACT, the Crew the IDEA. The Crew is where what America stands for got into *Moby-Dick*. —*Call Me Ishmael*

What about the ship? Ahab is Captain Fact of the *Pequod*. The American Indian was a skilled part of the IDEA from the beginning. Melville named his whaleship for the FIRST Indian tribe to be exterminated by North American Christians. On May 26, 1637, the Pequots were trapped by the colonial militia in Mystic, Connecticut. During the ensuing massacre Narraganset Indians helped the Puritans. The *Pequod* is a cannibal of a craft, decorated with the relics of whales she has run down, killed, and cut up into sections. Pequot warriors decorated themselves with the scalps of their enemies.

During 1675–1676 the Wampanoags and their leader Metacomet-King Philip, were destroyed. Philip, who had waged a bloody and very nearly successful rebellion, was finally cornered in a wood in Rhode Island, where another Indian shot him through the heart. The English soldiers cut his body into quarters. His head was sent to the pilgrim settlement at Plymouth. Cotton Mather later wrote in *Magnalia* that Captain Mason "sent them in the head of a Leviathan for a Thanksgiving-Feast." Twenty years later, when Mather actually saw the skull of Metacomet, he "tore off the blasphemous Leviathan jaw for a souvenir."

> "The ship! The hearse!—the second hearse!" cried Ahab from the boat: "its wood could only be American!"
> —*Moby-Dick*, Chapter 135

> *It was in meadows of brit he found his seed.*
> —*Call Me Ishmael* (italics mine)

—

The second catapult for Melville's novel, its stimulant and affective attraction, was mutiny. Melville, who had once lived happily with cannibals, had also been a mutineer. Olson had seen Eisenstein's postrevolutionary silent film *Potemkin*. A twenty-two year old sailor's act of barbarism was Fact #2.

This occurred on the *Globe*, another whaleship from Nantucket cruising in the Pacific. On the night of January 26th, 1842, Samuel Comstock, a Quaker schoolmaster's son and a descendent through his mother, of one of Nantucket's proudest whaling families, murdered his

captain and the chief mate with an axe. Next, he shot the third mate with a musket, and fatally wounded the remaining one with a two-edged instrument used for cutting whale blubber. Comstock met the two surviving officers shouting, "I am the bloody man, I have the bloody hand and I will be revenged."

Olson cut this into the structure of his own Melvillian semi-documentary drama at the end of "PART TWO is source: Shakespeare." Mutiny refocuses attention on Cannibalism. In the chaos of Comstock's frenzied cry, design has come again. Rhythm. DROMENON. A single human rebellion somewhere at sea will spread to Ahab's extra-human hate, and from there a premonition of general misfortune. Malice is the fruit of the whaling industry. Malice is concentrated in the heartless immensity of the Universe. Malice is the history of Progress.

> Tashtego stood in the bows. He was full of the fire of the hunt. He hated Pip for a poltroon. Snatching the boat-knife from its sheath, he suspended its sharp edge over the line, and turning towards Stubb, exclaimed interrogatively, "Cut?" —*Moby-Dick*, Chapter 93

Pip—the shadow of Pip.

> Out from the centre of the sea, poor Pip turned his crisp, curling, black head to the sun, another lonely castaway, though the loftiest and the brightest. —*Moby-Dick*, Chapter 93

Pip's body bobs up, but the infinite sea of his soul sinks. He has seen "God's foot upon the treadle of the loom." Who is the captive king?

> ... from him only will the old State-secret come.
> —*Call Me Ishmael*

—

In The Flag of Ahab

> *God keep thee! Push not off from that isle, thou canst never return.*
> —*Moby-Dick*, Chapter 58

Americans exploded the first atomic bomb at Alamagordo, New Mexico, July 16th, 1945, at sunrise. Heat from the blast fused the surrounding

desert sand to glass. On August 6th (Japanese time), members of the crew of the *Enola Gay* dropped the atomic bomb on Hiroshima. In one second a 650-foot fireball seared the earth and utterly destroyed every building within a mile. In the city of 343,000 people, 66,000 were killed outright. 66,000 were wounded, burned, or maimed. Three days later America dropped another bomb on Nagasaki.

This was the same week Charles Olson finished writing *Call Me Ishmael*. The same week, one hundred and twenty-three years earlier, Herman Melville was born in New York City, and the *Essex* sailed from Nantucket to hunt whales.

> ... when Commodore Perry wanted a writer to tell the story of the opening of Japan, Hawthorne recommended Melville as the Pacific man.
> —*Call Me Ishmael*

In July, 1946, a pin-up poster of Rita Hayworth, dressed in a skimpy nightgown, and kneeling in a disheveled bed, was glued to the nose of the first atomic bomb Americans exploded in peacetime. The bomb was dropped on tiny Bikini Island in the Pacific. Bikinis are named after the fact, because they are supposed to produce an equivalent explosive effect on the libido.

Later, dozens of nuclear test explosions were carried out in the Pacific. During the 1950s America tested more nuclear bombs in Nevada and New Mexico. While these bombs were detonated, members of the 433rd Army Band, dressed in bermuda shorts, yellow scarves and pith helmets, stood in the desert sunrise playing "The Stars and Stripes Forever." Newspapers called them the Atomic Band.

Henry Adams once said, "America has always taken tragedy lightly."

—

Olson's third Last Fact is only a note that Melville jotted down in the back pages of his *Journal Up the Straits:*

Eclipse.
Noah after the flood. Cap.[tain] Pollard
of *Nant.* [ucket]

—

The beginning of man was salt sea, and the perpetual reverberation of that great ancient fact, constantly renewed in the unfolding of life in every human individual, is the important single fact about Melville. Pelagic. —*Call Me Ishmael*

Pelagic: adj. [*pelagicus*, fr. GK *pelagikos*, fr. *pelagos*, sea + ikos-ic]
1. of, relating to or living in the open sea: OCEANIC

Freud begins *Moses and Monotheism* by noting that the biblical interpretation of the name Moses—"He that was drawn out of the water"—is incorrect folk etymology. Trajectory of the eye over a world view. The eye obeys the will of the viewer. Aboriginal place names as against European nomenclature is a first American FACT. Etymologies and genealogies are precious allegories for poets swimming through libraries.

PERICLES. Where were you born?
And wherefore called Marina?
MARINA. Call'd Marina
For I was born at sea.
PERICLES. At sea! What mother?
MARINA. My mother was the daughter of a King,
Who died the minute I was born.... —*Pericles*, V, i

Marina's mother, Thaisa, was thrown unconscious and coffin'd into the Mediterranean Ocean. The sea cast her up on Ephesus, "shrouded in cloth of state: balm'd and entreasur'd," and Lord Cerimon made her breathe again by employing Theurgic magic and woeful music. Emblematical Ishmael, in the Pacific Ocean round and round contracting, was buoyed up by pagan Queequeg's coffin until the ship called *Rachel*, searching for her missing children, rescued him. Melville thought the names of all fine authors were fictitious because they stood for the ubiquitous and magic spirit of all Beauty. Keats asked to have HERE LIES ONE WHOSE NAME WAS WRIT IN WATER carved on his gravestone. The Egyptians said of their underworld God: "This is the form of him whom one may not name, Osiris of the mysteries, who springs from the returning waters." Brahma gave birth to Vishnu, but the Vedas were lying at the bottom of the ocean and the God was

useless without writing: "... so Vishnoo became incarnate in a whale, and sounding down in him to the uttermost depths, rescued the sacred volumes."

Pelagianism: *n -s usu. cap* [Pelagian + ism]: the teachings of Pelagius condemned as heretical in A.D. 431 and marked by the denial of original sin, the assertion that each individual has freedom of the will to choose not to sin, and the avowal that each person's freedom of the will includes the unassisted initiating power to move toward salvation and to appropriate divine grace necessary thereto.

> The Ancient of Days forever is young,
> Forever the scheme of Nature thrives;
> I know a wind in purpose strong—
> It spins *against* the way it drives.
> What if the gulfs their slimed foundations bare?
> So deep must the stones be hurled
> Whereon the throes of ages rear
> The final empire and the happier world.
> —Melville, "The Conflict of Convictions"

—

Melville's meeting with and admiration for Hawthorne altered the original shape of *Moby-Dick*. Without Melville's study of Hawthorne, Olson's study of Melville would be inconceivable. "Hawthorne and His Mosses" is *Call Me Ishmael's* skeleton. Here Melville discussed Shakespeare's immense value for his own writing, the power of blackness hidden beneath the deceptively gentle surface of Hawthorne's stories and novels, and a possible future for American writing.

And here let me throw out another conceit of mine touching this American Shiloh, or "Master Genius," as Hawthorne calls him. May it not be, that this commanding mind has not been, is not, and never will be individually developed in one man? And would it, indeed, appear so unreasonable to suppose, that this great fullness and over-flowing may be, or may be destined to be, shared by a plurality of men of genius? —"Hawthorne and His Mosses"

Olson quotes from Melville's "Scrawl" frequently.

In 1851 Melville marked a passage in his copy of Hawthorne's story called "The Gentle Boy."

> "Friend," replied the little boy, in a sweet though faltering voice, "they call me Ilbrahim and my home is here."
> The pale, spiritual face, the eyes that seemed to mingle with the moonlight, the sweet, airy, voice, and the outlandish name, almost made the Puritan believe that the boy was in truth a being which had sprung out of the grave on which he sat.

Ilbrahim, Ishmael, Ahab, Hawthorne, Melville, and Olson are all aspects of an American Shiloh. American men and boys, hand in hand at home together, share a privileged sovereign discourse. Hamlet, Macbeth, Timon, Lear, Marlowe, Webster, Shakespeare, Jonson, Blake, and Yeats stand in the same linear sequence.

—

Olson's chronicle of his own evolution as a poet in 1945 owes its title to *Moby-Dick*'s fictitious narrator's terse three-word order concerning naming. "Call me Ishmael." *Cogito ergo sum.*

Ishmael's drama is done on the third day of the Chase. Olson's study provides three Facts. The three Fates. The three Graces. The three witches in *Macbeth*. Goneril, Regan, Cordelia. Portia's three chests of gold, silver, lead. THREE. The mystic number. Occult ordering of wild power. The *Pequod* has three masts and three mates—Starbuck, Stubb, Flask.

> "Look aloft!" cried Starbuck. "The corpusants! The corpusants!"
> All the yard-arms were tipped with a pallid fire; and touched at each tri-pointed lightning-rod-end with three tapering white flames, each of the three tall masts was silently burning in that sulphurous air, like three gigantic wax tapers before an altar.
> —*Moby-Dick*, Chapter 119

Christianity adopted Antiquity's conception of a universe based on the threefold partition of the world. Noah hooped the world together

into three continents. Typology of the Trinity and the Holy Family. The mystical vision of earth as an *Orbis Terrarum* developed by the early Church Fathers, gathered in its wake wide-ranging biblical, allegorical, geographical and scientific associations. The three wise men represented the three continents. Saint Augustine decreed that citizens of his celestial city could only come from Europe, Asia, and Africa. A defined and limited space had been given to man by God. There *he* must dutifully dwell. In 1491 Europe was understood to embody civilization in its highest form. Catholic Europe was the seat of God's power. Catholic Europe was history's paradigm and supreme criterion. The re-appearance of Greek and Roman authors, a newly awakened sense of the relation of magic to memory, fascination with perspective in Renaissance literature and art, interest in maritime navigation—all these curiosities heralded the possibility of another space, vacant and vast.

"The Chase—Third Day"

> *The morning of the third day dawned fair and fresh.... "What a lovely day again! were it a new-made world, and made for a summer-house to the angels, and this morning the first of its throwing open to them, a fairer day could not dawn upon that world. Here's food for thought, had Ahab time to think; but Ahab never thinks; he only feels, feels, feels; that's tingling enough for mortal man! to think's audacity. God only has that right and privilege."*
> —*Moby-Dick*, Chapter 135

—

Olson subtitled Part Five of *Call Me Ishmael*, NOAH. Here he recalls that in 1400 Dante's fictive Ulysses forced his crew to sail West. They found a New Land, but were drowned before they landed. These sailors had followed the sun's track in search of unpeopled places.

Dante, the medieval theologian, consigned his hero to Hell. There he and his companion Diomed burn in one flame for the crime of restless audacity. Dante, the poet, glorified Ulysses at the same time he condemned him.

Three times God's fury, in the shape of a storm, whirled their frail craft round. Then the sea closed over them.

> 1. WITCH. A sailor's wife had chesnuts in her lap,
> And mounch'd, and mounch'd, and mounch'd. "Give me," quoth I.
> "Aroynt thee, witch!" the rump-fed ronyon cries.
> Her husband's to Aleppo gone, master o' th' *Tiger.*
> But in a sieve I'll thither sail.
> And like a rat without a tail;
> I'll do, I'll do, and I'll do. —*Macbeth*, I, iii

Melville was a nineteenth-century man. He consigned his anti-hero Ahab to oblivion in the Pacific Ocean, then rescued the shadow-aspect of Ahab/himself: *Ishmael.*

When the Fates ordain that Ishmael will take the place of Ahab's Parsee bowsman in the third light open boat on the third day of the chase, all goes according to their plan. The sailors are tossed out of the rocking craft by their furious quarry, "the third man dropping helplessly astern, but still afloat and swimming." Ishmael is that man. Pip bore witness of his Light. Pip's listeners heard but called him mad. Ishmael alone escapes to tell the story.

On his third voyage, Admiral Columbus realized that he had not arrived at an archipelago near the passage to the Indian Ocean. He had reached a mainland called Paria by the natives. He explained in his *Letter to the Catholic King* (1498) that this place must be the new heaven, hidden until then. The Admiral returned from his fourth voyage to "India" in chains, his energy, hope, and fortune gone. Another defeated and disappointed wanderer.

On September 4th, 1504, Amerigo Vespucci wrote a letter from Lisbon to Pier Soderini. The *Quator Americi Vesputti Navigationes* was the first written document that treated the new found lands as a separate and single entity. The *Orbis Terrarum*, real because it had been written, was now contradicted by an orbis *alterius*. In 1507 the *Cosmographie Introductio* published a Latin translation of Vespucci's letter with the

Waldeemuller engraved World Map. This was the first chart to show AMERICA's name. "We are the last 'first' people."

The world had a fourth inhabited part, mapped and written. Inhabitants of this fourth part might not be descendents of Adam. Prometheus had stolen fire from the sun again. Sailing to havens ahead unknown, did the original navigators—Columbus, Canca, Michele da Cuneo, and Vespucci—sometimes feel their ships might be enchanted, rushing backward through a pattern of inaccessible representation? Melville wondered for them in the "Try-Works" chapter:

> ... then the rushing Pequod, freighted with savages, and laden with fire, and burning a corpse, and plunging into that blackness of darkness, seemed the material counterpart of her monomaniac commander's soul. —*Moby-Dick*, Chapter 96

America was invented as it became visible.

—

> Ortega y Gasset puts it that the man of antiquity, before he did anything, took a step like the bullfighter who leaps back in order to deliver the mortal thrust. —*Call Me Ishmael*

Whalefighter Ahab howls an inverted benediction on the hot steel of the harpoon he has baptized with the blood of three pagans. Tashtego (Indian), Queequeg (Polynesian), Dagoo (African). Primeval perfection of 3.

> "Ego non baptizo te in nomine patris, sed in nomine diaboli!"
> —*Moby-Dick*, Chapter 113

Melville told Hawthorne that this was the secret motto of *Moby-Dick*. Marlowe and Shakespeare might have balked at such blasphemy. Iago knew it, but from that time he never spoke a word. The Declaration of Independence *does* make a difference. Only an American Shiloh would have dared to utter it. Ambidexter Cotton Mather might have shuddered, then secretly applauded.

"...look here.—three peaks as proud as Lucifer. The firm tower, that is Ahab; the volcano, that is Ahab; the courageous, the undaunted, and victorious fowl, that, too is Ahab; all are Ahab; and this round gold is but the image of the rounder globe, which, like a magician's glass, to each and every man in turn but mirrors back his own mysterious self." —*Moby-Dick*, Chapter 99

—

In the "Call Me Ishmael" section of PART ONE, Olson says that his book will be about the failure of American Democracy. He is chiefly interested in "a Melville who decided some time in 1850 to write a book about the whaling industry ..." This study will be about "MEN"—Olson rarely mentions women—who, when faced with an obdurate climate, "a tomahawk sun," plus the malice of American SPACE whose fulcrum is the Plains, are forced to square the circle and become specialists. What he does not say is that when faced with the SPACE of Leviathan, Melville's head, he must claim for himself some positivity.

Call Me Ishmael, but I am really someone else. Calling is always a first step toward possessing the unknown. Language surrounds chaos. Naming delimits the open and defines dominance. Re-naming is an overt coercion of original freedom. A specialist wants to positively identify something. Each product in a Capitalist system must have a certified trademark. Naming is an affirmation of value by man. In the history of the Americas, Christian connotation nullified aboriginal tradition.

—how man acquires the lost dimension of space. There is a way to disclose paternity, declare yourself the rival of earth, air, fire and water. —*Call Me Ishmael*

Olson's precarious text, his "marriage of spirit to source," is a Genesis.

Unto us a child is born.
Unto us a son is given.
And his NAME shall be called *Wonderful.*

The Americas are named for a magian rover-exaggerator. American Indians are so-called because of a dreamer. Even Columbus had another

name. From the age of fourteen Cristobal Colón was a wanderer. Although he spoke many languages, he claimed no motherland or tongue. The Admiral believed he had reached the skirts of Asiatic lands older than Abraham. Before time began with the shambles of history all the world was water. In the margin of the *Journal* of Columbus, Las Casas has written:

> "They were all groping in darkness, because they did not understand what the Indians were saying."
> —Cited in Todorov, *The Conquest of America*

—

While Olson seems to be saying that the interpretive principle of *Call Me Ishmael* is economic, what his study is speaking is the emancipation of its author from automatism.

Moby-Dick is more than just a book about the whaling industry, more than a novel about the death of American Democracy, more than an illustration of the realization that *"the inertial structure of the world is a real thing which not only exerts effects upon matter but in turn suffers such effects."* (Olson, *Selected Writings*.) Ideologies are regenerative for some artists. Ravished by Freudian terminology and primed with Heisenberg's Uncertainty Principle, Olson strides into the mystery of the Sperm Whale God.

> It is the facts, to a first people.
> (Nothing is without efficient cause.)
> —*Call Me Ishmael*

Specialists want to nail things down. Poets know to leave Reason alone. In "PART TWO is source: Shakespeare," Shakespeare walks away with the nail. Olson's mind follows his blood and reductive principles collapse. "Those deep faraway things ... quick probings at the very axis of reality...." that Melville was so drawn to in the tragedies of Shakespeare, fix and fascinate Melville's interpreter. Olson shares Melville's attraction to s loosened scope in the blood-lust of ambition stalking *Macbeth, Othello, Lear,* and *Timon.* His text subverts itself. Every single sentence is riveting.

Creation, like the dark continent of language itself, is open to infinite critical interpretation, to historical change, to changing vagaries of fashion.

Polar oppositions—a dialectic of form and content—shimmer at the novel's parameters of restriction and release. Through live-long nights shrouded with thick darkness the poet-navigator, like his predecessor Captain Pollard, becomes a commander first, a cannibal second, third,

"a night-watchman." —*Call Me Ishmael*

In Olson's poetic diapason, space sounds motion, signs speak vision, and rhythm reads back archaic cries. Facts are caesuras. Facts are rhythmic leaps. *Moby-Dick* is an inexhaustible quarry. *Moby-Dick* is an incandescent and subversive text. ENERGY SPEED DIRECTION, Americans who run can reach.

Why, this is the world's soul.
—*Call Me Ishmael* (Olson noting Melville's noting the Stranger's comment in *Timon*)

—

Whence come you, Hawthorne? By what right do you drink from my flagon of life? And when I put it to my lips—lo, they are yours and not mine. I feel that the Godhead is broken up like the bread at the Supper, and that we are the pieces.
—Melville, "Letter to Hawthorne"

Where was Moses when the lights went out? Moses Mosses Moby maybe. If God was the Word and the Sea is a great shroud, Who's there?

... some Inca trying to find a lost home. —*Call Me Ishmael*

In the dream of murderous union between fathers and sons, pieces of a past are broken and eaten. Pushed backward through time, Man's hierarchical position is a recent invention. *What lies under?* Is the human universe definable if you have left women out of the definition? Where is the mother then?

"There she breaches! there she breaches!" was the cry, as in immea-
surable bravadoes the White Whale tossed himself salmon-like to
Heaven. —*Moby-Dick*, Chapter 134

HAMLET. Say on. Come to Hecuba.
1. PLAYER. "But who, oh, who had seen the mobled Queen—"
HAMLET. "The mobled Queen?"
POLONIUS. That's good, "mobled Queen" is good.
1. PLAYER. "Run barefoot up and down, threatening the flames
With bisson rheum, a clout upon that head
Where late the diadem stood, and for a robe.
About her lank and all o'erteemèd loins
A blanket, in the alarm of fear caught up." —*Hamlet*, II, ii

Mobled, that is, *veiled*, with face muffled; past participle of the verb to
mob(b)le.

———

But Ahab, my captain, still moves before me in all his Nantucket
grimness and shagginess.... —*Moby-Dick*, Chapter 33

On the Earth's Edge is alone the Way to Stand
At Her Helm Eastward and Comprehend
She is a Spinning Globe Turning Her Back Always
On the Vault of Heaven Falling Away From Her Westward
The Star The Moon The Sun Racing
Ahead of Her and She Passing Going at 11.000 Miles
Per Twenty Four Hours Always
In This Direction Catching
Like Water on Her Teeth the Universe
Ahead of Her Always Facing
Forward and Passing Creation Backward To Her Own Night
Little Spun Boat or Beetle of Her Places
In the Great Heaven of Ocean —*Maximus*

The End of Art

silencio silencio silencio
silencio silencio silencio
silencio silencio
silencio silencio silencio
silencio silencio silencio

Art in art is art.
The end of art is art as art.
The end of art is not the end. —Ad Reinhardt, 1966

I should say—however hard I find it to justify this theory—that "concrete" by its very limitations offers a tangible image of goodness and sanity; it is very far from the now fashionable poetry of anguish and self.... It is a model, of order even if set in a space full of doubt.
—Ian Hamilton Finlay, 1963

How needful it is to enter into the darkness and to admit the coincidence of opposites, to seek the truth where impossibility meets us.
—Nicholas of Cusa
(note in Ad Reinhardt's daybook)

A lot of the background of this book is in the Mount Athos tradition that an icon is so alive that if you cut it it will bleed.
—Thomas Merton
(letter to Ad Reinhardt)

So bird, so spirit
so uplightly flies
That what before
That what behind
The bright bird knows not, lies. —Robert Lax, 1939

In 1953 the Swiss poet Eugen Gomringer published his first book of
CONSTELLATIONS.

The following year *From Line to Constellation* which was to become the
basic definition of a concrete poetry aesthetic, was printed. Gomringer
had come to concrete poetry through his association with concrete art,
which seemed to offer specific solutions to problems of line, surface, and
color. Until 1950 he had been writing sonnets.

In New York in 1953, Ad Reinhardt had chosen to paint geometri-
cally. A geometry of balance and monochrome that reduced abstraction
to its barest essentials. By 1956 he had reduced his materials even further,
using only dark colors. Here were truly simple paintings; simplicity was
their mystery. Paintings that offered no compromises. Paintings that
forced the viewer to search for what was offered.

The ideas of these two men, one an artist, one a poet, were not
original. What ideas ever are? As early as 1921, a new kind of poem was
being called for by Mondrian, among others. Just after World War I the
De Stijl Manifesto proclaimed:

the duality between poetry and prose can no longer be maintained
the duality between form and content can no longer be maintained
Thus for the modern writer form will have a directly spiritual meaning
it will not describe events
it will not *de*scribe at all
but ESCRIBE

it will recreate in the word the common meaning of events
a constructive unity of form and content ...

> Leiden, Holland, April 1920.
> theo van doesburg
> piet mondriaan
> anthony kok.

From Line to Constellation, when it appeared, helped to give focus to work that poets in many countries had been exploring. Gomringer saw a universal poetry. The languages of the world were moving toward unity. Abbreviations used in slogans and advertisements had brought about a new sensibility. Now the idea of a sentence could be stated and understood in one word. This simplified use of language seemed to mark not the end of poetry but a beginning. New words, freed from the baggage of past associations and restored to their primitive simplicity, would recapture the power they had lost. The new poet could be concerned with clarity and conciseness. "Restriction in the very best sense—concentration and simplification—is the very essence of poetry. In the constellation something is brought into the world. It is a reality in itself and not a poem about something or other. The constellation is an invitation."

For Reinhardt there were sources, too. In 1919 Malevich had painted his white on white works, and in the same year Rodchenko answered them with a black on black painting. Georgia O'Keeffe had painted *Black Cross* in 1929, which Reinhardt had admired, and more recently Newman and Rauschenberg had both made black paintings. But as

Lucy Lippard has pointed out, the historical interest in Reinhardt's work "lies in the formal possibilities also raised by Turner, Manet, Monet, Vuillard, and Bonnard rather than in the choice of blackness or darkness as a vehicle."

Reinhardt was both a student and a teacher of art history. An expert on Eastern art, he spent a great deal of time traveling throughout Europe and the Middle and Far East. In the jet age the world seems smaller—easier, therefore, to see art in. For a man with a few thousand dollars in his pocket, the world was, in fact, a museum. He was impressed with the ideas of Henri Focillon and George Kubler, who emphasized formal relationships in art history, not subjective ones. The review Reinhardt wrote for *Art News* of Kubler's book, *The Shape of Time*, is central to an understanding of Reinhardt's work. He saw himself as a logical development in that shape. The black paintings were to be an end to the easel tradition in western Europe.

> The one direction in fine or abstract art today is the painting of the same one form over and over again. The one intensity and the one perfection come only from long and lonely routine preparation and attention and repetition. The one originality exists only where all artists work in the same tradition and master the same convention.
> —Ad Reinhardt

To look at his paintings—really to look—would require time and silence and a careful search for the point where line or shape begins or ends. Forward, or back.

> The higher we rise, the more concise our language becomes, for the Intelligibles present themselves in increasingly condensed fashion. When we shall advance into the Darkness beyond Intelligible it will be no longer a matter of conciseness, for the words and thought cease altogether. When our discourse descends from the higher to the lower, its volume increases, the further we move from these heights.
> —Pseudo-Dionysius

Pleasures reside in silence and darkness; monotony not of boredom, but of calm.

Ian Hamilton Finlay, the Scottish writer and publisher of Wild Hawthorn Press, is one of the concrete poets who has been and continues to be most inventive in his use of image and model, name and what is named. Like Reinhardt, his work has always been concerned with something far more than simple subtraction. For Finlay, the esthetic of concrete art is only valid insofar as it is the manifestation of the eternal classical spirit. When *Rapel*, his first book of concrete poems, was published in 1962, it was clear that Finlay was a spiritual descendant of Gomringer. But Gomringer, although closely associated with painters and sculptors, particularly with Max Bill, has continued in his commitment to the printed word. Finlay has always used or evoked the plastic arts in his work. He has brought poetry off the page and out into the environment. He has made poems in stone, wood, glass, and concrete. Now the land he owns and lives on in Scotland has become his poem. The current notepaper from Stonypath, printed by Wild Hawthorn, has an epigram at the top:

PAN
incorporated PICK
Society of Scottish Garden Poets
Stonypath Dunsyre Lanark Scotland

and at the bottom:

The PICK is mightier than the PEN

It is both humorous—and serious. In his excellent book on Finlay (*Ian Hamilton Finlay: An Illustrated Essay*), Stephen Bann wrote that what Finlay has done at Stonypath is "to irradiate the area with meaning, through the exactly gauged installation of inscriptions, constructions and other types of poetic work. In this way, the enclosing area has come

to seem hardly continuous, in any but the most literal sense with the surrounding hillside."

To Reinhardt the ideas of Focillon and Kubler were crucial. To Finlay the long essay by Gombrich in his book, *Symbolic Images*, called "Icones Symbolicae," which discusses the platonic idea of images as instruments of mystic revelation, has been a key influence. Particularly the section on the "Philosophy of the Impresa." The joining together of a picture with a poem or title (emblem), or with a short motto (impresa), produced, during the sixteenth and seventeenth centuries, a mass of books on the subject. Now it is a lost art. Far from being an empty intellectual exercise, Gombrich feels that this matching of image to picture led back to such basic concerns as mystery, metaphor, and metamorphosis. In 1665, Emanuele Tesauro, in his *Cannocchiale Aristotelico* (Aristotelian Telescope), looked at the Universe of metaphors, emblems, symbols, puzzles, and riddles, etc., and then set them down for composers, artists, teachers, and preachers to use; he noted that the first fundamental for the art of the Impresa reads, "The perfect Impresa is a metaphor." Over two hundred years before the De Stijl Manifesto, we find Père le Moine saying in *De L'Art des Devises:*

> Were I not afraid of rising too high and of saying too much I should say that there is in the Device something of those universal images given to the Higher Spirits which present in one moment and by means of a simple and detached notion what our minds can only represent in succession and by means of a long sequence of expressions which more frequently get into each other's way rather than help by their multitude.

In 1966 Ian Hamilton Finlay wrote to the poet Robert Lax asking for an introduction to Ad Reinhardt, whose work he had seen and admired. Finlay wanted to have Reinhardt and Bridget Riley collaborate on an issue of his magazine, *Poor Old Tired Horse.* The letters concerning this project can be found among the Reinhardt papers in the Archives of American Art.

```
q u i e t     t e i u q

q u i e t     t e i u q

    t e i u q     q u i e t

    t e i u q     q u i e t

            - - -

s i l e n c e     e c n e l i s

s i l e n c e     e c n e l i s

e c n e l i s     s i l e n c e

e c n e l i s     s i l e n c e

            - - -

    q u i e t     t e i u q

    q u i e t     t e i u q

t e i u q     q u i e t

t e i u q     q u i e t
```

Robert Lax and Ad Reinhardt had been students at the same high school. During that time, says Lax, he was writing poems (some fat, some vertical) and Reinhardt was already developing a geometric, cubist style of his own. As time went on, the vertical poems predominated until he wrote one about birds—completely vertical in shape—for the

valedictory address. Both men went on to Columbia University where they met and became close friends with Thomas Merton. Merton and Lax later converted to Catholicism and, although he never joined an organized religion, Reinhardt was intrigued by their reasons for doing so. Merton's decision to join a Trappist monastery was an important enough event for Reinhardt to have listed, in his biographical resume, the day he tried to talk Merton out of it. There is a remarkable and probably coincidental similarity between Reinhardt's description of his black paintings and the description of the holy city of Jerusalem in the Book of Revelation.

A square (*neutral, shapeless*) canvas, five feet wide, five feet high, as high as a man, as wide as a man's outstretched arms (*not large, not small, sizeless*), trisected (*no composition*), one horizontal form negating one vertical form (*formless, no top, no bottom, directionless*), three (*more or less*) dark (*lightless*) no-contrasting (*colorless*) colors, brushwork brushed out to remove brushwork, a matte, flat, free-hand painted surface ... which does not reflect its surroundings—a pure, abstract, non-objective, timeless, spaceless, changeless, relationless, disinterested painting—an object that is self-conscious (no unconsciousness) ideal, transcendent, aware of no thing but art (*absolutely no anti-art*). —Ad Reinhardt

And the city lieth foursquare, and the length is as large as the breadth: and he measured the city with the reed, twelve thousand furlongs. The length and the breadth and the height of it are equal. And he measured the wall thereof, an hundred and forty and four cubits, according to the measure of a man, that is, of the angel. And the building of the wall of it was of jasper: and the city was pure gold, like unto clear glass.

And I saw no temple therein: for the Lord God Almighty and the Lamb are the temple of it. And the city had no need of the sun, neither of the moon, to shine in it: for the glory of God did lighten it, and the Lamb is the light thereof. —Saint John the Divine

Ad Reinhardt, *Abstract Painting.* 1966.

The same John who wrote "I am Alpha and Omega—the beginning and the end the first and the last."

Robert Lax says that *Poem,* 1939, which Mary Ellen Solt included in her anthology, *Concrete Poetry: A World View,* was the first he had written that was vertical in both form and feeling—an echo of a time in childhood when he first saw Brancusi's *Bird in Space.* In 1941, while working for the *New Yorker,* he wrote long poems in a private journal. Here the verticality of the writing was starting to become obsessive, one word below another, one syllable below another. "A form composed by an inner necessity with nothing so cool as a form to guide it." Slowly the theory began to shape itself, and he saw the advantages in such a form:

the look of the poem: i've always liked the
idea of a poem or a word as a single (arp-like)
alone on a page

(an object of contemplation)

but i've done a few poems in the shapes of
pears, wings, altars, stairs, or doors
ajar (after manner of george herbert,
dylan thomas or i h finlay)

i like white space &
i like to see a vertical
column centered
sometimes verticality helps in
another way

image follows image
as frame follows frame
on a film

verticality helps the
poet withold his
image until
(through earlier
images) the
mind is prepared
for it.

During the time Lax lived in New York, he and Reinhardt often discussed their work, each leaving the other to follow his own inclinations. Reinhardt read all the poems Lax wrote in the two or three years before he left for Greece, and though he preferred the more abstract ones, he was fond of *Circus of the Sun*, Lax's least abstract book. Reinhardt even considered illustrating it and worked out some preliminary drawings, but decided against it feeling that a poem on a page facing an illustration put poet and painter into a competitive relationship. It is interesting that when Reinhardt finally did enter into such a collaboration for Finlay's magazine, *Poor Old Tired Horse*, he did so as a writer not as a painter. Robert Lax says that rather than looking to the de Stijl

group or later to the concrete poets for theoretical guidance, his constant move toward simplification has been influenced by Haiku and Bansho poems, as well as by Norse and Icelandic ones. That economy is of the essence in art was a tenet supported not only by Reinhardt but by their close friend, painter, sculptor, prose writer, and theorist Robert Gibney, and by Mark van Doren in his lectures on Shakespeare.

The 1966 summer issue of the *Lugano Review* contained work by Lax, Reinhardt, Merton, and Finlay. The spiritual affinity that bound the three Americans together allowed them to remain close intellectual companions for all their adult lives, and, of course, had an effect on the work they produced. Most interesting is Merton's translation of Nicholas of Cusa's *Dialogue* between a Christian and a Gentile. At one point in the discussion the Christian says to the Gentile:

> Truth is but one. For there is but one unity, and truth coincides with unity. Therefore just as there is found in number only one unity, so in many there is found but one truth.

> Vision, then, which is without color, is unnameable in the realm of color, since there is no name of any color that corresponds to it ... Now God is to all things as vision is to color.

The piece by Reinhardt in the same issue, "Art in Art is Art-as-Art," is written in blank verse. One of the stanzas reads:

> A color in art is not a color.
> Colorlessness in art is not colorlessness.
> Blue in art is blue.
> Red in art is red.
> Yellow in art is yellow.

> Dark gray in art is not dark gray.
> Matt black in art is not matt black.
> Gloss black in art is gloss black.
> White in art is white.

Robert Lax's long poem *Black & White*, also in this issue, is one of his sparest. In fifteen pages he uses only three words and one sign—black, white, stone, &. These are placed in twenty-one different groups or combinations. Group 1:

<div style="text-align:center">

black black

stone stone

</div>

and, finally, group 21 reads:

<div style="text-align:center">

white white

& &

black black

black black

& &

black black

black

&

black

white

&

black

black

&

black

black

&

black

</div>

The same issue carried Mike Weaver's article, "Concrete Poetry," one of the best to have been written on the subject. In it, several poems by Finlay were reproduced and discussed at length. Most interesting, in this context, was *Homage to Malevich*.

It was during this same year that Finlay wrote to Lax, "I am amazed that you know Ad Reinhardt. I only discovered his paintings this year and am very keen on them.... Ad Reinhardt struck me by reason of the great dignity of his work ... that cool quality but by no means cold, by no means. The only thing really like Malevich I've ever seen. Really like, I mean. Anyway I thought, there is a man I would really like to talk to ... and there aren't many people I feel like that about nowadays. Your own poetry has—or often has—that kind of gravity I'm talking about. Not a heavyness, its a gravity, and its not a seriousness, its a gravity.... I have a real hunger for it just now. I used to use humor to make a distance and keep it art but now I feel this as being an inadequate means." When he wrote this Finlay cannot have been aware that Reinhardt had himself been a humorist for years. At one time a cartoonist for PM and a lifelong admirer of Krazy Kat, Reinhardt's frequent attacks on the "Art Establishment" were often coated with humor, masking a deep and passionate concern for the seriousness of his battle, which was rarely personal but always esthetic. The man who called himself The Great Demurrer in a Time of Great Enthusiasms hid his own enthusiasm for the "One Art" under a mask of irony.

In a letter he later wrote to Reinhardt, Finlay carried this concern still further. "There is a problem with concrete poetry, I mean my own— that they are grave pictures. In Scotland there is a lot of heavyness that is something quite different from gravity, something quite unartistic and this made me feel that humor was a very important thing in so far as it makes a distance, a space, and art needs that sort of space.... But I have started to feel that humor is not a way of doing things—that there ought to be evening poems as well as afternoon ones—and your pictures please me very much by having this distance, they are absolutely art and not by being *funny*. But that they are grave, anyone can see. Not heavy but grave. I wrote everyone about them with a sense of awe for I reckoned that anyone who is not thick, and who can have that distance, and yet be grave, is remarkably an adult."

THERE IS JUST ONE painting everytime.
THERE IS JUST ONE DIRECTION, ONE DIRECTIONLESS-
ness, ONE FORM, ONE FORMLESSNESS, ONE
FORMULA, ONE FORMULALESSNESS, ONE
FORMULATION.
THERE IS JUST ONE image, ONE imageLESSNESS,
ONE plane, ONE DEPTH, ONE FLATNESS, ONE
COLOR, ONE COLORLESSNESS, ONE LIGHT,
ONE space, ONE time.

0 0 0

THERE IS JUST ONE
REPETITION, ONE
DESTRUCTION, ONE
CONSTRUCTION, ONE
DISSOLUTION, ONE
EVANESCENCE, ONE
ABSTRACTION,
ONE RHYTHM.
THERE IS JUST ONE
QUALITILESSNESS,
ONE OBJECT, ONE
SUBJECT.
THERE IS JUST ONE
STYLE, ONE STYLELESS-
ness, ONE MATTER,
ONE SEQUENCE,
ONE SERIES,
ONE CONVENTION,
ONE TRADITION.
THERE IS JUST ONE
PARTICIPATION, ONE
PERCEPTION, ONE
INVISIBILITY,
ONE INSIGHT.

Poor Old Tired Horse, p. 7

Finlay's proposal for the way this issue of *Poor Old Tired Horse* should be done was to have Bridget Riley do the drawing and layout on cards—eight pages—and then send the cards on to Reinhardt. He would write in the spaces in his own careful and beautiful script and the completed package would then be sent back to Finlay who would have Wild Hawthorn

print it. Finlay says, "I recall that Bridget Riley sent a very neat parcel (containing the layout), and I have often used it as a standard for parcels; in my experience with *Poor Old Tired Horse* the best artists did the best parcels, but Bridget Riley's was unique in that it was not only superior, but democratic: it was held together with a safety pin."

It is easy to see what attracted Finlay to Reinhardt's work—in a way he was seeing his own reflection. Both men liked to be thought of as unsentimental classicists—classicists who had purged their work of all biographical revelation—yet they brought to their work sensibilities that are romantic and even religious. Reinhardt in particular viewed painting as a ritual process. What the color black meant to him—all the infinite power of suggestion it held. What the sea (both word and thing) meant to Finlay. And perhaps the implications in the word and color have really been arrows pointing to the same mystery which for both men is Art.

Ian Hamilton Finlay, *Fisherman's Cross.*

Ian Hamilton Finlay's *Fisherman's Cross*—again the cruciform, icon of redemption in continuity—is a poem whose visible form is identical to its structure. A concrete poem in concrete. No longer print on white paper, no longer the Universe of the blank page as in Mallarmé, but the silent voice of stone on stone. Form and content are one. Like the black paintings, the edges—demarcations—are blurred but definite, either /

or. The two words, seas and ease, are as close in value as two slightly different blacks are close. Here the words are close visually and rythmically. The ea combination in the middle is in my memory as the ea in eat, ear, hear, cease, release, death, and east, where the sun rises. These are open words and the things they name are open. There are no vertical letters, just as there are no sharp sounds to pull the ear or eye up or down. Life (seas) rhymes with Death (ease). The cross made by the words has been placed inside a hexagonal form which blurs the edges. The eye wanders off toward the borders until ease (almost seas backward), in the center, draws it back as does sleep, or death, or the sea.

> Death is a Crosse, to which many waies leade, some direct, and others winding, but all meet in one center. —Henry Vaughn

Finlay's poem *Homage to Malevich* requires a search for solution on the part of the reader / viewer exactly similar to that required by Reinhardt's later paintings. The poet has made an exact arrangement with complete economy.

```
l a c k b l o c k b l a c k b
l o c k b l a c k b l o c k b
l a c k b l o c k b l a c k b
l o c k b l a c k b l o c k b
l a c k b l o c k b l a c k b
l o c k b l a c k b l o c k b
l a c k b l o c k b l a c k b
l o c k b l a c k b l o c k b
l a c k b l o c k b l a c k b
l o c k b l a c k b l o c k b
l a c k b l o c k b l a c k b
l o c k b l a c k b l o c k b
l a c k b l o c k b l a c k b
```

First I see a group of letters in a rectangle—then the words *lack*, *block*, and *black*. The *b* running down the right-hand column seems arbitrary. Is this to be read horizontally, vertically, or all at once? Unlike Robert Lax, whose poems do read vertically, this poem has so many ways of being read that it is really up to the reader to bring meaning into it, just as one is finally left to find one's own meaning in a Malevich (white) or Reinhardt (black) painting. If you give this poem time and thought, you begin to see that there are tightly linked elements here. Tightly linked, and at play. The two words *lack* and *lock*, look alike, but mean opposite things. Modified by a variable (b) they form two new words, *block* and *black*. The *b* at the end which at first seemed arbitrary now makes perfect sense. An extra that has created something else. Carry it over to the left and begin with *black*. The vertical letters *l*, *k*, and *b*, positioned as they are, make vertical lines that pull the eye up and down, and that pulls the *o*, *a*, and *c* letters apart (the *o*'s and *a*'s are the only ones that vary). The round short letters give a horizontal tug which prevents the poem from being read up and down. The *black* (figure) and *block* (ground) balances with *lock* (stability) against *lack* (instability). Something open versus something closed. Are *lack* and *black* one and the same image, or exactly opposite? Are *block* and *lock* alike? All this is exactly what the title or subject suggested—Malevich's search for formal invention. Do black and white open or close? Are they absence or presence? Sense or nonsense? Here, just as in Reinhardt, it is hard to separate color from color, shape from shape. Here form and content are completely bound (locked) together.

Finlay has written a poem-booklet entitled *Homage*, dedicated to Robert Lax. The cover in red (crimson) has two black crosses in white squares at the top right hand corner. One is Richtofen's German aeroplane cross, the other is Reinhardt's compositional cross form. The two cross shapes echo a similarity between the two names: Richtofen / Reinhardt. Both men have come to be associated with a color. Black—Reinhardt, red—Richtofen. Other connections, the pilot alone, the artist alone, air/sky, air/picture plane, are here for the reader to add. As in the Impresa, an image has been transferred elliptically yet exactly.

The last word in the poem is "black" but the cover is red. Again a balance between variables. The poem is written vertically, in the manner of Robert Lax.

The work of these three men—two poets, one painter—is classical and romantic, impersonal and personal, a reconciliation of opposites. Always there is a sense of order and repose. They tell us that to search for infinity inside simplicity will be to find simplicity alive with messages. In my end is my beginning. Finding is the first act.

One color, one colorness, one light, one space, one time.

1974